Aubrey Beardsley

Twayne's English Authors Series

Herbert Sussman, Editor

Northeastern University

TEAS 459

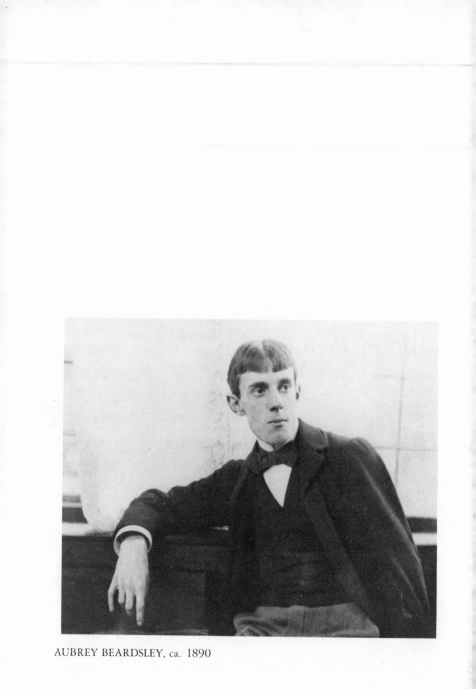

AUBREY BEARDSLEY, ca. 1890

Aubrey Beardsley

By Ian Fletcher

Arizona State University

Twayne Publishers
A Division of G.K. Hall & Co. • *Boston*

Aubrey Beardsley
Ian Fletcher

Copyright 1987 by G.K. Hall & Co.
All rights reserved.
Published by Twayne Publishers
A Division of G.K. Hall & Co.
70 Lincoln Street
Boston, Massachusetts 02111

Copyediting supervised by Lewis DeSimone
Book production by Kristina Hals
Book design by Barbara Anderson

Typeset in 11 pt. Garamond
by Compset, Inc., of Beverly, Massachusetts

Printed on permanent/durable acid-free paper
and bound in the United States of America

Library of Congress Cataloging in Publication Data

Fletcher, Ian.
 Aubrey Beardsley / Ian Fletcher.
 p. cm.—(Twayne's English authors series ; TEAS 459)
 Bibliography: p.
 Includes index.
 ISBN 0-8057-6958-7 (alk. paper)
 1. Beardsley, Aubrey, 1872–1898—Criticism and interpretation.
2. Drawing, English. 3. Drawing—19th century—England. I. Title.
II. Series.
NC242.B3F55 1987
741.6'092'4—dc19

Contents

About the Author

Ian Fletcher, a professor at Arizona State University, was educated in Britain at Dulwich College and at Goldsmith's College, University of London.

For twenty-six years he taught in the English Department of the University of Reading. In 1982 he came to the United States on appointment to the English Department at Arizona State University.

He has published several volumes of verse and translation, and has edited the poems of Lionel Johnson, Victor Plarr, and John Gray, along with three volumes of essays by different hands: *Romantic Mythologies*, *Meredith Now*, and *Decadence and the Eighteen Nineties*. In addition, he has contributed numerous articles and poems to such periodicals as the *Times Literary Supplement*, *Encounter*, the *London Magazine*, the *New Review*, the *Malahat Review*, the *Southern Quarterly*, and *English Literature in Transition*.

At present he is engaged on a selection from his essays in the fin de siècle period to be published under the title of *W. B. Yeats and Some Contemporaries*, a study of the art historian Herbert Horne, and a volume of literary memoirs.

Preface

An early death, notoriety in life, and the drama of his images have ensured that Aubrey Beardsley has never been devoid of attention, both favorable and dismissive. A further reason for this resonant "afterlife" derives from the nature of his drawings. They appear to invite and yet to defy "reading"; the theater of their black and white arrests the attention and then either fascinates or repels: the viewer either becomes a voyeur or shields his eyes. The world that Beardsley the artist presents is feverish, sinister sometimes, sometimes almost surreal. In about a dozen drawings only does he move beyond caricature, grotesque, satire, and the erotic to pure formalism or a "vision of evil" in W. B. Yeats's expressive phrase. It is by virtue of "Messalina" or "The Wagnerites" or "The Toilette of Salome" that he can be claimed as a major talent. In his other work he remains a brilliant decadent: parody, irony, and disbalance are deployed for their own sake.

He has had severe, distinguished detractors. Roger Fry, for example, the most influential of British art critics in the earlier twentieth century, terms him "The Fra Angelico of Satanism,"[1] wishing to stress the disjunction between the modernity of Cézanne and primitive art on the one hand and the fin de siècle, the art and culture of the late nineteenth century on the other. Recent art in the view of Fry and his Bloomsbury associates could only be French or West African-Polynesian; if it were English, it could only be Bloomsbury. Had Fry been less of an advocate, he might have observed elements of abstraction in Beardsley; economies of line that cut through any plodding record of conventional reality. But for him, as for his successors up to the recent present, Beardsley's art was too fatally compromised by its literariness; too anxious, so it seemed, to be approached hermeneutically like a text for full liberation as graphic art. As Beardsley's drawings mostly and deliberately refer back to literature, music, or other works of visual art, the point can hardly be dismissed.

To meet such objections and prove Beardsley's respectable part in the lineage of contemporary art, those who almost despite themselves admire him sometimes attempt to protect him from being locked in fin de siècle illustration: the gallery of Alphonse Mucha, Charles Ricketts, and Laurence Housman. Such admirers point to his line melting

into pure abstraction and projecting autonomous shapes in, say, "The Toilette of Salome." They may also insist that the drawings record the artist's psychological stresses and that their source lies within rather than without. Indeed, from the initial response to Beardsley's images up to, say, the 1950s, it has been assumed and repeated that Beardsley, even when ostensibly illustrating, insolently evades any direct connection with his text by irrelevance, anachronism, and the grossest mockery. None of this could be presumed to apply to Beardsley's "embroideries" (Beardsley's own word) to Alexander Pope's *Rape of the Lock*. Here, indeed, the word "embroidered" alludes to the finicking rococo dottings rather than to anything specifically added or irrelevant to the text. Beardsley follows his text all too faithfully; he capitulates to Pope and the consequence is a suite of uneven drawings. Yet till recently these faithful transpositions of Pope's poem, tainted with prettiness as they are, have been hailed as the artist's supreme achievement.

Beardsley's most popular images are undoubtedly the counterpointed black and white of his drawings for Oscar Wilde's *Salome* in its English dress. Here we move to another extreme. It seems that the artist distances himself from the text by derision and by caricature of the author and his work. But once more a later criticism has corrected this blunt judgment. Beardsley is indeed deeply engaged with the text and with what is implicated within the text. If the artist does furnish a drawing to the taste of those who see a "demon of progress" at work in the history of painting, it will spring less from his subservience to the word as in the Pope series than through a more subtle and at bottom a dialectical relation to the word as in the *Salome* sequence.

A favored way of dealing with Beardsley is through biographical speculation. The uneasiness provoked by his images often results in telling yet again the tale of his dismissal from the *Yellow Book*; his dealings with Wilde and Whistler; the wound of his birth and his early physical separation from his mother; his intimacy, perhaps even in the dialect of the law courts, with his sister Mabel; his erethism, mental masturbation brought about by tuberculosis and by difficulty of access to women. More seriously, such events can be used to explain, though not necessarily explain away, the images. As Theodore Roethke puts it, "anything that's longer than it is wide is a male sexual symbol, say the Freudians."[2] But the images are so conscious, so unremitting, and so controlled (except in the *Bon-Mots* vignettes and in a few other places) that the superego seems always to have been superogatory. The mood of Beardsley's fetus image, for example, does not surely echo

the pathos of exclusion, but the privilege of the voyeur who sees all of the game. That too is doubtless subsumable under Freudianism: who bears the Bow must also bear the Wound. We must be hurt into art; but with Beardsley the compensation is not a second best. Erethism is furnished with a self-expressive pen as well as a hand. However, it would be ungenerous and untrue not to record that the Freudian approach has resulted in pertinent insights. It has also been deployed with eloquence by Brigid Brophy to deny the literariness of Beardsley's images: "The tension that dominates all his compositions is entirely in the design and in the medium. None of it is borrowed from the incidents, and still less the characters, of any story he may adopt. This makes it less strange than it superficially looks, in a personality so passionately literate, that Beardsley *didn't* after the Hamlet picture of his teens, much draw on or from Shakespeare. Shakespeare was *too* literary for Beardsley's requirements: the images too perfectly fused into their literary vehicles of character and action."[3] But what then of Pope? Isn't he literary, too? And what of a drawing like "The Cave of Spleen," where Beardsley minutely follows Pope's images? Is this really "pure image?" and is it "the epitome of the rococo" as Brophy argues? And Brigid Brophy uses the modes of literary criticism and its vocabulary: irony, ambiguity, and verbal elaboration of image to make her points.

The argument of this book is that Beardsley's finer images mediate dialectically between text and reader. He is engaged in gestures that are both critical and rhetorical, elucidating the subversive (for the author) or the disconcerting (for the viewer) elements in the given text. And the disconcerting extends not only to subject but to the interpretation of the subject: the viewer is unable to rest in a reading of the image.

The biographical accent is muted. The first chapters deal summarily with the life. The second records some of Beardsley's principal images: their changing significance and development. The third chapter takes us to the point of the first "leap" in his art, the moment of "Siegfried." Chapter 4 concentrates on the first extended displays of his early maturity: the *Morte D'Arthur* illustrations and the *Bon-Mot* vignettes of 1893 and 1894. The fifth chapter deals with *Salome,* where early influences melt into a new and entirely personal idiom that consummates the black and white technique. In chapter 6 the illustrations to the *Yellow Book* (1894–95) are discussed and their principal stylistic features analyzed: the preference for modern, urban, and nocturnal topics, and the disbalance of central figures. In the seventh chapter, the *Savoy*

magazine and other drawings of the phase (1895–96) are looked at. A new classicism invades Beardsley's art: figures are centralized; a plastic and somewhat monumental quality also enters into the work. The simple black and white idiom is complicated by dotting and the influence of both French seventeenth- and eighteenth-century rococo can readily be detected. Beardsley's dealings with the poster, with book illustration and bookplates form the substance of chapter 8, while in chapter 9 Beardsley's ambitions as a man of letters and his illustrations to his own works are rehearsed. The artist's last illustrations dealt with in chapter 10 show him still restlessly experimenting with the styles of the past: Greek vase painting and Japanese *shunga* in the illustrations to Aristophanes' *Lysistrata*; an acrid sensuality tingeing the later *Juvenal*; floridly classical models in what little was accomplished in the *Volpone* drawings. Only in the illustrations to *Mademoiselle de Maupin* is there a new noncommittal, indeed enigmatic, realism; the Beardsley woman remaining sensual but destructive no longer. The technique of added washes is only successful in part. These offerings alone constitute a really radical shift, and it is idle to speculate as to the direction of his gifts had he been allowed more time. In the final chapter the question of the value and significance of Beardsley's art is addressed and his reputation summarily discussed.

This "afterlife" has been varied. It has involved neglect by art critics and scholars; intense enthusiasm by a few collectors and in consequence what amounted to a mass production of forgeries, some of which can be traced back to Leonard Smithers, his partner H. S. Nichols, and the mysterious briefless barrister John Black. Like Oscar Wilde, Beardsley was famous in many countries, though merely notorious in England. Both men were "modern" and both exploited and were exploited by the new means of communication: the "new journalism" originating in the United States in the earlier 1880s. As a consequence of the acts enforcing compulsory education on England in 1870 and in 1874, the new literate masses were let loose on the printed word, and newspapers and magazines were furnished for them, vowed to instant news, instant controversy, instant polarization, and the routine coarsening of issues into personalities. In the middle ages, as Wilde observed, they had the rack, now we have the press. Nonetheless, both Wilde and Beardsley used the popular media, were used by it, and in the end were broken by it. Beardsley fell with Wilde when the Irish dramatist was condemned for homosexual acts in 1895.

The second reason for the rapid fame of Beardsley or the "Beardsley"

of the popular press was the result of experiments made in mechanical reproduction between 1880 and 1890 that created a revolution in the printing of drawings. As James Thorpe succinctly puts it: "Economy in time and cost and far greater accuracy were the most valuable virtues of the new process. Newspapers could print an illustration within a few hours of its delivery, whereas before they would have had to wait for several days." Instant news demanded instant illustrations for instant readers.

The construction of a line block was in essence a development of the process of etching:

The pen and ink drawing is photographed in reverse on to a zinc plate covered with a sensitized gelatine fil. The lines are protected against the action of the acid, which is used to eat away the white or unprotected parts of the design, and are thus left raised in relief to receive the ink, in the same way as metal type. The zinc plate is then backed with wood to strengthen it and raise it to the required height so that it can be set with the type for printing. . . . Half-tone blocks, which are generally used to reproduce photographs and tone drawing, are generally made of copper. The illustration is photographed through a glass screen with fine lines of varying mesh drawn across in both directions. These break up the design into a collection of dots of varying degrees of size and closeness, thus producing a close approximation to the gradations of tone in the original. The degree of mesh varies according to the required fineness of the block and the quality of paper on which it is to be printed.[4]

The firm of block makers with which Beardsley had most dealings and of which he most approved was that of Carl Hentschel. The first line block had been printed in 1876, the first half tone in 1884, and by 1888 both processes had begun to supplant wood engraving, so that Beardsley's career began a year or two after these processes were established and he was not tied by early training, convention, or ideology like William Morris to the wood engraving or the wood block. With the line block and half tone, the artist could rely on having his design reproduced very nearly in facsimile, though the size might well differ from the original drawing. Generally the original was reduced, as this tended to improve the effect. Any substance that made a black mark could be used: pen and ink, pencil, lamp-black, or ivory-black (in oil or water color), lithographic or ordinary chalk, conte crayons, charcoal, Chinese white, or process white. Chinese white was often used rather as we now use liquid paper correction fluid to amend errors in drawing.

Although photomechanical reproduction eliminated the middleman of engravings and so translated the original design more accurately, the degree of accuracy has perhaps been overestimated. A proper study of Beardsley's draughtmanship requires a study of the original drawings, many of which have been preserved and most of which are in public collections. The detail of a drawing can be coarsened or blurred in reproduction. To look at the originals, though, is not always easy. Beardsley's drawings are scattered: most are in the United States, some in Britain, a few in European institutions, a few (some possibly still unrecorded) in private hands. The degree of accurate reproduction varies. As a consequence, no attempt is made here to comment on the relation of originals to reproductions. A close and elaborate examination of the originals therefore remains to be accomplished, though a number of pertinent comments will be found in the indispensable Studio Vista volume by Brian Reade.[5]

It is assumed that readers will have a body of the illustrations before them as they read this text, for the "minute particulars," the literalism of Beardsley's art, make it unlikely that readers will be able to envisage the various designs as they read.

Beardsley's timeliness—he is a perfect example of Hippolyte's Taine's mechanistic formula for aesthetic force: the Man, the Milieu, and the Moment—lies in his drawings of women; his establishment of new physical types that have a "modern" quality of complex attractive repulsiveness. It is a gallery comprising the bold, the sexually aggressive, the sensual: knowing adolescents, corrupt children or children about to become so, sisters of the night, and the fat woman—dominating, unscrupulous—who literally presents the empire of the flesh in the irresistible wave of her bosom. The 1890s were inhabited by versions of the "New Woman," active in politics, art, music, and literature, reacting against the double standard of morality, experimental in her celebration of sexuality, whether heterosexual or sapphic: altogether a type of carnal enterprise that had been the privilege of the aristocracy and distinctly less usual among the middle classes with their worship of respectability.

Beardsley's images could be read both as lurid parody or admiring record; but they could not fail to kindle irritation or anger. The Beardsley woman barely conformed in any of her incarnations to Victorian notions of beauty. Like some of his contemporaries, Beardsley sought, if not beauty, sexual attractiveness at all events, in strange forms, discovering sometimes the "beauty of ugliness," the ideal of those artists

and literary men who gladly accepted the title of "Decadents." In his image of woman there was inevitably frustration and fear. He grew up and was most of his life confined to a world of women; he had little experience of the aggressive open world of men. But he could sense a truth that transcended his limited situation. All of his women, whether in middle age or breaking into puberty, are vibrant with the desire for sexual pleasure and the desire for power through sexuality. The Beardsley woman is adept in sexual politics. This was the moment when women were beginning to invade the male-dominated world, and the record of that moment gives his drawings additional topicality.

Beardsley scholarship and criticism is mainly a feature of the last twenty-odd years, though it would be ungrateful not to mention such figures as Arthur Symons, Robert Ross, and R. A. Walker (Georges Derry) who were pioneers in the establishment of a Beardsley canon and assisted in defining the precise nature of his gift, while not to acknowledge indebtedness to Brigid Brophy, Simon Wilson, the late Lord Clark, Stanley Weintraub, Miriam Benkovitz, and, last but most, Brian Reade, would be simply dishonest. Without Reade's altogether admirable Studio Vista book and his catalog of the Beardsley exhibition of 1966 at the Victorian and Albert Museum, London, it would not have been possible to have attempted this work. Suggestions from friends and students also proved invaluable: Linda Dowling, Linda Zatlin, Chris Snodgrass, Anthony Collins, Peter Crompton, and Ashok Chanda.

Ian Fletcher

Arizona State University

Chronology

1872 Aubrey Vincent Beardsley born 21 August at Brighton, Sussex, England.

1878 Goes as a boarder to Hamilton Lodge Preparatory School in Sussex.

1879 Contracts tuberculosis.

1881 Moves to another preparatory school at Epsom, Surrey.

1884 Lives in Brighton and attends Brighton Grammar School as a day boy.

1885 Becomes a boarder at Brighton Grammar School and is encouraged to act, write, and draw by his housemaster, Arthur William King.

1888 Becomes a surveyor's clerk in London. Lives with his family in the London suburb of Pimlico. Produces and acts in amateur theatricals.

1889 Becomes a clerk in the Legal and Guardian Assurance Company. Severely ill.

1890 Publishes an essay in *Tit-Bits*.

1891 Edward Burne-Jones praises Beardsley's drawing and advises him to study art professionally. Autumn, begins evening classes under Fred Brown at the Westminister School of Art.

1892 Meets Aymer Vallance and Robert Ross. Inherits £500 from his mother's aunt. Visits Paris where he meets the painter Puvis de Chavannes. Frederick Evans introduces him to the publisher J. M. Dent. Autumn, Dent commissions him to design an edition of the *Morte D'Arthur*. Gives up job with Legal and Guardian against parents' wishes.

1893 February, begins drawing for the *Pall Mall Budget*. April, first number of the *Studio* contains an article on him by Joseph Pennell, illustrated by eight drawings. May, visits Paris and sees *Tristan and Isolde,* the source of his "The Wagnerites." Receives commissions from the publishers Lawrence and Bullen for illustrations to Lucian's *True History*. J. M. Dent commissions

vignettes to three volumes of *Bon-Mots.* June, receives a contract from John Lane and Elkin Mathews to illustrate the English translation of *Salome.*

1894 Takes over a lease on 114 Cambridge Street, Pimlico. February, English translation of *Salome* with his illustrations and cover designs. April, poster for John Todhunter's *A Comedy of Sighs* and W. B. Yeats's *The Land of Heart's Desire.* First issue of the *Yellow Book* published by Mathews and Lane, with Beardsley as art editor. Period of assymetrical black and white drawings.

1895 April, Oscar Wilde arrested for homosexual practices. Association of Beardsley and the *Yellow Book* with Wilde leads to Beardsley's designs being withdrawn from the April issue of the *Yellow Book,* and he is sacked as art editor. Forced to move from Cambridge Street. Publisher Leonard Smithers offers to pay Beardsley £25 a week for his work. Plans with W. B. Yeats and Arthur Symons a new periodical to be published by Smithers. June, leases 57 Chester Terrace, London; gives it up in December. Summer and early autumn in Dieppe with Symons, working on the *Savoy.* Ill again.

1896 January, first issue of the *Savoy* with Beardsley as art editor. April, second issue features portion of Beardsley's unfinished romance "Under the Hill." March, in Brussels with Smithers. Returns to London, too ill to work. Meets Marc Andre Raffalovich, his second patron of these last years, and Raffalovich's friend John Gray, poet and later priest. July, moves to the country, too ill to work. At Epsom. Finishes the *Lysistrata* drawings for Symons. At Bournemouth to end of the year. December, last issue of the *Savoy.*

1897 Still at Bournemouth. Converted to the Latin Catholic church through influence of Gray and Raffalovich. April, travels to London, then to Paris. May, at St Germains, near Paris. Very ill. July, at Dieppe. November, returns to Paris. Moves to Hotel Cosmopolitaine at Menton on the Riviera, southern France. Able to work intermittently. *A Book of Fifty Drawings.*

1898 Last despairing letter to Leonard Smithers asking him to destroy obscene drawings. Dies 16 March at Menton.

1899 *A Second Book of Fifty Drawings.*

1904 John Gray edits *The Last Letters of Aubrey Beardsley.*

Chapter One
The Life

Aubrey Beardsley's brief life was dramatic, though the drama was mostly confined to his art and its reception. His mother, Ellen Pitt, was the daughter of Surgeon-Major William Pitt, whose career was for the most part spent in the service of the East India Company and chiefly in Bengal where he met and married Ellen Lambe, the daughter of a Scots indigo-planter. On his retirement, William Pitt settled in Brighton, an elegant resort on the south coast of Britain, popularized by the prince regent and with many regency buildings, including the regent's own mock-oriental and rococo pavilion with its domes, minarets, and florid interiors, which were to play some role in Beardsley's art.

The Pitt family had previous associations with Brighton for William Pitt's father had practiced medicine there. William's daughter Ellen was dashing and handsome though slender enough to be referred to as "bottomless Pitt." That Ellen was unconventional, we may gather from the manner in which she made the acquaintance, without formal introduction, of Vincent Paul Beardsley, a Londoner who had inherited tuberculosis from his father and who was lodging in Brighton to improve his health. Vincent Beardsley was of small independent means and had not been trained to pursue any particular profession. There appears to have been opposition to a proposed marriage by the Pitt family on the snobbish ground that Vincent's father had been a manufacturing goldsmith and was thus excluded from gentility. Ellen was strong-minded, though, and the couple were married at Brighton on 12 October 1870.

For Vincent, so one account runs, the marriage had an inauspicious start, for he was sued by a clergyman's widow for breach of promise to marry and was consequently forced to sell off some property he possessed in London. We also hear of some later loss of fortune. It was not long before Mrs. Beardsley came to the view that she had not merely married beneath her socially and morally but had even lost the compensation of security. However, most of our information about Vincent

comes from his wife, and accounts of his brutality and shiftlessness may well be harshly colored.

Vincent and Ellen had two children: Mabel, born on 24 August 1871, and Aubrey Vincent on 21 August 1872. Mrs. Beardsley was afflicted with puerperal fever at the time of her second delivery, and Aubrey was separated from her at once. Both children were born at Brighton; the address on Aubrey's birth certificate gives the surgeon-major's address as the residence of the father. Vincent Beardsley, it seems, had no permanent home of his own and was soon forced to take a job. He worked first for a telegraph company and later for two breweries and appears to have been reasonably conscientious. Even so, Ellen Beardsley was forced to supplement the family income by acting as governess and giving occasional piano lessons. Aubrey's first talent indeed was musical, and at a later date he and his sister Mabel were sufficiently accomplished to play, as sibling prodigies, duets in public. Aubrey's physical frailty was marked. His mother recalled him once helping himself up some high steps with a fern, the child dandy prefiguring his own later announcement that he had caught cold from leaving off the tassel from his cane. At seven Aubrey suffered his first attack of tuberculosis and was sent to a boarding school in the country, the first occasion on which he had been able to escape the crushing affection of his mother, though perhaps a little early for the release. After two years he was removed to Epsom, a spa just south of London, and it was during his period there that he acquired his first patron, Lady Henrietta Pelham, for whom he drew illustrations in various books sent to him by the elderly aristocrat. Fifteen of such drawings survive, two being versions of the solemn, archaically dressed little Kate Greenaway girls so popular in the 1880s, and the image of the Greenaway girl was to be repeated in one of the grotesque illustrations to *Bon-Mots* published in 1893–94 and vestigially lingers in other drawings.

In 1883 Aubrey and Mabel went to live with an aunt at Brighton; the sea air was perhaps thought to be beneficial to Aubrey's lungs. Brother and sister attended the High Anglican church of the Annunciation of our Lady sited at some distance from their aunt's house so that the choice of its services represented a deliberate act on the part of the Beardsley children. By the 1880s the Anglo-Catholic movement had passed into its ritualist phase and provided better "theater" than its rather monochrome rivals. In the religious development of Aubrey and Mabel, there was to be a logical progression, for both of them (and

indeed Mrs. Beardsley) were to be received into the Latin Catholic church.

In that same year Aubrey proceeded to Brighton Grammar School as a boarder. Here he encountered A. W. King, who taught science and was also the boy's housemaster. The relationship between the two was informal and affectionate. King believed in Aubrey's talents and opened his library to him, and the two continued to maintain friendly relations to the end of Beardsley's life. As he was to write: "At a time when everybody snubbed me, you kept me in some sort of conceit with myself."[1]

While at school, Beardsley completed thirty satirical illustrations to the second book of the *Aeneid* and published a ballad on the victory of a naval vessel, the *Valiant*, over a pirate ship, while a local paper, *Brighton Society*, admitted two sets of light verses, "A Ride on an Omnibus" (9 July 1887) and "A Very Free (Library) Reading with Apologies to W. S. Gilbert" (14 April 1888). All his life he was to cherish literary ambitions, and certainly he possessed some talent in both verse and prose. In 1887 the school magazine published a sheet of eleven small sketches, illustrating puns on the vocabulary of the game of cricket. But Beardsley's activities extended also to the drama. King indeed, as Brigid Brophy observes, seems to have turned Brighton Grammar School into a school of drama, and Beardsley was closely involved in King's activities.

As "Schoolboy" on 20 December 1886 he spoke the prologue to the Brighton Grammar School's Christmas entertainment, an historical pageant, written like the prologue by King himself, and a portrait sketch of Aubrey in the part survives. He was on stage again two years later as Mercury in the prologue that King wrote for the *Pay of the Pied Piper*, a comic opera, and also as Herr Kirschwasser, besides furnishing eleven illustrated drawings for the program. But by this time Beardsley was no longer at Brighton Grammar School; he had been removed precipitately and probably against the school's advice.

It was not, however, Aubrey's last connection with the school's extramural activities. On 7 November 1890, a conversazione was held at the Royal Pavilion for the Old Boy's Association, and he provided an original farce entitled *A Brown Study*. His schoolmate and friend, later a famous impresario, Charles B. Cochran, produced and acted in the play. He also at one time possessed the manuscript of *A Brown Study*, but this like other early Beardsley scripts has disappeared.

Having left school, Beardsley returned to London, and a drawing

for the program of "The Cambridge Theatre of Varieties," a title taken
from the Beardsley family's lodging at 32 Cambridge Street, Pimlico,
informs us that Aubrey and his sister acted and sang in *The Jolly Mash-
ers*. There were two "mashers"—raffish young men about town: Aubrey
no. 1, or M. Aubre, *Perruquier*; Mabel no. 2, Madame Mabelle, *Cos-
tumier*. Mabel, it seems, was not averse to wearing men's clothes and
was the source of some of the images of female transvestism in Aubrey's
drawings: Mrs. Margery Pinchwife, for example, from Wycherley's *The
Country Wife* and Mademoiselle de Maupin from Théophile's Gautier's
sapphic and transvestite novel of that name.

Beardsley's first job had taken him to the District Surveyor's Office
of Clerkenwell and Islington, suburbs just north of "The City," the old
business district of London, and in 1889 he began work in the city
itself when he took up a clerical post with the Guardian Life and Fire
Insurance Company at their Lombard Street office. The work, though
not arduous, was boring, and the subtle drawing "Le Débris d'un
Poète" (The remains of a poet) of 1892 records the boredom with a
certain comic disgust. It was in 1889 also that Aubrey had another
grave bout of illness that set the pattern of hemorrhage and recovery
that was to recur during his short life. His thin stooped body and thin-
beaked face were topped by short reddish hair, emblematic of the al-
ternate languor and vitality imposed by the rhythms of his illness.
Perhaps the onset of illness crystallized Beardsley's awareness of his gift
and the brief time that was to be granted him to realize it. Like John
Keats, another sufferer from tuberculosis, his work matured rapidly,
and 1893 and 1894 were to witness something resembling the mirac-
ulous year of 1819 in the development of Keats.

In 1891 the Beardsley family moved a short distance to another
lodging house in Pimlico, that district of 1850s terraces, where they
attended another "advanced" Anglo-Catholic church, St. Barnabas.
Ellen Beardsley had encountered the vicar, the Reverend Alfred Gur-
ney, when he was a curate at St. Paul's, Brighton. Malcolm Easton
vividly describes the order of worship at St. Barnabas: "The incense-
laden air vibrated to Gregorian chants; for after a silence of three cen-
turies the ancient ecclesiastical music was being restored, and the
beauty of the singing . . . had become in the words . . . of one of
Gurney's warmest supporters 'unsurpassed and unsurpassable.'"[2]

Gurney had been inducted to St. Barnabas in 1879 and held to that
cure till his death in 1898. He was, as Beardsley was to become, an
enthusiast for Wagner and the author of pietistic volumes of verse in

the late Pre-Raphaelite tradition. Like his aunt, Mrs. Russell Gurney, he was a generous patron of the arts, and like her he patronized Beardsley. The drawings that Aubrey produced for the Gurneys at this time were themselves rather tepidly Pre-Raphaelite and devotional.

During 1891 Aubrey visited James McNeill Whistler's Peacock Room, now in the Smithsonian Institute, Washington, D.C., where Whistler's painting *La Princesse du Pays de la Porcelaine* was hung. At that time the room was part of a house at Prince's Gate in West London. He also made a number of visits to Hampton Court Palace, once a royal residence situated a few miles upstream on the River Thames from the British capital. The canal and formal gardens and the Wren court outside and the Mantegna cartoons *The Triumph of Caesar* within were all the target for his admiration and were to be reproduced in his imagery. And he also spent much time with Mabel at the National Gallery looking at fifteenth-century Italian painting, those painters before Raphael so admired by the English Pre-Raphaelites for their candor of vision, though Beardsley most admired the delicate line of the drawings of this period. Given these allegiances, it was barely surprising that Beardsley should visit the living master of the Pre-Raphaelites: Edward Burne-Jones. Burne-Jones belonged to the second generation of that school, those who followed Dante Gabriel Rossetti's version of the original P. R. B. principles: "vision" rather than Truth to Nature. He was a close friend and associate of William Morris and had been a director for some years of the famous firm of Morris, Faulkner, and Company, which specialized in reviving the lost crafts of the Middle Ages. Beardsley had heard that Burne-Jones's studio was open to the public and on the afternoon of Saturday, 12 July 1891, along with Mabel, called at the master's eighteenth-century London home, the Grange, 49 North End Road (demolished in the late 1950s by the local Borough Council to make way for cheap apartments, the slums of tomorrow). Although the studio was actually open by appointment, Burne-Jones had them admitted, introduced them to Oscar Wilde and his wife who were taking tea at the house, showed the young people his paintings, and then looked at the portfolio that Aubrey happened by some fortunate chance to have with him. Though he rarely encouraged the young to try and make a living as artists, Burne-Jones was sufficiently impressed by Beardsley's drawings to suggest that he learn the grammar of his art.

Beardsley consequently began attending evening classes under Fred Brown, one of the founders of the New English Art Club, followers (at

some distance) of the French *plein air* and Impressionist painters. Apart from an early sketch in ink and wash, Beardsley's art was not to follow this "advanced" line of painting; raw nature was not for him. Although Burne-Jones took it for granted that Beardsley would produce easel paintings, in Victorian England the highest form of visual art, the drawings that he saw at the Grange were not, as Burne-Jones might have supposed, sketches for paintings. Aubrey was indeed to produce only three paintings in oil, though his posters were to be designed in color, and he not infrequently used washes on his pen and ink drawings. As Brigid Brophy puts it: "Burne-Jones had, in fact, recognized the existence but not the nature of Beardsley's genius. The misunderstanding was helpful in that it set Beardsley to explore the genius himself."[3]

The act of defining his identity as an artist led to the recognition that his gift was literary and critical, much of his artistic energy deriving from literary sources. More important was his recognition that he could exploit the new photomechanical advances in reproduction by the use of line and by black and white, the color of print itself. The artist was no longer dependent on his drawing being redrawn on a plate, mostly by another hand and mostly coarsened in the process. The drawing could now be translated directly and more faithfully. That dramatic juxtaposition of black and white through wide margins was the idiom of much of the private press printing of the time and in particular of James McNeill Whistler's *The Gentle Art of Making Enemies*. The wit and dandyism of Whistler and Oscar Wilde was to become a model for Beardsley, along with their brilliant manipulation of the "new" journalism with its new mass audience and their teasing of the bourgeoisie. Beardsley's note, though, was to be even more acrid and insolent than Whistler's.

Already he cultivated darkness and seclusion. Before he began drawing, he would darken his workroom, laboring by the light of candles set in two tall ormulu candlesticks, following with his pen the flicker of shadows on the paper. This sounds like a prescription for self-hypnosis, but Beardsley was firm in denying that he saw visions anywhere except at the end of his drawing pen. It has been suggested that the model for his procedure of drawing was the decadent hero of J. K. Huysmans's novel *A Rebours* (1884), Des Esseintes. Certainly Beardsley's rejection of nature in his pursuit of art was typical also of Huysmans's hero.

While working at the Legal and Guardian, Beardsley frequented the

nearby bookshop of Frederick H. Evans, a distinguished portrait and architectural photographer in platinotype. Evans not merely photographed the artist, but furnished also photographic reproductions of his work and exchanged books for Beardsley's drawings. And through Alfred Gurney, probably in 1891, Beardsley met the writer and designer Aymer Vallance and Robert Ross, friend of Wilde, elegant and acute journalist and connoisseur, who began immediately to buy Beardsley's drawings and was later to write a study of his friend that can still be read with profit. And acquaintance with Ross involved acquaintance with Wilde and with Wilde's circle. Vallance, on the other hand, belonged to William Morris's circle, but Beardsley's relations with that great patternmaker were not to be fortunate.

It was through Evans's bookshop that Beardsley was to be delivered from the business world. J. M. Dent, the publisher, called on Evans and discussed his plan for the illustration of Sir Thomas Malory's fifteenth-century version of the King Arthur stories, the *Morte D'Arthur*, a favorite text of the Pre-Raphaelites. What Dent appeared to have had in mind was a line block version of Morris's hand-engraved woodblock, a swifter and more economical version of the fake medieval Kelmscott vogue, the extension of wallpaper by other means. Dent had in mind an illustrator in the Burne-Jones vein, and Evans suggested Beardsley. Dent asked for a specimen of the artist's work; Beardsley drew "The Achieving of the Sangreal" and obtained the commission at £250. *Le Morte Darthur* (as the Dent volume is actually entitled) appeared in monthly parts between June 1893 and 1894 and, with its 361 drawings and decorations, amounts to what is virtually half of Beardsley's adult output.

In June 1892 Beardsley had visited Paris for the first time, taking with him some twenty of his drawings. These he showed to the symbolist painter Puvis de Chavannes who paid him an amiable but faintly equivocal compliment. The visit confirmed Aubrey's taste for all things French, and the year is also marked by the first trace of Japanese influence on his work and a new imagery that disconcertingly coexisted for a short time with the usual Pre-Raphaelite icons; as he himself put it: "strange Hermaphroditic creatures wandering about in Pierrot costumes or modern dress; quite a new world of my own creation . . . extremely fantastic in conception but perfectly severe in execution" (*L*, 43, 34). A new world perhaps, but others such as Verlaine had already been attracted both by hermaphrodites and pierrots, Beardsley added fetuses, harpies, and eunuchs. This imagery was to reveal itself most

elaborately in *Bon-Mots*, an anthology of sayings from the eighteenth century and Regency wits; Beardsley's images bore no relation to the letterpress.

By the autumn of 1892, Beardsley had given up his attendance both at art school and at the Legal and Guardian; the latter step displeased his mother and more particularly his father. Aubrey was by now receiving a fair number of commissions for his drawings, and precarious health may well have convinced him that any protracted period of training was pointless. About this time Aymer Vallance introduced Beardsley and his drawings to C. Lewis Hind who was preparing a new monthly magazine, the *Studio*, and by February 1893 was also editing the *Pall Mall Budget*, employing Beardsley to make topical caricatures, a false direction.

The debut of both the *Studio* and of Beardsley himself was made in April 1893: it might be said that he awoke to find himself infamous. Beardsley designed the cover printed on dark green paper, and the American critic and artist Joseph Pennell wrote the issue's principal article: "A New Illustrator: Aubrey Beardsley," which included reproductions of Beardsley's drawings. The part that Pennell played in furthering Beardsley's reputation was perhaps overemphasized by Robert Ross in his book on the artist; but Beardsley himself did not underestimate it.

In the middle of these exhilarating developments, Beardsley once more visited Paris, this time as a recognized young artist, heralded by Pennell's article and the imminent serial appearance of the *Morte Darthur* illustrations. We hear of the visible signs of a new confidence: a dandiacal uniform of gray coat, gray waistcoat, gray trousers, gray suede gloves, gray soft felt hat, and gray tie knotted wide and loose in the approved French manner: a small triumph of underplayed affectation.

And in June 1893 the *Morte Darthur* began appearing. It was furiously received by Morris as an act of usurpation: the old master evidently considered that he had a monopoly of King Arthur. He was loyally followed in his distaste by Burne-Jones.

It is at this time that Beardsley becomes "Beardsley": the partly self-created, partly journalistic, image coheres. Pennell in his piece had acutely recognized that Beardsley was "modern" in spite of his rejection of Impressionism. He had also rejected Pre-Raphaelitism and its distrust of the machine, frankly accepting the new technological processes and exploiting them in his art. "Master of the Line Block," so Pennell

calls him, the contrast being with the laboriously hand-crafted wood-block so beloved of Morris with the consequence that a few copies only of the hand-printed Kelmscott Press editions could be produced and then only for the wealthy. Beardsley's images could be transmitted to a wide audience (with sharpness if not always with accuracy) to Paris and New York, and by his involvement with the art of the poster could invade the eye in public and unexpected places. This was art brought directly to the people, Morris's ideal.

These were the years of the "new" journalism, of engineered public controversy; of letters to the papers; of interviews; of a reaction against high Victorian values that was encountering more and more hostility from the middle classes and the newspapers and other organs of opinion. These were also the years when the "new woman" was kindling uneasy laughter. Beardsley was re-creating woman in his drawings as both traditional femme fatale and new independent being. Though he was only twenty-one, he was already transforming the last decade of the century into the "Beardsley Period." Angular, menacing, depraved, or simperingly corrupt, the Beardsley woman inflamed the eye just as Wilde's paradoxes and hints more connivingly inflamed the mind. Beardsley's notion of woman was polemically directed against the soft blonde candid ideal of the English. And, like Wilde, Beardsley both used the available media and was used by it; the whole art of advertising included advertising oneself as well as one's product. In 1893 his art began to be encountered in many places: in magazines, on hoardings and walls, on the covers and interspersed among the pages of books. Besides contributing to the *Pall Mall Budget*, his designs appeared on books published by David Nutt and Longmans. And in December of that same year he began his fruitful but finally disastrous association with John Lane when he designed the first of his twenty-two Keynotes series, books issued by the firm of Mathews and Lane.

The first consequence of his new prosperity was a move in the summer of 1893 to a new home, still in Pimlico, 114 Cambridge Street. Part of the pattern that Brigid Brophy has remarked on: a going back to places—Brighton, Epsom, Pimlico—as though going back in terms of places could involve going back in time and so prolong his life. He would take a year off his date of birth each year. But it was not a return to Ellen Beardsley, the mother he was to dominate but also to be dominated by as illness rendered him more and more unable to fend for himself. It was his sister Mabel who shared the house at Cambridge Street; Mabel, the partner in the earlier "Cambridge Theatre of Vari-

eties," his confidante and perhaps more. She is the only woman (aside from his mother) with whom there is any record of his being emotionally involved. Brian Reade has suggested that Beardsley was a nonaggressive homosexual and so vulnerable to advances from both sexes; Wilde's friend Mrs. Ada Leverson is reported to have attempted to seduce him.

The house at Cambridge Street was decorated by Aymer Vallance. The drawing room was painted violent orange, while against the door and skirtings slender black, with pillars that spread out at the top into conventional interlacing twigs and branches covering an orange colored ceiling, while there were glimpses of a gold and black lacquer cabinet, a Chinese screen, and the carved and gilded arm of a chair. On Aubrey's bedroom walls hung the finest and most explicit Japanese erotic prints in plain frames against delicately colored backgrounds "the wildest fantasies of Utamaro." The contrast with the Burne-Jones house and its Christian primitives was strictly programmatic.

Beardsley had first met Oscar and Constance Wilde on that memorable afternoon at North End Lodge in 1891—"charming people"— and the beginnings of his friendship with Ross the following year soon brought him to the fringes of the Wilde *cénacle*, a *cénacle* that included Max Beerbohm, More Adey, Lord Alfred Douglas, and Ross himself. But it was not until 1893 that the two major figures of the "decadence" became publicly associated. In that year *Salome*, Wilde's *symboliste* drama in French, was published in Paris and Beardsley's initial reaction was of uncomplicated admiration. He produced a drawing illustrating Salome kissing Iokanaan's severed head with a quotation from her actual words: "J'ai baisé ta bouche, Iokanaan, j'ai baisé ta bouche" (I have kissed thy mouth, Iokanaan, I have kissed thy mouth), which was reproduced in the *Studio*. Clearly Aubrey hoped that he might be invited to illustrate the English version of the play. It has also been said that he had ambitions to be translator as well as illustrator, and that his disappointment partly accounts for his relationship with Wilde deteriorating. That deterioration is not documented, but certainly there were various reasons for it.

Wilde's circle at this time was composed of homoerotics, most of whom were practicing homosexuals. Beardsley's sexual tastes were either muted or equivocal: he showed no signs of actually "coming out." Even Max Beerbohm, who may well have had something of a similar psychological makeup, had a special relationship with Reggie Turner, one of Wilde's circle, which, if not precisely physical in the

full sense, did not preclude the acceptance of little presents. The other members of Wilde's group, moreover, though talented and witty, were hardly men of genius; Beerbohm, the most talented and also the most detached, posed no threat to Wilde's supremacy. Beardsley, in Lionel Johnson's phrase, had "a boyish insolence of genius" and in that sense was a threatening presence. Wilde was too intelligent not to realize that Beardsley's discipleship was generally brief and usually ended in parody. Generally good-natured, Wilde's comments had an unusual edge when their subject was the young artist: "don't sit on the same chair as Aubrey, it is not compromising," an exacerbated reaction to the mysterious nature of Beardsley's sexuality. Or on Beardsley's taste for the eighteenth century: "There are two ways of disliking poetry, one being to dislike it, the other being to like Pope."[4] And Wilde equivocally compared Beardsley's art to absinthe which is "to all drinks what Aubrey's drawings are to other pictures; it stands alone; it is like nothing else; it shimmers like southern twilight in opalescent coloring; it has about it the seduction of strange sins. It is stronger than any other spirit and brings out the subconscious spirit in man. It is just like your drawing, Aubrey; it gets on one's nerves and is cruel."[5] Precisely because both were wits and dandies, they could hardly not be rivals, and the disparity in age—Wilde was the older by eighteen years—excluded the possibility of an angry friendship. Whistler, an older man than Wilde, had broken off his friendship with the great aesthete for similar reasons, though Whistler's personality was hard and malicious. And Beardsley, though finally recognized by Whistler as a genius, disliked the man sufficiently to parody him and avoid his company.

The counterpart of Parisian café life in London was to be found at the Café Royal in Regent Street with its smoky acres of painted goddesses and cupids and tarnished gilding; its golden caryatids and its filtered, submarine illumination, composed of tobacco smoke, of the flames from chafing dishes and the dim electric lighting within.[6] It was the usual meeting place of artists, poets, men of letters, and their hangers-on, and in spite of the disastrous rebuilding of the café and the whole street in the period just prior to the First World War, it continued to be a focus of Bohemian life until the outbreak of the Second. It was at the Café Royal, we may imagine, that Beardsley, Wilde, and Wilde's entourage discussed Beardsley's next important commission, the illustrations to the translation of Wilde's drama in French, *Salome*.

The English translation of *Salome* had been accomplished by Lord Alfred Douglas, but in Wilde's view unsatisfactorily. It was revised by Wilde and published in February 1894. Beardsley furnished the illustrations for which he was paid fifty guineas: a fair sum in those days. He also furnished motifs for the cover, a border for the list of pictures, and the title page along with thirteen illustrations including a revised version of "The Climax" which had secured him the commission in the first place. Two further illustrations did not appear in the book but were published in 1907 by John Lane, who had been responsible for the 1894 volume, that "fly in the amber of modernity"[7] who was cordially disliked by both Beardsley and Wilde. Lane expurgated two of the illustrations, and the third, "The Toilette of Salome," was redrawn. Four of the illustrations contain images of Wilde, one at least distinctly cruel, though Beardsley caricatured friends as well as enemies. However, by the end of 1893 we may conclude that relations between author and illustrator were somewhat strained. Aubrey acquiesced in, if he did not initiate, the exclusion of Wilde from the magazine the *Yellow Book* of which he was to become art editor in the early part of 1894. And Wilde himself was disconcerted by the reversal of the usual role of illustrator as submissive interpreter of the author's intentions. At all events, the caricatures and what Wilde felt to be a deliberate evasion of the spirit of the play produced more comment: "Beardsley's art," he declared, was "cruel and evil and so like dear Aubrey, who has a face like a silver hatchet, with grass-green hair."[8]

However, the two men still moved in the same circles and, in February 1895, at the invitation of Wilde, Beardsley attended the first night of Wilde's brilliant farce, *The Importance of Being Earnest*, in the box that the playwright had secured for their mutual friend, Mrs. Ada Leverson. And in the previous year Ellen Beardsley had asked Robert Ross to secure Wilde's help in forwarding Mabel's theatrical career. Whatever the nature of Beardsley's relationship with Wilde, his own notoriety was certainly responsible for the next major episode in his career, his role as art editor of the *Yellow Book*. Beardsley had met Henry Harland, an American expatriate *littérateur* supposedly in the consulting room of a specialist in tubercular diseases, possibly early in 1893. By the end of that year Beardsley and Harland were on warm terms, and on 1 January 1894 he visited Harland's house in the Cromwell Road (West London) to discuss the founding of a new magazine, which would publish "advanced" art and literature: "Our idea is that many brilliant story painters and picture writers cannot get their best

stuff accepted in the conventional magazine, either because they are not topical, or perhaps a little risqué" (*L*, 278). They offered the notion to John Lane, that shrewd son of a Devonshire farmer, bibliophile turned book producer, who welcomed it, calculating the precise degree of shockability that was profitable, though the new periodical was not intended as the organ of decadence or of any new movement at all. It was designed like a well-produced book, and its hard yellow covers resembled a yellow French novel; yellow had also been one of the favored colors of the Aesthetic Movement of the 1870s and 1880s: in Gilbert and Sullivan's *Patience* one of many catchy moments alludes to "greenery-yallery Grosvenor Gallery." Beardsley was appointed art editor and furnished a new cover design for each volume besides decorating the spine.

The first issue appeared in April 1894 and, though it included contributions by Sir Frederic Leighton, the president of the Royal Academy, by the esoterically respectable Henry James, by the superintendent of the British Museum Reading Room, and by William Watson, a poet of the lower second class, it was the younger contributors who set the tone: Arthur Symons with his jolly verses about "The chance romances of the streets, / The Juliet of a Night," the insolent and lazily mannered essays of Max Beerbohm, the painter Walter Sickert with his dubious interiors, and most particularly Beardsley himself, whose images stung the journalist J. A. Spender to the not wholly serious suggestion that nothing would meet the case but "a short act of Parliament to make this kind of thing illegal."[9] In general, the critics were harsh, but the volumes sold.

The fifth issue of the *Yellow Book* was due in April 1895. On 5 April Wilde's libel suit against Lord Alfred Douglas's father, the "scarlet" Marquess of Queensberry, who had accused him of "posing as a sodomite," broke down. On that same day Oscar Wilde was arrested at the Cadogan Hotel in South Kensington and "staggered to a hansom outside," carrying a copy of what was reported to be the *Yellow Book* but was actually a yellow paper-covered French novel. It was ironic that both Lane and Beardsley had been anxious to distance the magazine from Wilde (his name does not appear among the somewhat optimistic list of contributors in the prospectus), and Wilde himself had declared, partly from pique, that the periodical's first issue was a failure, "and it's not even yellow." Max Beerbohm met Wilde one afternoon at the Café Royal and asked him what the drawing for the *Yellow Book* was like, for Beardsley had been showing it around. "Oh you can imagine

the sort of thing," Wilde replied. "A terrible naked harlot smiling through a mask and with *Elkin Mathews* written on one breast and *John Lane* on the other."[10]

But the magazine had been fatally compromised by journalistic inaccuracy. A mob gathered and stoned the windows of Lane's bookshop, for the Wilde case had inflamed all those who supported the respectable vices. Harland was in Paris, Lane on his way to New York. A dim figure called Chapman was in charge. Some of Lane's authors pressed for Beardsley's dismissal, encouraged by the high-toned niece of Matthew Arnold, Mrs. Humphry Ward, and by Alice Meynell and her posse of parlor Catholics, while Lane received a stunning cablegram from that poet of very moderate talents, William Watson, who did his bit for the respectable vices by traveling round England with a constantly replenished supply of contraceptives: "Withdraw all Beardsley's designs or I withdraw all my books."

At this crucial moment, the fifth volume of the *Yellow Book* was about to appear, and it was decided to purge the issue of all taint of Beardsley. Five plates after his designs were removed and another design by Patten Wilson, a safely minor artist, was substituted for Beardsley's front cover. The back cover, however, which embodies the list of contents and had been unchanged since the first issue, and the spine, remained, perhaps through oversight.

That Beardsley had not lost his spirit may be gathered from a letter he wrote in reply to the art critic Haldane Macfall's attack on his work in *St. Paul's*. Macfall had claimed that Beardsley's work, like Wilde's, was "un-English." What that grave accusation involved soon became apparent. It was "without manhood" and "effeminate, sexless and unclean." "As to my uncleanness," Beardsley replied, "I do the best for it in my morning bath, and if he has really any doubts as to my sex, he may come and see me take it" (*L*, 223). Beardsley's letter was not actually published, but he was amused by Macfall's answer, and the two men were soon friendly enough.

Beardsley's livelihood was virtually gone. At a stroke, he had passed from relative prosperity to being without income, though a few commissions from Lane remained to be fulfilled. His art had been sentenced like Wilde's person and writings at the Old Bailey. In June 1895 he was forced to give up 114 Cambridge Terrace. Mabel by this time had been on the stage for a year, but in spite of her charm, intelligence, and wit, her career was somewhat fragile. Moreover, she was often away on tour when her presence would have been tonic. The

events of that bitter spring seem to have led Aubrey into a phase of dissipation, which alarmed his mother and did no good to his health, but of that little record remains.

W. B. Yeats, an imaginative source, describes how Beardsley arrived at the rooms Symons shared with Yeats at Fountain Court in the Temple, with a young woman who belonged to Leonard Smithers's circle and emphatically not to that of Yeats. Aubrey was a little drunk and, putting his hand on the wall, he stared into a mirror and muttered, "Yes, yes, I look like a sodomite." But then he denied the fact and began railing against his ancestors, accusing them of one thing and another, including the great William Pitt, the Earl of Chatham, from whom Beardsley, by family tradition no doubt, declared himself descended."[11]

Lane had not opted all of Beardsley's activities, though other commissions were not extensive. In 1894, for example, he had designed, as part of his sensitivity to the "modern,"some colored posters. He was familiar with the work of the French poster artists: Jules Cheret and Henri Toulouse-Lautrec. He provided a poster for the publisher T. Fisher Unwin's children's books, for the same publisher's Pseudonym Library, and for the actress Florence Farr's season at the Avenue Theatre. For Lane himself, there were the twenty-two covers of the Keynotes series.

After leaving Cambridge Terrace, Beardsley lived in lodgings including, rather oddly, one earlier occupied by Wilde at 10–11 St. James's Place. Two very different patrons now offered themselves: Marc Andre Raffalovich, wealthy Anglo-Franco-Russian-Jewish, had come to London in the early 1880s and, attempting a salon succeeded only— the paronomasia is Wilde's—in founding a saloon. Wilde and Raffalovich were hostile to one another, and Raffalovich, whose version of homoeroticism was, unlike Wilde's, in practice as well as theory Uranian, was to write two studies of homosexuality, where Wilde is viewed as having violated the exalted ethics of the sect. Earlier, Raffalovich had succeeded in capturing the beautiful young poet John Gray (supposedly the original of Dorian Gray) from Wilde. Gray had been baptised into the Latin Catholic church in 1890 and, under Gray's influence, Raffalovich was to follow suit in 1896. Gray himself later became a formidable priest. After his own conversion, Raffalovich was to pursue Beardsley with all the fervor of the recent convert, though with somewhat more subtlety than most. He was a poet of an almost invisible talent, and for Raffalovich's last volume, *The Thread and the*

Path, Beardsley had designed a frontispiece: a nude amor, which David Nutt the publisher rejected on the ground that the figure was hermaphroditic. As Raffalovich was paying for publication, Nutt's gesture was rather noble. Assisted on occasion by Gray, Raffalovich pursued Beardsley with gifts of flowers, books, chocolates, walking sticks, opera tickets, and the manuscripts of some letters he had received from George Meredith, and when he knew Beardsley well enough and when Beardsley was desperate enough, ten pound notes. Beardsley addressed him as Mentor, a title taken from the seventeenth-century French Bishop François Fénelon's *Télémaque*, a moral fable that became vastly popular in eighteenth-century France, one of Beardsley's favored periods. Mentor is actually the Goddess Minerva in disguise (an allusion Brigid Brophy relates to Raffalovich's bisexuality) and guides the young Telemachus through many wanderings in search of his father Ulysses. The hero is taught to reject materialism and sensuality and to learn the uses of adversity, all of which might have seemed to Raffalovich highly appropriate to Beardsley's situation—poor, ill, disgraced. Beardsley might also have been alluding in the same vein of quiet irony to "the torrent of divinity" that is veiled by the pagan surface of Fénelon's narrative.

Leonard Smithers, Beardsley's other new patron, had begun his career in the midland manufacturing city of Sheffield as a solicitor, had set up in London as a bookseller, turned to publishing in the open market, and as his finances deteriorated, limited editions of risque volumes and plain pornography. There are amusing stories of how, when Smithers was warned by an informant in the police that a raid on his premises was imminent, he would fill several large traveling bags with dubious literature and deposit them in the left luggage section of various London railway termini till the immediate danger was past. Drink, drugs, and women and a genuine devotion to literature were Smithers's main characteristics and inevitably brought him to ruin. Given Beardsley's state of health, Smithers's tutelage was of necessity somewhat academic. Smithers succeeded Lane as Beardsley's main, if rather sporadic, source of income. His idiom was very much the postdated check. The *Yellow Book* did not precisely turn gray after Beardsley's departure, but if the letterpress maintained a fair standard, the art work became distinctly less distinguished. Smithers had hopes that he might be able to produce a periodical that would win the audience that found the *Yellow Book* after April 1895 somewhat tame, though the editor he chose, the poet and critic Arthur Symons, had no wish

to tie the new periodical, the *Savoy*, too publicly to "decadence."

The *Savoy* was in essence an Anglo-French venture. After the Wilde trial, "Decadence," the New Hedonism, experimentation in morals and manners, enlarging the frontiers of what could be publicly drawn and written, was no longer mildly and sometimes even agreeably shocking; it was plainly dangerous; Oscar had meant it, after all. England was clearly no appropriate place in which to organize an "advanced" periodical, even though it was to be published and take its name from the theatrical quarter of London. France was traditionally less puritan, if even more chauvinist than England; and where the English were generous to political exiles, the French were equally so to cultural outcasts. Besides Symons, the cast was Charles Conder, fan-painter (a very 1890-ish art that, like some later phases of Beardsley's art, looked back to eighteenth-century France), Beardsley, and Symons; the place was Dieppe, an agreeable watering place on the Normandy coast to which many of the English writers and artists of the period were attracted and where Wilde himself was to settle after his release from prison in 1897. W. B. Yeats, though not able to be present at Dieppe, had been involved in the preliminary discussions back in London. Beardsley designed the prospectus announcing the new periodical, and gave it as might be expected a polemical tinge: a John Bull figure as Hermes with wings and winged sandals, a major stomach, and a very, very small erection, though the image was nonetheless censored, as was Aubrey's design for the cover of the first issue, intended for the Christmas market, but not actually appearing till January 1896. The first attempt showed a young governess with a whip and a Cupidon, naked under an open cloak and a large plumed hat, about to piss on a copy of the *Yellow Book*. George Moore objected to this superfluous provocation. In the revise, the Cupid changed sex and the *Yellow Book* vanished.

After the third quarterly issue, the *Savoy* was transformed into a monthly, probably a mistaken decision. That engine of the Philistine, Messrs. W. H. Smith which had a monopoly of the railway bookstalls, refused to display the magazine. They objected to Beardsley as a general principle, and this may have led them to assume that an illustration by William Blake, the eighteenth-century poet and mystic, was in fact a Beardsley production. It appears that one of Smith's managers was willing to display the offending object if, contrary to their expectations, the *Savoy* had a brisk sale. The magazine's life was more brilliant but also more brief than that of the *Yellow Book*. Beardsley's health

was now in marked decline; he had collapsed on a visit to Brussells with Smithers in March of 1896, and this may also have had some effect on the decline of the *Savoy*. The last issue in December of 1896 consisted of contributions purely by the literary editor Symons and the art editor Beardsley, and Beardsley's contributions seem to have been earlier unpublished work. Once more Beardsley had been deprived of an arena, and he was by this time less well-placed than he had been eighteen months earlier to make an energetic bid for commissions.

But the magazine had at least kept Beardsley's name before the public and had furnished him with opportunities for his literary ambitions. He contributed to it three poems (with illustrations) and in prose his fragment (once more with his own illustrations) "Under the Hill," a sanitized version of *Venus and Tannhäuser*.

It was also in 1896 that Smithers commissioned from Beardsley illustrations to an edition of *The Rape of the Lock* and a new prose translation of Aristophanes' *Lysistrata*. Both works witness to the artist's claim that he changed his style as a woman changes her hats every summer. Indeed, during this year there were two changes of style, though there are connections backward to earlier work. *The Rape of the Lock* is justly described as "embroidered": the new influence is the French rococo illustrators of the eighteenth century. The idiom is central composition, graded dots, and a generally crowded and distorted space. As to the *Lysistrata*, Beardsley had studied Greek vase painting at the British Museum in 1894, and he was aware of Jane E. Harrison and D. S. MacColl's elegant folio *Greek Vase Paintings* (1894) with its black and white illustrations, though those barely provided the detail that he needed for his own interpretations of the Greek comic poet. His own drawings drew necessarily on detail from Japanese erotic prints and from the nineteenth-century Belgian artist Félicien Rops with his cruel depiction of woman, his satanism and pornography. With the *Lysistrata* Beardsley himself definitively moved into the closed world of the pornographic, though the drawings themselves with their heroic phalluses can be read as an index of the artist's sexual frustration. But if the provocative loose clothing and long patterned stockings recall standard images of the pornographic, as well as Rops, the general tone of Beardsley's work here remains genial rather than sinister and, like Aristophanes himself, the attitude to women is one of ironically friendly acknowledgment of their superiority. Fine as these illustrations are, they are exceeded by the few drawings for Juvenal's

sixth satire where Beardsley responded to the Latin poet's pungent misogyny.

He was now separated from friends and few days passed without his writing, mainly to his patrons Raffalovich and Smithers. After the collapse of March 1896 the letters become largely a calendar of dissolution.

From now on Aubrey's mother, resuming a more and more dominant role in his life, bundled him from one locale to another in search if not of recovery, of stability at least. None was Paris or London, and though some were found at first charming, all soon became depressing. From his illness and his weakening body, he maintained a distance that stemmed self-pity and despair. "I am only a poor shadow of the gay rococo thing I was" where tone and style at least suggest continuity. Self-hatred of an ironic species he had always practiced on his sallow face and creaking lung. The doctor gives him a complex medicine that perfectly blackens his stools and a turpentine bath that provokes his skin to "a magnificent rash." "An exciting overflow" covers yet another hemorrhage and, when the physical horrors insult human dignity but must be recounted, he simply concludes: "perfectly beastly is it not?" (*L*, 223). All that now enabled him to live was obsessive work, and the condition for work was imprisonment: the impossible polarization of Raffalovich and Smithers; the imprisonment by the mother who dominated and was dominated by him. But if the desire to work was obsessive, the capacity for work was failing.

Neither of his patrons was deceived. Smithers judged him incapable of sustained effort. Beardsley promised work that he could not achieve, and Smithers sent money when desperately appealed to, but in his favored idiom of the postdated check, or the check drawn on insufficient funds. Beardsley's payment was notionally £25 a week, though £12 was the norm. Multiplied by thirty to inflate it to the real terms of the 1980s that sounds adequate, but hotel life, doctors, and medicines no doubt reduced it further. And Mrs. Beardsley had to live, too. On Raffalovich he had now become dependent for any untoward expenses: both Smithers and Raffalovich had become, to pluralize Wilde's phrase, the owners of Aubrey; but Raffalovich was now concerned as much with his soul as with his body. For Smithers, Beardsley in his letters assumed a coarse mondain tone, a cynical gaiety perfectly out of place in one who had so little access to woman; in one who had an imaginary vicious past. He observes in the same vein to a homosexual

friend that "chastity has almost become a habit with me . . . but it will never become a taste"; and after the extraction of a tooth with three long roots, he discovers that even his teeth are phallic (*L*, 222); everything, he tells us in the letters, is phallic, always excepting the appropriate area of Arthur Symons.

The letters to Raffalovich are full of a painful devotional archness: books and objects are "charming" and "adorable": there is a distinct tinge of *Saint Sulpicerie*, a cosy sectarian tone. But this is counter-pointed by Beardsley's admiration for the sterner elements of baroque religion. Was there any suggestion of a Paul Verlaine-like *parallèlement*, an accentuating modal discord: to know grace one must sin and be aware of one's sin, between what was offered to the two correspondents? Probably not, but it is dangerous to infer too much from the little we really know about Beardsley's interior life.

The Beardsley woman changed her face over the last year. In one illustration to Théophile Gautier's *Mademoiselle de Maupin*, old, fleshly, equivocal, she is accepted for what she is, neither aggrandized nor satirized. And in the few illustrations that were accomplished for Ben Jonson's play *Volpone*, where the general model is the seventeenth cen-tury, the most striking image is of an initial "M." And composing that image is a naked, gravid-seeming mother eagerly greeted by a clam-bering putto all in context of two pillars formed from many-breasted female torsos with the capitals surmounted by detached female heads. Woman before tended to be destructive and sterile. "A babe," Brigid Brophy suggests, "returning happily to the embrace of M for Mother (or perhaps for Mother Church)."[12]

In April 1897 Beardsley and his mother traveled to Paris, escorted by Raffalovich's personal physician and from the French capital to nearby St. Germain. In July he was at Dieppe, where he was visited by Smithers and where they both met Wilde who had been recently released from prison and was calling himself Sebastian Melmoth. Re-lations between Beardsley and Wilde appear to have been resumed, and Beardsley promised a frontispiece (never executed) to Wilde's *The Bal-lad of Reading Gaol,* which Smithers was to publish the following year. The autumn was spent in Paris where Aubrey busied himself with illustrating Gautier and then in November made the final move to the Hotel Cosmopolitain at Menton accompanied by his mother.

He agreed to edit a periodical that Smithers planned. It was to be called the *Peacock*, a Whistlerian and aesthetic motif, and he stipulated that Wilde should be altogether excluded from it. To dine quietly with

"Sebastian O'Scar" was one thing; to be publicly associated with him was another. It was not just that the decadent past was to be rejected; his new criteria were classical: "a savage strictness"; the accent was to be on the critical; verse was to be used parsimoniously and the fashions of today and yesterday violently excluded: Burne-Jones and Morris on the art side while the impressionist criticism and cheap short storyness of the *Yellow Book* and the *Savoy* were to be attacked. And yet Beardsley was not normally devoid of bravado. We can confidently ascribe his hard attitude to the dependence on Raffalovich. Yet if Raffalovich was predatory, he at least provided the means for Beardsley to die decently. He hinted in his letters to Mentor that he would leave Dieppe to avoid Wilde's presence, but Vyvyan Holland, Wilde's younger son, tells us how he was taken by his mother to see Beardsley at the Cosmopolitain and how Beardsley spoke with great affection of his father. They were no longer rivals; one was a broken, the other a dying, man. Precisely how seriously Aubrey took his Mentor, it is difficult to say; he was certainly more at ease with John Gray, and he seems genuinely to have admired the devotional rococo of Gray's *Spiritual Poems* published in the previous year. The time for cheering himself with naughty letters to Smithers was gone. Beardsley died more than decently: in spiritual as well as physical anguish, clinging to crucifix and rosary, tracing the last terrible letter to Smithers to its conclusion,

Jesus is our Lord and Judge
Dear Friend,
 I implore you to destroy *all* copies of *Lysistrata* and bad drawings. Show this to Pollitt and conjure him to do the same. By all that is holy *all* obscene drawings.
 In my death agony. (*L*, 439)

That agony went on for nine days. It ended on the 16 March 1898. For his sister, Mabel who arrived before the end, Aubrey "died as a saint," and his mother reported him a "benediction to the house" adored to the end by all the strangers offstage. Was Beardsley's final submission to God and the church more significant than the weariness, pain, and terror of a dying man? "Nothing but work amuses me at all," he had written not long before, and when he realized that he would work no more, alone, from his bed, he threw his drawing pen from him in a last gesture. He died a few moments later. A gesture of pain, frustration, rage? Or a gesture of submission, sacrifice, or rejec-

tion of his gift? And if a saint, what species of saint? A Jansenist saint, strayed out of his loved seventeenth century? Sanctity is responsive to the age and its culture, and the 1890s had its cult of the youthful saint and martyr. One of the principal actors in the decadent school, Joris Karl Huysmans, had died in a serene agony, offering a throat ravaged by cancer to God. And the conversions to the Latin Church of poets and artists of the end of century were numerous. But these questions have no answers. A life can only be criticized by another life, and those who dismiss Beardsley's conversion as the fruit of a dying man's terror tell us more of themselves than of Beardsley.

Vincent Beardsley, the obscure father, died in 1909. Mabel, the adored sister, in 1916 after a long illness bravely and wittily borne. She is commemorated by W. B. Yeats in his poem "Upon a Dying Lady" and by Ezra Pound in his Pisan Cantos. Ellen Beardsley lived on till 1932 and survived to give her version of her own and her son's story and to acquire a civil list pension.

Chapter Two
Images and Themes

We may begin by saying what Beardsley is not. He is not an impressionist, nor is he an expressionist. We can hardly connect him with the tradition of visionary painters, for as he himself remarked, he did not allow himself to see visions except on paper. But Beardsley's images do not, like those of the symbolists, operate as hieroglyphs. They demand to be "read" certainly, but more than not they resist reading. The symbolist image defies reading only in the sense that it defies a single interpretation; its meanings are multiple, defined by context and by the operation of the unconscious, that "Great Memory" of Jung and Yeats.

Beardsley was essentially eclectic: He had no facility, no admiration for nature-pantheism, the superstition of the cultivated classes. Virtually without formal training, he was, as Reade observes, unable and mostly unwilling to observe, compare, and rationalize what he saw before him in the manner of the French schools.[1] But he did take short cuts through nature and was sometimes disconcertingly literal as well as literary. He will often take a term from the vocabulary of social slang, or from the conventions of pornographic illustration and reproduce it: the monkey, the dwarf, or the bandbox on the cover of *Savoy*. Along with this there goes a pungent economy in which objects are established with a minimum of means: the navel and the one nipple of the young man in the "Ave Atque Vale" is a signal example.

The tone of his mature art is frequently equivocal. As a decadent artist, he tended to treat serious matters flippantly, trivial matters seriously. He is a parodist of both theme and iconography. In the image of Saint Rose of Lima ascending to Heaven in the arms of the Madonna, he deals equivocally with the convention of the Baroque assumption; in the "The mysterious Rose Garden" with the traditional image of the Nativity, the impregnation through the ear of the Virgin, not by illumination but by sly sibilations; in a mocking reprise of the "Et Ego in Arcadia" iconography and theme as found in Nicolas Poussin, Antoine Watteau, and Jean-Honoré Fragonard.

Much of Beardsley's work directly connects with literary texts. Yet he is far from meeting the naive prescription that the illustrator should mediate between image and general reader, helpfully selecting the focal moments. Beardsley is indeed much concerned with the reader or viewer, but hardly in the humble facilitating mode of the average illustrator and reader is the precise word. Yet he does mediate between author and reader, not conducting word into image, but bringing to light rather what are implicit, forbidden, or subversive elements of a text so disconcerting the author and forcing the reader to become a voyeur by recognizing in himself what he condemns in others. But Beardsley discomfits the viewers further: even if the viewer recognizes parody or irony, his superiority is soon threatened; he senses himself as an intruder in a dangerous space. Familiar objects are first defamiliarized and no sooner responded to, than defamiliarized again. This is essentially a dialectical process issuing in no sort of synthesis, but rather in a hanging paradox, or in a Swiftian species of "reversed irony."

Continuity in theme and image appears through their subjection to reprise, images particularly from Wagner's operas that even invade texts remote from them in spirit. Such subjects and images furnish organic connections between the earlier and later works of the artist, though their recurrence is diminished in the last year of Beardsley's working life.

That Beardsley's art proceeded through a series of leaps is commonplace. He early learned to use both stylistic and iconographical caricature and cultivated the grotesque to liberate his art from influences he found constricting. His earliest influence was Pre-Raphaelitism: the long stemmed neck, the melancholy sensuality and mysticity of Dante Gabriel Rossetti's women and the elongated bodies and hieratic faces of Burne-Jones's figures of both sexes. It was indeed hard to evade the presence of such images, many times reproduced, popular with the aesthetic avante-garde, even popular in Paris. And the Pre-Raphaelites, now into the third generation of the school, were widely imitated. Other early influences were necessarily more sporadic and personal, though no less forcible: the Mantegna cartoons in Hampton Court Palace and individual works by Antonio Pollaiuollo, Carlo Crivelli, and Sandro Botticelli, the fruit of visits to galleries with Mabel, along with the woodcuts in Francesco Colonna's *Hypnerotomachia Poliphili* (The dream struggle of Poliphilius) of 1499, the first part of which was partly translated in the late sixteenth century and reprinted in 1894; facsimiles of the 168 woodcuts had been published in 1888.

The tall, straight figures, arches, tiled floors, occasional symbolism and brooding figures influenced the book illustrators of the 1890s. A little later, after a visit to Whistler's Peacock Room, the American painter's imagery was also frequently embodied in Beardsley's designs.

The more pervasive Pre-Raphaelite presence, though, demanded more violent transcendence. The drawing in indian ink and chinese white, "Incipit Vita Nuova" (Here begins the New Life), which can be dated in 1893, immediately prior to the *Salome* suite of drawings, is a powerful example. The title is programmatic: a fetus (Brian Reade suggests an allusion to the artist's own generation) with hydrocephalous head reads in an opened book that has the title of an early work of the great Italian poet Dante Alighieri. This text, an autopsychology, particularly obsessed Dante Gabriel Rossetti who had been named after and identified himself with the author of the *Vita Nuova*. Rossetti, the most powerful personality among the Pre-Raphaelites, attempted to construct his own life round the events of the *Vita Nuova*, the sense of ideal love mediated through the figure of a young girl. Dante dates his imaginative life from the moment when he met Beatrice Portinari on one of the bridges over the Arno at Florence. In Beardsley's drawing, the new life is interpreted with a disconcerting literalism: the book is balanced against the body of a formidable female of the type that Rossetti painted in his last phase acting as a species of fleshy lectern. The grouping of mother and abortion is a version also of the familiar medieval and Renaissance icon of Madonna and Child, but this Madonna is depraved. The curvilinear white line that edges its way up the heavy massed black of the lady's hair and the one black falling vein of hair does not suggest the art nouveau whiplash line; rather it anticipates the spermatic lines in Edward Munch's Madonna that point to a tragic sexual resonance. The spirit of Beardsley's drawing is mischievous rather than satirical. Unlike Dante, Rossetti did not possess an objective religious order within which his spiritual and numerous carnal loves could be clearly related. Rossetti had only a personal order, and the line between the sensual and the mystic was all to often confused, though a more positive way of describing Rossetti's religion of love would be that it attempts to detect an absolute within personal relationships. It is this vague mysticism of the flesh that Beardsley exposes, and the drawing is an early and excellent example of his acute critical response.

Rossetti's hair fetichism is also stylistically parodied in the heading of chapter 33, book 8 of the *Morte Darthur* by images of two girls with

sinuous avalanche of hair. In later drawings, Whistler, Greek vase painting, and art nouveau are similarly mocked. The issue of Beardsley's digestive and emetic response to other works partly accounts for that radical change of style every summer until 1895.

In so accenting the dramatic leaps and captures of his early and middle career, we should not overlook its continuity. In another drawing of 1893, "How King Arthur Saw the Questing Beast," the artist introduces peacock moons and semilunes (courtesy of Whistler) and a faun, all of which will inhabit many later drawings. More important is the use of the interstices as a slag heap for which objects are wildly co-opted more or less at the whim of the pen's rhythm; among them covert or overt depictions of the male and female genitals.

Nearly all of Beardsley's work begins with a text. We have noted how in the dialectic between reader and text the reader is first constrained to respond to something in himself rather than in the drawing or the text. And Beardsley often enacts the drama of self-incrimination by establishing a mediating figure within the drawing, a surrogate of himself: the page in *The Rape of the Lock* series; the fallen angel in the frontispiece to *Salome*; the prone grinning urchin who lifts the stage curtain to enjoy the contours of a winged John Bull's wizened erection on the front cover of the prospectus to the first issue of the *Savoy*. For the *Lysistrata* drawings, though, there is no impresario, not even Lysistrata herself. The genial candor and directness of the imagery comprises heroic penises and gallant wives who survive without copulation by the help of a friend or by the solitary deed. This is not pornography, but it translates the text with immediacy and so requires no play with equivocal overtone. On the other hand, the page may mediate in *The Rape of the Lock* drawings, but since Beardsley again translates the text directly, the mediator has for the most part no role. Here the artist subjects his art to the text so that, despite the controlled bravura of the drawing, the sparkling pastiche of the French rococo, the faithful but still inventive repertory of objects in "The Cave of Spleen," the series is without drama; it is merely illustration.

But to turn to more positive examples. In Oscar Wilde's *Salome* Beardsley excavates the "modern" elements in the play. As Wilde himself complained, Beardsley transformed the lisping, barely adolescent princess and priestess of the Moon into a formidable castrating machine, creation of the male psyche at a moment when the homosexual dandy felt threatened by the mannish "new" women (the alliance of these sexual extremes was to come rather later). Beardsley recognizes a

rival impresario in Wilde and embodies that recognition in the caricatures of the dramatist that are prominent features in the suite of drawings. None of this need imply that the artist found the drama factitious; rather, he seizes on the sexual politics of Herodias and Salome. Still, the hinge of the action is the execution of Iokanaan and kissing of the dead face, and these were sufficiently realized in the text to inflame Beardsley's imagination: he conveys both with an eerie lucidity.

Images such as fetus, dwarf, hermaphrodite; satyr and satyra; effeminized men; aggressive women; Pierrots; the toilette scene, always from the point of the voyeur—all those stress isolation, exclusion, passivity; and much criticism relates them to Beardsley's sense of his own exclusion from life's feast. It is tempting to read those images as the protest of the unconscious self against his condition, as images suppressed by the conscious self and emerging the more violently on paper. However, factors work against reading his themes and images as testaments of anxiety, even if castration motifs can be identified: such as women with emphatic dog teeth and heads budding into horns. The fetus, for example, represents Nature, and Beardsley at no time had a high opinion of her work, the Romantics in their "Moonings" over her: Pantheism, the superstition of the cultivated classes. Beardsley seems to regard his isolation as a privilege rather than a curse, and his tone is generally too acrid to qualify him as wearing his heart on his pen. To be a voyeur permits him to observe more clearly and above all to address his images to his audience. His is less an expressive than a rhetorical art. And if music was one of Beardsley's compulsions, so that his lines, his blacks, and whites are "composed," set against one another, disposed like chords; so far as the actual presentation of his work goes, theater furnishes the appropriate metaphor: the shrill tone, the sensationalism, all suggest theater in its more professional and less literary aspect.

The late nineteenth century is fruitful in versions of the mask: it will be sufficient to mention Oscar Wilde and W. B. Yeats in literature and James Ensor in the visual arts. Beardsley's use of this feature depends somewhat less on the mask as such as on the masking revealed in attitude and gesture, visual ambiguities that stem from his fascination with theater. Another *topos* ambiguously treated also, is that of the doppelgänger or divided self as counterpart, accuser, savior and lover, specially in relation to love-death confrontation as between Tristram and Isolde or John and Salome.

"I am grotesque or nothing"—so runs Beardsley's famous definition

of his own art. The word itself derives from a species of Roman orna-
mented design discovered first during fifteenth-century excavations of
the ancient city. Named after those grottoes in which they were found,
the new forms consisted of human and animal shapes, fauns, satyrs,
interspersed with foliage, fruit and flowers in fantastic designs without
any relationship to the logical categories of classical art.

Mikhail Bakhtin has distinguished grotesque from classic in terms
of how it presents imagery of the human body. Classical art "presents
an entirely finished, completed, strictly limited body, which is shown
from the outside as something individual. That which protrudes,
bulges, sprouts, or branches off . . . is eliminated, hidden, or mod-
erated. All the orifices of the body are closed. The basis of the image
is the individual, strictly limited mass, the impenetrable facade." The
grotesque body, though, "is cosmic and universal. It stresses elements
common to the entire cosmos: earth, water, fire, air; it is directly re-
lated to the sun, to the stars. . . . this body can merge with various
natural phenomena, with mountains, rivers, seas, islands, and conti-
nents. It can fill the entire universe."[2] A source, nearer to Beardsley,
brings us perhaps closer to his tone rather than his imagery. John Rus-
kin in the *Stones of Venice* (III, 3) defines the grotesque as an unstable
catachresis wavering between the laughable and the terrible; an alien-
ating process that edges the comic with anxiety.

Elements of the grotesque are patently present in Beardsley's art.
The fluvial cycle in "The Climax"; the orifices, bulges, sproutings of
vegetation in *Le Morte Darthur* borders and above all the merging of
vegetable into animal forms; the return, dynamic and continuous, of a
current of forms. Equally so is the insistence on unclassical activities
such as scratching, farting, and (in the *Lysistrata*) masturbating.

Chapter Three
Early Work up to "Siegfried"

Beardsley's was barely a Mozartian precocity. Before the accomplishment of "Siegfried, Act II," limited though that is, none of his work possesses special promise. The line of his future development is not altogether premised either, though his early caricatures of the headmaster of Brighton School, if not beyond the scope of a talented schoolboy, point at least toward the grotesque art of later years. More striking is the drawing of Niccolo Paganini, with its touch of the sinister in the elongation of the famous violinist's head and body and the queer shadows cast by, but not wholly related to, the feet, as if the virtuoso was indeed half-demonic. That elongation we shall meet again in the drawings of the *Yellow Book* phase (1894–95). And of an equal accomplishment is the crude but forcible profile of the actress Sarah Bernhardt, first in a series of images of actresses and divas: Gabrielle Réjane, Mrs. Patrick Campbell, or Katharina Klafsky, As John Russell has well said: "Beardsley was young when the great performers, whether in opera or the spoken theatre, or in vaudeville, were generally 'larger than life.' Reputations could not be faked up on film or with doctored phonograph records: everything had to be done, and seen to be done. Beardsley learned a great deal from these people about the projection of personality, and about the importance of an absolute technical command and about the elimination of superfluous detail." Moreover, Russell continues, Beardsley's own ruthless professionalism was an echo of the dedication brought to tragedy or Wagnerian opera by the artists he admired.[1]

But he had a long way to travel in a short space. The eleven sketches illustrating a cricket team (with its eleven players), another schoolboy effort, have some broad visual puns on the terminology of the game that also predict later, subtler, and more provocative developments. The 1888 drawing of Holywell Street, London, which survives in the form of a half-tone plate, represents one of Beardsley's few attempts to draw in an impressionist mode. The subject, a cityscape and in particular a street given over to trade in "curious" books (no less than more

blunt pornography), combines impressionist with decadent subject matter. One gas lamp barely illumines the seedy deserted thoroughfare; objects are created by their own shadows or persist only in wavering silhouette. The windows of buildings are dark niches like the spaces for urns in a columbarium. Dating from the same period are some burlesque drawings—mostly in pen, ink, and wash—of himself and Mabel at their amateur theatricals or offering their music in Pimlico, and these, along with other grotesques and caricatures, are not unrelated to the nineteenth-century English tradition of George Cruikshank, famous as one of the illustrators of Dickens.

Pre-Raphaelite Influence

Modern literature makes an appearance in a pencil, pen, and ink sketch of about 1890, illustrating a scene in Ibsen's *Ghosts*, act 1, between Pastor Manders, Mrs. Alving, and her son Oswald. Both Oswald and his mother have thin mouths set close under noses with bridges slightly collapsed in allusion perhaps to the venereal heredity of the Alvings, though similar facial features occur in the illustrations to *Manon Lescaut* of the eighteenth-century Abbé Prévost. And these features are also to be found in works showing the principal influence emerging in 1891; Pre-Raphaelitism. A pen, ink, and wash drawing of a belaureled Dante to the left shows the poet gazing at a bird that is flying down with a sprig in its mouth, perhaps of olive, perhaps even of poppy, for the allusion to Dante Gabriel Rossetti's painting *Beata Beatrix* (Beatrice in bliss) is plain. A sonnet handwritten on a scroll that assumes most of the right-hand side of the drawing recalls Rossetti's habit of positioning sonnets of his own composing on the frame of his paintings to provide a dialectic of poetry and icon: "Why not," Whistler observed, "simply frame the sonnet?" Some attempt is also made to integrate images and calligraphy in the manner of Blake's illuminated books. The sonnet itself is unattributed but is distinctly modeled on Rossetti's less distinguished efforts. A fellow clerk at the Guardian Fire and Life Insurance office, which now had Aubrey in thrall, had immediately inspired this focus on Dante. The poet's countenance, though, is soulful rather than as traditionally represented, stern and aquiline. Other drawings dating from the later months of 1891 have the thick stemlike necks and full brooding lips of Rossetti's women, while others are more than tinged by the influence of

Sir Edward Burne-Jones, leader of the second generation of Pre-Raphaelites.

The Perseus Drawings

Two drawings of the Greek hero holding the head of the Medusa date from 1891 and 1892 respectively. They may be considered slightly out of sequence, for they reveal a change in attitude toward Burne-Jones and the Pre-Raphaelites. In "Perseus and the Monstre," the monster's head is held out by the hair by a young man with exaggerated profile and figure bent back in a decorative stylized circle. This is clearly a burlesque, Beardsley's familiar method of assimilating and rejecting influence. The second drawing in indian ink and pencil shows an attenuated Perseus—another Burne-Jones feature: his male figures often seem to be veterans of famine. Two slender panels confine the effeminized hero; the upper has a frieze of small figures, a Medusa at the center, while behind a censer fumes on a tripod. The mode of decoration suggests house furnishing and points to an Art and Craft context. The hero, far from exulting in his act, seems merely exhausted, his head drooping with a twist-bladed sword in his right hand and the severed serpented head in his left. He looks away from us in the same gauche and shy manner as the hero in "Siegfried, Act II" like a girl caught playing awkwardly with a boy's toys. Perseus has acquired also something of Medusa's ferocious hair style, a feature now not infrequent in the drawings. The tone might seem to be equivocal, but other drawings of the same period suggest the contrary.

The Reverend Alfred Gurney, an early patron, commissioned a number of religious drawings in these years. They betray Pre-Raphaelite and Quattrocento influence, though "Hail Mary" with the Madonna in left profile, a lily stem bisecting her hair, is altogether Burne-Jones. It was also to secure for Beardsley along with his Tannhäuser drawing the commission from J. M. Dent, the publisher, to illustrate the *Morte Darthur*.

A pencil drawing also of 1891 presents an attenuated epicene figure gingerly edging through some saplings under the title, "Hamlet Patris Manem Sequitur" (Hamlet follows his father's ghost) a theme from act 1, scene 4, of Shakespeare's play. "Withered Spring" submits to another influence: the heavily lined style of Walter Crane, a prominent arts and crafts painter and illustrator of books. This can be read as a

direct comment on the artist's own condition. A largely masked motto on a Victorian revival Gothic gate reads, "ars . . . longa" (art is long) and, by implying the remainder of the Hippocratic quotation "vita brevis" (life is brief), lending emblematic resonance to the scene. It is the first of a series of drawings, most of them dating from near the end of Beardsley's career when, partly by means of an inscription, he comments on his own situation, but the later images are without the slightly narcissistic pathos of "Withered Spring" with the usual daintily epicene central figure.

Hermaphroditus

The influence of Simeon Solomon, a painter and draughtsman of the second phase of Pre-Raphaelitism, can be detected in this color drawing with a subject taken from Ovid's *Metamorphoses*. The title comes from that source, but technically Hermaphroditus is an androgyne. He sits with a long scarf strung out between his thighs and round his neck. His expression, at once sleepy and nonaggressive, suggests that he has found some similar being with whom to achieve coition or that he is like Lord Rochester's swain "only pleased with only me." The audience is enabled to accept the image as distanced by the classical allusion, as in no way threatening. The fourth book of Ovid's poem (lines 285–388) expounds the etiology of the fountain of Salmacis. A son was born to Venus and Mercury who combined the personal beauty of both parents. Brought up by the Naiads while still adolescent, he enjoyed wandering solitary through various lands and viewing unknown rivers. He came at last to a pool whose guardian nymph Salmacis fell in love with him and attempted to seduce him. The boy was not ripe for love, and the nymph pretended to leave, but from her hiding place saw him strip himself and dive into her pool. The sight of his naked body inflamed her further, and she exulted in the thought that he was now in her power. She too dived in and raped Hermaphroditus, winding her arms round him so strictly that he could not escape her embrace. He struggled, and Salmacis prayed to the gods that they might be joined forever in one. Her prayer was granted. The two became one—half a woman, half an adolescent boy. In his anguish the boy prayed that whoever entered the pool might become half a man and be altogether soft in his frame. This prayer, too, was heard.

Beardsley would obviously be familiar with Solomon's friend the poet Algernon Charles Swinburne's version of the tale based on the

famous statue of the sleeping hermaphrodite in the Louvre, a statue in which it is difficult at first to detect that the figure has organs of both sexes. Like Swinburne, Beardsley mysticizes and distances the episode. A more realistic version may be found in Roden Noel's "The Water Nymph and the Boy," an extended lyric spoken by the nymph that permits the author luscious homoerotic lingerings over the boy's stripping and the details of his barely pubescent body. It is possible that Beardsley had come across the poem, since Noel was popular in the 1890s. The importance of this drawing is that it contrasts with the very different treatment of the theme in the title page to Wilde's *Salome* of 1893. The androgynous image is transformed into a true hermaphrodite, a figure whose possession of the organs of both sexes is not blurred but luridly accented so that the spectator views the image as that of a frustrated monster. This involves a distinctly more aggressive attitude on the artist's part toward his audience. The hermaphroditic term that acts as the heading of chapter 71, book 10, of the *Morte Darthur* is iconographically close to the *Salome* drawing, but its expression is certainly less lurid and the organs are reversed: male breast and female pudenda. The youth who is bringing offerings of fruit has hair that parodies Rossetti's hair fetish.

A final influence can be detected in the portrait of the painter and art teacher Fred Brown, whose pupil Beardsley was for a year—the only period of training the artist was to receive. Whistler's etchings and his famous Peacock Room are levied for the surrounding detail.

The Litany of Mary Magdalen

This pencil drawing of 1891 anticipates the equivocal tone of Beardsley's later religious icons. The kneeling figure of the saint echoes the image of St. John in the fifteenth-century Andrea Mantegna's engraving of "the Entombment" with the lamenting opened mouth and painfully clasped hands. Mary's three attendants, two men and a woman, have fixed sneers and flattened heads; the woman is twiddling with the saint's rosary. A dwarfish Pierrot-like figure with panting tongue stares at the pleasing sensuality of the repentant female sinner. This is the first appearance of the spectator who will inhabit so many of the drawings; here, like the grotesque of "The Stomach Dance" in the *Salome* sequence, he is powerfully involved rather than the ironist who in other drawings comments on the action and draws the spectator into its ambit. On the right of this drawing, a standing girl resembles

the Magdalen in features, though whether she expresses mockery or wonder is not easy to define. Her body is partly truncated by the frame, a device that anticipates a number of later drawings creating a sense of disbalance and uneasiness in the spectator.

A comparison of "The Litany of Mary Magdalen" with "The Repentance of Mrs. M." of 1894 which was to appear in the fourth volume of the *Yellow Book*, clearly shows the leap in Beardsley's art. Background and perspective have been perfectly abolished and the decor is now Quattrocento no longer but if anything of the Regency. Mary no longer kneels at a lectionary or portable altar but at a table with goat's feet, a comment on what Mrs. M. is renouncing, domesticating and secularizing the rite. The heavy swirl of the elderly epicene's coat on the right of the drawing contrasts with the girl at extreme right who is economically drawn while her naked body is more radically bisected by the frame. A diminutive tassel hangs from the dandy's coat, a device anticipated by the page's more substantial tassel in one of the *Salome* drawings, "The Woman in the Moon"; both are stationed at the pubes. The panting dwarf of the earlier drawing is now reduced in scale and carries what is either a jewel box or a monstrance, both relevant to Mrs. M. as an updated version of the Magdalene.

An Intimation of Isolde

The drawing in pen, ink, and watercolor of Katherine Klavsky, probably dating from 1892, relates to her role as Isolde in the London performance of Wagner's opera *Tristan and Isolde* of that same year. Posed in the slender panel that circumscribes several drawings of this period, the diva has black ringlets of hair counterpointed with small horizontal spines and this feature reappears in "How King Arthur saw the Questing Beast," in "Siegfried, Act II", and in the *Salome* suite of drawings. It is echoed disconcertingly on the long wizened column to the left. Isolde's high-shouldered posture is repeated in "How Sir Tristram Drank of the Love Drink" in the *Morte Darthur* (chapter 24, book 8 of volume 1). Perspective which is masterful in the *Morte Darthur* drawing is absent here: Isolde appears to be on stage but, like the angel in Rossetti's *Annunciation*, seems to be floating rather than standing. Nor is the Malory drawing the last treatment. Beardsley was obsessed by Wagner, in particular by *Tristan and Isolde* and *The Ring*, and although he was to attempt some desecration (and so transcendence) of Wagner in his unfinished romance *Venus and Tannhäuser*, the fasci-

nation of and submission to Wagner's images remained with him to the end.

The neo-Japonesque Style

It was in the year 1892 that the first leap in Beardsley's art occurred. Now he was programmatically to change his style, or so it was generally said, every summer. That leap was what he himself was to describe as "an entirely new method of drawing and composition, something suggestive of Japan, but not really japonesque. Words fail to describe the quality of the workmanship" (*L*, 43). And in another letter he speaks of having "in certain points of technique . . . achieved something like perfection at once" and of having "produced about twenty drawings in the new style in about a couple of months" (*L*, 34). The new style emerged as a fusion of elements in Whistler's art, itself influenced by Japanese prints, himself a significantly more "modern" artist than the Pre-Raphaelites, along with the asymmetries and vibrant economic lines of Japanese art. The new style begins to emerge in the drawing of Raphael Sanzio and involves, according to Brian Reade, "the dramatic and decorative use of black areas . . . arrived at, it appears, by means of experiments with blots of indian ink and the value of assymetry in the placing of these areas of black." As Reade points out also in these early "neo-Japonesque" drawings, the areas of black ink are heightened by scratching and rubbing, irritating the dried surfaces, so here and in "Le Dèbris d'un Poète" the areas have a richness of texture, especially when descriptive of textiles, which is not at all Japanese.[2]

"Les Revenants de Musiques"

"Le Dèbris d'un Poète," however, represents a more conclusive essay in the style, for the immediate influences are transcended and Beardsley's individual note is more pronounced. Of "Les Revenants de Musique" (The ghosts of music), another "fine line" drawing of the spring or early summer of 1892, Simon Wilson, a precise and eloquent guide to the works of this period, observes: "The whole sheet is first divided into a beautifully proportioned assymetric geometric grid, within which small masses of black are then disposed, 'calling' to each other across the expanses of white. These in turn are animated by a few slender but dynamic lines,"[3] or chords. Such a description clarifies

Beardsley's movement toward the triumphs of *Salome*, the hesitant ges-
ture toward the mastery of the line block and the pungent appositions
of black and white.

In "Les Revenants" a young man slumps in a slender cane chair, the
species of art nouveau furniture in the style of the aesthetic movement
designer E. W. Godwin that inhabits some of the later drawings. He
looks down while of two smaller figures to the extreme right of the
drawing, one is partly truncated by the frame. One figure has the
voluminous robes and high hunched shoulder of Isolde and both have
flaring hair like horns; taken together these features indicate female
aggression. Another lower figure is more decidedly spectral with hair
and contours established entirely by line, flowing out of the thick black
band that separates a bottom border and echoing the horizontal move-
ment of the tree within the border. A top border projects just over
halfway across the drawing space and both divides the latinate lettering
of the title from the body of the drawing and acts as a decorative ele-
ment to the screen with its two curvilinear stems and petals marked
by stylizing dots. The drawing is trisected into three unequal segments
by borders of differing length. The subject is perhaps a romantic young
man haunted by the ghosts of some great music he has just experi-
enced, probably Wagner, and his response to such music has left him
exhausted.

"The Birthday of Madame Cigale"

"The subjects," Beardsley wrote of these neo-Japonesque drawings,
"were quite mad and a little indecent. Strange hermaphroditic crea-
tures wandering about in Pierrot costumes or modern dress; quite a
new world of my own creation" (*L*, 43). If the description barely fits
"Les Revenants de Musique," it aptly covers "The birthday of Madame
Cigale" (Cicada), where the Japanese influence is so marked that it is
not altogether assimilated: the subject matter has become personal, but
the mode of execution is not as yet equal to the new bizarre concep-
tions. We have two borders of unequal length, both decorated with
birds, the bottom a frieze with emaciated peacocks or "bedraggled
Birds of Paradise left out in the rain," as Oscar Wilde puts it. The top
border is supported by a black beam in the manner of a Japanese house,
and the drawing is given depth by two stylized trees while a third is
abruptly severed by the area supported by the lower panel. A curtain
right, stylized cloud forms, and a floating long-stemmed peacock

feather provide the whole offscape. Seated under the roof beam is a woman leaning forward with right hand lifted in a benedictory gesture or gesture of welcome. Her posture exposes her right breast and navel and iconographically predicts the first version of "The Toilet of Salome," though both breasts and a large frontal expanse is on show in the later drawing. Salome faces to the left, Madame Cigale to the right. A procession of admirers advances from the right frame bringing gifts: bunches of flowers, a bird of prey, a hatbox with the designation "Madame," what appears to be an oversized button hook, and an unidentifiable object on a salver, trussed, with four diminutive legs and no head. The visitors, whom Reade relates to the grotesques of the *Bons-Mots*,[4] are as oddly assorted as their offerings: one with egg shaped head and faun's ears has the top hat and slender cane of the contemporary dandy; another has a pigtail, all have pointed shoes, and two have Levantine pantaloons. Madame Cigale is clearly a luminary of the demimonde, or perhaps one of the refined courtesans of Japanese prints and novels.

'Le Dèbris [*sic*] d'un Poète"

The impact of "The Birthday of Madame Cigale" is attenuated by the floriation of detail. "Le Dèbris d'un Poète" (The remains of a poet), probably dating from the summer of 1892, answers the proud description that the artist himself gave of his new art: "Fantastic impressions treated in the finest possible outline" and "extremely fantastic in conception but perfectly severe in execution" (*L*, 34). As Wilson justly observes, as with "Les Revenants de Musique," severity in composition is married to severity in execution. Here absolute blacks are placed "in finely judged relationship to each other and then balanced against large areas of pure white," while forms are defined "by barely more than a single bounding outline."[5] A young man—back to us, face a little to the right—on a high stool strongly left centered turns over the pages of a thick ledger and faces up to a bundle of contracts. The image is powerful, suggesting as Wilson points out the intensity of the illuminating monk or the experimenting alchemist. The title enigmatically offers a direct comment on Beardsley's life, the waste of his large talents, and his brief time at the office of the Guardian Life Insurance Company. The word "poet" alludes to the artist's continuous ambitions to be a man of letters. The bottom border, also a carpet with large white sunflowers on black, may represent the aesthetic energies sub-

merged by routine. The touch of humor and the absence of obvious self-pity are notable and typical.

"The Achieving of the Sangreal"

A sample drawing made to confirm J. M. Dent, the publisher's commission for the *Morte D'Arthur*, "The Achieving of the Sangreal" in indian ink and wash, constitutes a slight regression in Beardsley's art, though composed in the new "fine line" manner. Beardsley had "still not freed himself from conventional illusionism of a line and wash technique and the drawing therefore had to be reproduced by photo-gravure and not by line block."[6] The Grail picture is still close to Burne-Jones and Puvis de Chavannes, the French symbolist painter, in the faces and ritual stillness of the figures, two of whom are elongated. The achievement of the two knights who are granted the presence of the holy cup is counterpointed and perhaps undercut by much ominous detail, as in drawings that can be grouped with the Grail picture, "How King Arthur Saw the Questing Beast" and "Siegfried, Act II." The base is formed by a jagged mass of black, representing water, with the bank emerging as a species of crust, peculiarly thin and perhaps insecure in the Grail picture. The water is crossed by vegetation in predatory forms; one shoot has a growth rather than a bud attached, and on another the incurling leaves shape themselves like mandibles while thorns without leafage and hairy blossoms of an ominous elabo-ration curve across the water. The accent of the figures and the straight, tall trunks at picture right is severely vertical but checked by the cur-vilinear and horizontal of the pool's lip and the arc of the water plants, an inverted moral gravity. The recession and the strict faintly rippling parallel lines of the river in the middle ground appear to be irrelevant to the theme unless the twists of water through the offscape reflect the indirections of the quest. There is no point of rest. The stiff hieratic angel's wings repeat the shapes of the foliage but are ragged and fluffed in fronds, or are they suckers? The haloed cup is also smothered with flowers that do not altogether belong to a cottage garden. The context is not merely bleak as in Puvis's "Le pauvre pecheur" (The poor fish-erman); these are bad lands. Such an impression is intensified by the swollen halo round the angel's head that burns off portions of one of the middle ground trees and the base of the angel's wings. The face of this equivocal "bird of god" is Pre-Raphaelite, owing more to Rossetti than to Burne-Jones.

"How King Arthur Saw the Questing Beast"

"How King Arthur Saw the Questing Beast" is obligingly dated
for us by the artist 8 March 1893. The drawing illustrates an epi-
sode in the earlier history of King Arthur when the king finds him-
self alone in a forest after chasing a stag: he sits by a fountain and
hears a noise of many hounds. "With that the king saw coming to-
ward him the strangest beast he ever saw or heard; so the beast
goes to the well and drank, and the noise is in the beast's belly
like the questing of many hounds; but while the beast drank the
noise in the beast's belly is silenced "(*Morte Darthur*, book. 1,
chap. 19).

Reade describes the illustration as "the most elaborate in the hair-
line manner . . . used for 'Siegfried' and for many of the *Bon Mots*
vignettes."[7] The viewer enters a world abandoned by a god of spiders,
blurred by webs and dust. Perhaps fortunately the "hair-line" style
proved untranslatable into photomechanical reproduction. There is a
strange profusion of what amounts almost to automatic drawing in the
details that decorate every part of the landscape: these include a treble
clef, a signature, a spider web, a phallus, and calligraphic flourishes in
the manner of the seventeenth-century writing masters. Though the
episode is bizarre rather than sinister, the disquieting qualities of the
Sangreal drawing are intensified. The landscape background again in-
volves the strong vertical thrust of trunks passing out of the triple lines
of the frame; two of the trunks sharply attenuated appear to grow out
of a blackish depth of water. The motif anticipates the executioner's
arm in "The Dancer's Reward" from the *Salome* series. Counterpointing
these vertical accents are the billowing semicircles of rock and water
and the almost horizontal figures of Arthur and the beast forming a
continuum, for Arthur's scarf flying up and round partially covers the
beast's peacock-moon scales that bubble like tainted water. (Reade
terms him "a pseudo-Japanese dragon.") Beast and king are connected
by the dead split tree trunk against which Arthur's head is placed and
which interrupts our sight of the beast's extremities, though these are
accented by the arc of Arthur's scarf. Together the two figures form an
acute hairpin curve. As they are physically, so too they are psycholog-
ically connected. The beast's eye stares obliquely at Arthur, while the
king's eyes under heavy lids are directed downward to the far left of
the pool where the beast is about to dip its beak. What we have is a
grotesque prefiguration of the male-female encounter theme, derived

from Gustave Moreau, that is frequent in Beardsley's work, particularly in *Salome*.

In many of the quest or accomplishment images the issue seems to be anticlimactic; doubt about what the audience will make of it or even a despairing recognition by the hero of kinship or collusion between himself and his victim. Here, though, the effect seems comic or parodic. Accenting this are accidental or random objects that inhabit the drawing. From the water, a serpent, echoing the serpentine rhythms present in the eroded twists of the landscape, looks up at Arthur while on the scum that dots the pool a cross-legged ragged bird is disposed, some travesty of goose or swan with drooping frondlike plumes, though the lines above the head suggest a crown so possibly the usual peacock is intended. A faun, holding his panpipes high, turns a startled, even a fearful, face toward the beast and scurries out of the drawing at the background half left, confirming the unresolved tension between centrifugal and centripetal so characteristic of this drawing.

Beardsley's emblem of three candles with three carets or drops beneath the raised middle candle had appeared for the first time in "The Achieving of the Sangreal" and is picked out here in white floats at the bottom left of the pool; it was to be abandoned again in the middle of *The Yellow Book* period. As a monogram it reflects the practice of Whistler with his butterfly and the art nouveau designer A. H. Mackmurdo, with his stylized two-leaved flower, or Walter Crane's visual pun on his surname. Besides the assertion of individuality, the device was a substitute for signature or initials that might well work against the formal rhythms of a work of art. As we have seen in some of the early drawings and will see again in some of Beardsley's classical drawings, the intention was not to exclude the discursive as such. But the whole drawing is highly difficult for the eye to decipher: the trunk is devoid of volume and the dark mass in Arthur's arms impossible to distinguish.

"Siegfried, Act II"

This drawing records a climactic moment in Wagner's opera, the moment when the hero has just killed Fafner the Dragon, who guarded the fatal treasure of the Nibelungs. As he frees his sword, Siegfried's hand becomes sprinkled with Fafner's blood; he quickly withdraws it: "The hot blood burns like fire!" Wilson justly describes the work as

"an utterly compelling fantasy in which Japanese, early Renaissance, and Whistlerian influences are absorbed into a completely personal style and vision."[8] But in spite of the unified style and vision, the result reads like a manifesto, a declaration of the designer's right to subordinate all to the whim of his imagination. Patterns of lines and dots seem to subjugate form, placing nearly all the objects in the plane of the paper, demonstrating an artifice that is over explicit. Siegfried, the "free" hero, redeemed from Wotan's will, of the third part of Wagner's *Ring* is an androgynous actor with spavined legs and a dainty, pantomime sword, who peers at his delicate right arm in some alarm as he detects a few drops of dragon's blood. The deviance from the operatic context is so acute that one is tempted to regard the image as satire or desecration. One can isolate here many of the constituents of Beardsley's later successes: the virtual elimination of any tones intermediate between black and white, black itself being used only for decor; no modeling of light or shade; the stylization of forms as shown here by the twice repeated five-leaved flower that encroaches on Siegfried from the left echoing the ominous flora of "The Achieving of the Sangreal"; the cryptic introduction of erotic forms into the decoration. The self-conscious theatricality of Beardsley's subjects is foreshadowed here not only in Siegfried's exotic costuming but in his shy gauche pose, turning to face the audience after his coup de grace but modestly dropping his eyes and almost dropping his pantomime sword.

Siegfried indeed as Principal Boy marks Beardsley's fascination with transvestism, while those spavined legs will reappear in "The Abbé" and elsewhere. The Beardsley line is almost lost in the work, engulfed in the mass of lines of an undifferentiated thickness. It is the consequence, though, of this blackness that Fafner's wings alone stand out and suggest the stunning power and delight with which the artist could invest his line. As with the Grail and the Questing Beast drawings, the eye is confused by the mass of detail. "Siegfried, Act II," though it anticipates still better things to come, makes us realize how benign was the influence, despite the limitation of that series, of the *Morte Darthur* in forcing Beardsley back into black and white.

Chapter Four
Morte Darthur and Bon-Mots

Before entering a discussion of two important commissions that Beardsley achieved in 1893, brief mention should be made of several other items. There is, for example, the first of a series of self-portraits dating from sometime in 1892. This is a simple head and shoulders—direct, undramatized—that leaves an effect of smoldering candor on the viewer. In the early months of 1893 he undertook some caricatures for the *Pall Mall Budget*. These are in no way striking, with the exception of one that was too much for the editor: a small rondel of Queen Victoria undertaking the role of a Degas ballet dancer.

Morte Darthur

The single- and double-paged illustrations, initials, and borders of this commission amounted to over three hundred and fifty drawings, and we may trace Beardsley's development from dependence on his late Pre-Raphaelite mentors, Burne-Jones and William Morris, to freedom through parody, caricature, and irrelevance. By the time he began these drawings Beardsley was already beyond the stage of submitting to such influences, but the nature of the subject forced him back initially into the medieval idiom. The subject itself was barely likely to attract his full powers, though judging from "King Arthur and the Questing Beast," he found at first that it could accommodate his art.

Recent criticism has asserted that the *Morte Darthur*, a compilation and expansion of French Arthurian sources made just after the middle of the fifteenth century, possesses undoubted unity, but the average reader is perhaps more likely to assent to the older view that the work dissolves into disconnected episodes and that the volume is best described as "The Collected Works of Sir Thomas Malory," if indeed that fifteenth-century felon was responsible for any of it. What remains certain is that the printer, William Caxton, edited it with considerable skill and gave it at least some specious organic quality. Parts of the

text are lively enough; others, such as the Holy Grail episodes, are likely to impose some tedium, and we may guess that Beardsley's reaction to the letterpress he was illustrating probably resembled from fairly early on in his labors that of the average modern reader. The values of medieval chivalry and mysticism, the primary importance of lineage, could not sate his taste for long; the cult was essentially high Victorian. Where Tennyson in his *Idylls of the King* treats Tristram as symptomatic of the decline of chivalry, and his love story as a virtual parody of Launcelot's, Swinburne represents later taste by exalting Tristram as absolute for love. However, Beardsley's enthusiasm for Wagner enlivened parts of the text for him, particularly those relating to the theme of love and death in the Tristram and Isoud episodes and to some degree the story of Guinevere's long adultery with Launcelot.

The publisher J. M. Dent's aim was to provide an alternative, "the poor man's Kelmscott," to the expensive and laborious hand-printed mode of William Morris's press with its wood engraving line block, by using the new (and cheap) method of photoreproduction that would translate Beardsley's drawings directly and into whatever size was required. This had the consequence of limiting in virtually every case Beardsley's work to black and white and inhibiting him from the pencil modeling of his early sketching. In the work of Burne-Jones, there is at least some substantiality of modeling, but with Beardsley, figures become decorative purely and are subsumed into the decorative integrity. In another way, though, Beardsley is less decorative than Burne-Jones and Morris in their illustrative work; the linear becomes a positive element; spaces between lines are shaped and articulated if at all by lines; space is negative. Design therefore becomes flat. Pure black and white further differentiates the line by devaluating its functional quality; the spatial design becomes purely two-dimensional. It is subjective rather than an attempt at objective description that is offered by the positive lines. Beardsley's figures, moreover, in the *Morte Darthur* designs, though highly specific in themselves, tend to become abstracted from the page or the book to which they belong, a quality that conforms to one of the classic definitions of a "decadent" work of art. Paul Bourget uses a biological metaphor to clarify the features of the style: for any organism to perform its functions with energy, it is necessary that the organisms composing it should perform their functions with energy, but with a subordinated energy, and this is true of all lesser organisms.

If the energy of the cells becomes independent, the lesser organisms will like-
wise ease to subordinate their energy to the total energy and the anarchy which
is established constitutes the *decadence* of the whole. . . . A similar law gov-
erns the development and decadence of that organism which we call language.
A *style* of decadence is one in which the unity of the book is decomposed to
give place to the independence of the page, in which the page is decomposed
to give place to the independence of the phrase, and the phrase to give place
to the independence of the word.[1]

Both Beardsley's black and white style and his attitude to the text are
defined by this summary of Bourget's notion.

Morris's illustrations, to the contrary, suggest incisions on the sur-
face of something substantial and, given his models—medieval man-
uscripts and Books of Hours—this is natural enough. Thus, Morris's
work is indeed truly decorative. Unlike Morris, Beardsley did not de-
sign and supervise the book as a whole, even when acting as art editor
for the *Yellow Book* and *Savoy*, and unlike the designers of the private
presses who on occasion furnished text as well as cover design, title
page, typography, illustration, and endpapers. Beardsley's later cover
designs or frontispieces are often tacked on to the typography of others;
he exemplifies the split between art and craft that is perhaps charac-
teristic of certain aspects of the art nouveau of the 1890s, and he is far
from fulfilling or even attempting to fulfill the program of the sym-
bolists with their demand for the total "sacred" book. It should none-
theless be stressed that this is Morris's ideal also. But it was perhaps
essential to Beardsley's mode of illustration that he should not be fully
implicated in the design of any work as a whole for otherwise he could
less readily impose his practice of bringing out latent and contradictory
meanings in the text by corrective oblique satire and over or under
interpretation; a critical dialogue between text and image. His page is
not, finally, unified, and his figures (and the spectator) are trapped,
suffocated in a hostile space.

In effect, then, Beardsley's illustrations remain subjective impres-
sions divorced from decoration; the foliage on the borders of the *Morte
Darthur* is distinctly less modeled than in the Kelmscott decora-
tions. There is less uniformity of arrangement and greater continuity,
while the sexual features of Beardsley's vegetation lend a voluptuous
mammary characteristic to the actual fruit: "powerful organic plant
forms pulsing with life," as Wilson admirably puts it.[2] In this respect
also "Siegfried, Act II," which first introduces the theater of breasts,

penises, and pudenda, is proleptic. In further contrast to Morris, the entire border begins to be graspable as a single complex unit, a single complex network of lines completely eclipsing actual individual fruits, a long distance indeed from early Pre-Raphaelite attitudes to Nature with its "minute particulars": God is no longer in detail. Such a complex network adds up to a calligraphic flow of line, while two marked symptoms of art nouveau appear: the whiplash line and the organic-voluptuous convergence. Beardsley is early in the art nouveau movement, but he has English predecessors in the Century Guild circle. A. H. Mackmurdo's first essays in the style date back to the early 1880s and in the Guild's periodical, the *Century Guild Hobby Horse* (1884–92), the idiom is also sporadically found. It is scarcely wonderful then that Morris should have acutely disapproved of Beardsley's designs no less than the method of mechanical reproduction by which they were transmitted. "A man should do his own work," not shamelessly appropriate and distort another's, particularly when that work related to the beloved Middle Ages. Beardsley, however, turned his own comment against Morris; Morris's work was "mere imitation of the old stuff, mine is fresh and original." (*L*, 44)

Fresh and original it may have been, but Beardsley became in the end impatient of the text; of the necessity to keep up with the monthly parts in which his images appeared and of the species of illustration which the text imposed. So much we may gather from the aggressive art nouveau features; by the touches of Japanese influence; the occasional blunt anachronisms and the occasional tired drawing; the repetition of designs and the expressions found in some of the repertory of angels, damsels, and other medieval fauna; and the merely partially masked allusions to male and female sexual organs in unusual places.

A number of the single and the double page drawings are still in the starved Burne-Jones vein with its effeminate male bodies. Such an image as the "Merlin and Nimue" (bk. 4, chapt. 1) looks back to the "Perseus" of 1892, while "Withered Spring," also of 1892, is adapted for the chapter heading of book 1, chapter 6.

As a group, the vignettes are the finest features of the book, representing Beardsley's somewhat greater interest in the symbiosis engineered by animal and vegetable life, but they have little contact with the plot. The single- and double-page illustrations are oppressively large and white; the forms coarsely delineated and often devoid of both verve and style. The large outdoor settings are somewhat foreign to Beardsley's temperament or capacity and often reveal an unwieldy at-

tempt to mingle illusionist perspective with a medieval flatness. Those illustrations necessarily relating more directly to the narrative, furnish a sharp index to his intensifying lack of involvement with the knights and their doings. His sense of the necessity of such involvement becomes much less important later; the indirections of his images here point forward to the time when his distancing from the text becomes energizing, for it allows him to interpret critically but not to be subdued by the discursive; not, in short, to be merely "literary."

To these sour comments, there are a number of exceptions such as the arresting, if overstated, use of black in "How Queen Guenevere Made Her a Nun." Malory tells us that, after the last great battle in which Arthur, his knights, and their enemies were all killed, the queen went to a nunnery at Amesbury and "wore white clothes and black and great penance she took, as ever did sinful lady in the land." Sir Launcelot arrives by chance at the nunnery, and when he is brought to her the repentant adulteress remarks to her ladies: "Through this man and me hath all this been wrought; and the death of the most noblest knights of the world; for through our love that we have loved together is my most noble lord slain." Wilson comments on Guenevere's face—pretty, sensual, young, as index of the adulteress and femme fatale—and on the sinister touch of the raven's beak silhouette of the cowl, a device that will be echoed in the monster's head formed by the ascending Virgin's robe in the St. Rose of Lima drawing. The lectern at which Guenevere reads has, like the table in "The Repentance of Mrs. M.," goat's feet. In the later drawing the feature accords stylistically and functionally with the object, but here is bluntly anachronistic. The purpose though is similar: to point emblematically to the particular deadly sin from which the female sinner most needs to be shrived. More stunning exceptions to all such strictures are two of the drawings that relate to the love-hate-death themes of the Tristram and Isoud passion.

"How La Belle Isoud Nursed Sir Tristram"

Before commenting on the two drawings, it may be as well to remind ourselves of some of the relevant details of the story. Tristram, the Cornish champion, kills his Irish counterpart but is gravely wounded. He turns up disguised at the Irish court, and the king hospitably commands his daughter La Belle Isoud (Iseult the Beautiful) to heal his wound. She does so, falling in love with him in the process.

No one at the Irish court is as yet aware that Tristram has killed their champion. The drawing illustrates a moment taken from this point of the narration. Isoud kneels at Tristan's bedside and, as Wilson interprets it, "with hooded eyes and unable to resist, tentatively lays her hand upon his thigh . . . the theme of passion held in check is echoed in the formal structure of the composition in which two figures, themselves drawn with extreme economy, are firmly contained within a boxlike grid of lines."[3] However, if Isoud's hand is touching, the location is more loin than thigh. But judging from the position of Tristan's arm, her hand seems farther away, raised tentatively before daring to touch. Her whole posture, awakened, tensed, about to spring, suggests that she has not yet released herself through touch. Beardsley has also used the border to comment on the scene. Wilson remarks on his "unleashing a continuous growth of flamelike tree forms, clearly expressive of the powerful natural forces gathering beneath the apparently calm surface of the lovers,"[4] to which one might add that the large ecclesiastical candle to the left of the picture seems to be about to burn the curtain pole; and even more emblematic are the tortured and writhing root forms significantly at the base of the border, which justly require the word "unleash." The whole image, indeed—border, candle, Isolde's posture—speaks of the contrition wrought to sexual desire and contrasts forcibly with the simple limpness of Tristram. The shape of the trees is highly formalized so that the tension between courtly surface and wild sexual impulse is once more delicately realized. Such rich psychological commentary is far beyond the static art of Morris or of his colleague in illustration, Burne-Jones.

"How Sir Tristram Drank of the Love Drink"

In this masterful drawing, the neo-Japonesque and flamboyant theatricality or rather operatic brio look forward to the triumphs of *Salome*. We reenter the narrative at the point where Tristram, despite his love for Isoud, has acted as marriage broker, arranging her union with his king, Mark of Cornwall. The scene is on shipboard; Tristram is taking Isoud to the Cornish court, but Isoud has discovered that Tristram has killed the Irish champion who was also her lover. She has also attempted to kill her lover's murderer while he lies asleep, but he opens his eyes just as she is about to despatch him with his own sword, and a complicated state of hatred and love is startled within her. Isoud is also wildly disturbed not only by her varying feelings toward Tristram

but her despair at his coldness in marrying her off to Mark. She pre-
pares a poisoned drink for him, her intention being to drink it after
him. Tristram's state is equally despairing, and he presents his sword
to her so that she can kill him, and then offers to drink from the cup
which he is perfectly aware is poisoned. It becomes a species of inverted
sacrament. "The cup that now I take will cure the hurt completely."
That does not sound like Malory, and indeed it is not. The whole
episode of the Irish knight as Isoud's lover, the revenge, the venomous
chalice is from Wagner's opera *Tristan and Isolde* that had haunted and
was to haunt Beardsley's imagination. The episode continues with both
drinking, but neither dying except in a metaphorical sense: "the little
death." Isoud's faithful servant has substituted a love potion for the
poison, with consequences that are as radical.

Round the right and over the top of the double line rectangular
frame, a serpentine art nouveau line runs with what are, according to
Reade,[5] blooms deriving from the *Clematis viticella* or bush bower and
the tulip. The effect is restlessly counterpointed by "the delicate
tensed up petals growing out of it." Across the curtain in middle
ground, an enormous Clematis as in "Siegfried, Act II" and "Achiev-
ing the Sangreal" sways upward slantingly to the right in "harsh
arabesque," which splendidly parallels Tristram's defiant gesture.
Isoud's Medusan hair-do and her high left-shouldered stance suggest
an operatic, proudly leaning pose, reminiscent of the Katharine Klav-
sky drawing and later reprises. But Tristram and Isoud are doubles,
though barely complementary. Isoud's shape is phallic, accentuated by
the suppression of her arms and the scrotumlike widening of her lower
skirt.

But we cannot rest in the antithetical mirroring. Isoud both menaces
and recoils. The double frame border enacts imprisonment in tragic
love while the irresistibly swaying line in the frame emphasizes all that
enclosed the doomed pair: fate; the fierce complexity of their need; the
line of sea birds in flight may establish a neat but illusory distance,
but are they flying away or toward the lovers? The prospect is narrow
so that the reading is once more ambiguous: will the draught liberate
or imprison? And is the slightly set back Japanese ocean really an
ocean, or is the whole scene taking place indoors? Wagner has ener-
gized Malory, and the power of the drawing derives from the uneasy
readings of this "weaving together of love and death into a single theme
. . . one of the most powerful devices in romantic art," so Wilson,
who also notes that this is the central theme of Wilde's *Salome*.[6]

Borders, Vignettes, and Chapter Headings

The decorative borders are a map of Beardsley's intensifying bore-dom. He may fill the right-hand margins with a pungent motif but soon tires of the repetition required in the smaller margins where the penning often becomes palpably casual; organic forms with felicitous curves often become absurdly squashed, as if in some glass tube, as for example on the left-hand side of the famous satyr border or in that surrounding "Merlin and Nimue."

The border of book 2, chapter 1, reveals Beardsley's practice at its best besides furnishing a bold example of his method. We are shown a dense swirl of bursting briars with every space extinguished in Morris's manner—the *horror vacui*—yet the decoration is not static pattern mak-ing but restless. Climbing in and out of the foliage are female fauns, unusual images that clearly relate to Beardsley's hermaphrodites, dis-quieting monsters, a collision of ideal and animal. The chapter heading is indeed inescapably Freudian: "Of a Damosel which came girt with a sword to find a man of such virtue as to draw it out of the scabbard." Something has occurred not to blur but reverse the gender roles, and the satyresses furnish comment on that. Satyrs are defined by animal horns, cloven hooves, and if the genitals can be glimpsed through the thick hair from waist to ankle, they should be ithyphallic. Here it is the leg of the satyress to the bottom left that is ithyphallic, the other cloven hooves more resemble female genitals. The source of the satyr-esses is probably Giovanni Battista Tiepolo's *Capricci*, widely dissemi-nated engravings.

The heading of chapter 14 of book 7 shows a figure with circumcised penis and female breasts caught among a tangle of "bleakly and capri-ciously stylized" Burne-Jonesian roses, which do not appear in the least to discommode it. The hermaphrodite's left hand grasps the underside of a rose into which it stares as into a mirror. The image is in dialogue with Burne-Jones's effeminized figures and finicking decoration but is by no means as radically disturbing as the hermaphrodite term of the *Salome*. Indeed, the effect may even be quizzical: the mirror as anxious corroboration either of one's monstrosity or one's bizarre beauty. A fe-male faun appears once more in the heading of chapter 11 of book 5 swinging a thurifer that faintly suggests a skeleton. The face is heavily lipped and male with a pertinacious jaw line, but the nipples are em-phasized by stippling and the breasts are mature. Three mysterious fronds, falling wing feathers perhaps, suggest some demonic rite that

is, so it seems from the white dots that float in black midair, being celebrated. The contrast of heavy black and white is somewhat dissipated by the profusion of objects, but the image remains disturbing.

In this dialogue between good and evil, good is represented by characteristically doleful offerings: Pre-Raphaelite girls, angels in long robes, while the evil surrogates are satyrs and fauns. In between such forces are ambiguous images such as nude androgynous youths, thorn bushes, and a plethora of peacocks. Beardsley is altogether more successful in suggesting tainted sensuousness and pagan mischief than is Burne-Jones, returning more fully perhaps to the spirit of their mutual idol, Botticelli, with his snub impish satyr. The point can be enforced if we compare the inertia and vacuous sentiment of the god in Burne-Jones's *Pan and Psyche* with the demonish rictus of the vignettes on pages 45 or 244 of the *Morte Darthur*. And not merely does Beardsley magisterially accent the sensual, he is also highly accomplished in his more sinister images such as the famous three frowning ladies or the two cherubs, one at least corrupt, on page 488, whom he repeats in "The Eyes of Herod," or that leering face imprisoned in the verticals of the stylized undergrowth on page 152. Nothing, however, exceeds the slyness and boldness of the heading of chapter 16 of book 17, which on first sight appears to be a view through a gully with slanting trees that form a roof of leaves, while in the dotted plain below, four trees are closely set to form a vaguely triangular shape with a small knob at the top. This alludes quite clearly to the genitals and pubic hair.

Beardsley's peacock imagery exhibits its moons as decoration in the dragon scales of "How King Arthur Saw the Questing Beast"; in the long train of "La Belle Isoud at Joyous Garde"; and as achieved birds in the chapter headings to book 14, chapter 3, where the design is simplified to white silhouettes against a plain black background, or the repeated heading of book 8, chapter 10, which reverts to black on white. These birds are distinctly stylized in the manner of Whistler's Peacock Room decorations (1878) and, as their expressions indicate, are ambivalent or amoral emblems, the faces accomplished with a daring cartoonlike simplicity, usually wearing an ironic grin, eyelids lowered in aristocratic languor, altogether splendid allusions to Whistlerian "l'art pour l'art," jocular anomalies in the dialectic of good and evil. Besides resisting moral interpretation, these peacocks with their engulfing plumes, erect or in train, defy all canons of realism by their apparent expansions to infinity, stemmed only by the picture's frame rather like Alice after she has helped herself to the magic potion and

her uncontrolled growth is only brought up short by the ceiling of the White Rabbit's cottage. (Children's books were one of Beardsley's fetishes ever since he had devoutly copied his Kate Greenaway girls.) The serpentine necks of some of these birds may well allude to the necks of Rossetti's stunners. The vivid harpy image, more frequently repeated than any other, of book 1, chapter 8, has peacock moons on her wings as has the winged heraldic beast of book 1, chapter 21, also repeated. And in one of the best of the vignettes, book 3, chapter 3, several times repeated, humorous and graceful with feathers rigid as spines, three self-assured swans glide along three parallel streams.

It remains difficult to ascribe much significance to the order in which the vignettes appear, and the repetition of images compounds the difficulty. However, it seems altogether appropriate that, toward the close of the book, the strutting peacocks appear, identical to an earlier vignette except that the left-hand peacock has assumed the place of an angel (p. 246 and 574). Beardsley here may well be playfully asserting his own tastes and mocking his own tiresome pseudomedievalizing vocabulary as in the margin design on page 183 in which a grinning, tongue-wagging devil apes two earnest angels, so subverting the tone of the whole page.

Beardsley's own languor in any pursuit of the plot line becomes oppressively obvious in the boredom and grief on the faces of his subjects. He deliberately confuses the issue by giving his maidens sinister grins in place of the wistful Pre-Raphaelite pout and lavishes anachronism and absurdity on their costume, whether through jaunty hat (p. 578) or figure (p. 869) with frilled shoulders and a plunging neckline (p. 842). A late image turns into a Pierrot as though Beardsley had casually mixed up a drawing from the *Morte Darthur* with one from the *Yellow Book*. One of the oddest of the bird images (the chapter heading of book 20, chapter 4, shows two birds in flight with necks interlocked like Alice's flamingo at the Queen of Hearts' croquet match, though here the birds have the necks of swans and feathers crossed by peacock moons.

Parody, caricature, emblem, muted allusion, the total effect of the illustrations is bewilderingly eclectic. Even in a brief sequence of images, the rage for stylistic change in his style may produce such an effect, but the number of borders, vignettes, and illustrations here massively enhances it. There is stylized water in the Japanese mode, for example, of one of the earliest drawings, the heading of book 1, chapter 4, (p. 6 of vol. 1). The boat and the figures, though, remain

obstinately medieval. The repeated design of the heading for book 1, chapter 11 (p. 19 of vol. 1), shows a mermaid with Medusan hair-do standing in shallow formalized water with a tail as long as the Loch Ness monster's, composed of the short feathers of Whistler's Peacock Room. Not only are the water forms conventionalized in the mode of Japanese art but "the varying and complicated undulations of the lines forecast the macaroni lines in art nouveau usually associated with hair."[7] The mermaid has thrown one wave form carelessly over her left arm like a long evening shawl. The short feathered moons are also utilized as pubic hair with tendrils reaching up, the center one flowing into the navel and more oddly the moons reappear on the underside of the left arm just below the elbow, suggesting perhaps the tufts of satyra.

Art nouveau and the Japonesque are once more prominent in the heading of book 7, chapter 4. A girl with one strand of hair forming a whiplash behind her stares at a group of strange trees with fungoid growths, their roots arched out of the earth like banyan trees, disposing themselves in whiplash shapes. The eclecticism extends to the Initial *J* possibly intended for the *Morte Darthur* but not used. R. A. Walker believed that this drawing was not by Beardsley, and Reade concedes that the adaptation of Celtic ornament is rare in the oeuvre.[8] If the initial is not by Beardsley, it is certainly a skillful use of his style, the economy of suggestion on the eagle faces and bald heads of the winged sphinxes and the grotesque fantasy of fish heads slender as serpentine arrows or with tongues like fluent rods; the heads themselves are caricatures of bird-brained women. One of the Glasgow or the Patrick Geddes circle at Edinburgh could be responsible. Clark, however,[9] reminds us that Beardsley was not ignorant of Celtic decoration; he was probably familiar with such works as John Westwood's *Facsimiles of the Miniatures and Ornaments of the Anglo-Saxon and Irish Manuscripts* (1868).

The heading used in the 1927 edition of the *Morte Darthur* for book 12, chapter 11 (p. 276), was rejected from the 1893–94 edition because of the spill of foilage into the left hand margin "in a way out of keeping with the other ornaments in the book." The dragon head at the bottom left of this image is echoed by the vegetation with its coils and jagged spines. Indeed, scales are not infrequent in the sequence of images; armor, for instance, constantly suggests reptile or insect scales.

If the *Morte Darthur* illustrations, a text with which Beardsley was far less involved, resulted in a work of uneven power, the cause is not readily to be found. The borders, initials, chapter headings, and a few

of the illustrations are successful. The reasons for that success are that Beardsley once more functions as critic, cutting through the gloss of chivalric and courtly values to expose the violence and sexual aggressions beneath the text; through a few tense drawings, the images of Tristram and Isoud, and of the adultress Queen Guenevere, but more particularly through the riot of line, the explosion of forks, orifices, nipples, and fruitlike bums in the drawings that only glancingly allude to the text. Nature in borders and chapter headings erupts with a self-circuiting energy that spats in monsters: hermaphrodites, satyresses with cleft feet and legs that are scaled like those of locusts and mantises (bk. 4, chap. 13): twynatures that are no nature; sphinxes with the beaks of predators. The human constantly melts into the animal: a boy with horns; while armor, the strong but delicate idiom of knightly identity, is no longer an artifact; the human skin has scurfed into the scales of reptiles and insects. There is a smear of schoolboy naughtiness in the gallery of genitalia, of swollen and aggressive stamens and pistils, but more that is purely programmtic. Nature in the world of these drawings is a font of copiousness and frustration, and what is unsatisfied constantly transforms itself into monstrous modes as in the hermaphrodites, gynanders, and other creatures of dubious gender. Put in this way the images perhaps seem more savagely sensational than they actually are, but read in sequence and slowly the effect becomes cumulative.

Bon-Mots

The miniature series of books issued between 1893 and 1894 decorate an anthology of the sayings of various wits of the late eighteenth and earlier nineteenth century: Samuel Foote, Richard Brinsley Sheridan, Charles Lamb, Sydney Smith, and Theodore Hook. It was a text toward which Beardsley was probably sympathetic. Here the pursuit of fortuity in the contour of casual blots and squiggles combines with Beardsley's vivid gift for the grotesque to produce astonishing images that parody past styles of art and dress and look forward to twentieth-century modes. The drawings embrace a wide variety of styles and subjects and some are repeated. In reproduction they are nearly all reduced, which may perhaps have blunted immediate adverse reactions from the public at the display of fetuses, pierrots, monsters, almost surrealist fauna, and even drawings that have no counterpart beyond those drawn by patients in a condition of schizophrenia or the laby-

rinths of *anamorphosis*, where (as is frequent in Beardsley's art) the angle of view determines the meaning. A sense of sinister humor and mystery pervades these decorations; indeed, many operate as emblems requiring and at the same time defying interpretation in a way found elsewhere in the oeuvre, but never perhaps at such an extreme and so consistently.

There is, for example, the much reproduced drawing in which a middle-aged woman in Pierrot outfit presents a frowning fetus with a clawed foot to a malign fur-coated figure with hair held back by bandages or by the windings of a corpse and with some hairy object, an abortionist's instrument or displaced phallic symbol, protruding from a pocket. A candle with flame pointing toward the donor repeats the phallic imagery. This was presumably drawn in the second half of 1893 and parodies Beardsley's own "Merlin Taking the Child Arthur into his Keeping" or the Pre-Raphaelite painter Ford Madox Brown's "Take Your Son, Sir?", just as the famous *Incipit Vita Nuova* parallels the vignette on page 157 of the *Morte Darthur*.

Beardsley's fetus, indeed, occurs even more prominently in the *Bon-Mots* series than elsewhere in his work. Sometimes the fetus has patently been untimely ripped from its mother's womb; elsewhere it grins in superior malice; its head elsewhere is linked to the outsize body of an old maid, or it survives to go out into the world and exist dandiacally in evening dress and with a minute cane. Or as a symbiosis of putto and fetus rides the arched back of some feline creature, while a Pierrot whose uniform is marked by Beardsley's personal emblem offers a quill pen and a butterfly attaches itself to the extended left arm. One fetus with serpent tongue sits on a stem while the stylized flower acts as ritual candlestick. Even Beardsley's troubling hermaphrodites are derided. One Pierrot has to make do with two heads, one mounted on top of the other while, in another image, a body blossoms into three heads including one that in this tricephalous carnival replaces the belly.

Other images present bodies as giddily fluid: Noses are streaked with eyelids and with eyes; fingers melt into antennas; breasts and vulvas catch at any exposed surfaces like jumping cactuses or suggest the terror of the *vagina dentata* in D. H. Lawrence's "beaked sex," all lit by the fear of castration. Women flick long serpent tongues; a devil in evening dress wears a top hat, pigtail, and black gloves. Another figure usurping a whole page holds a dripping, severed head, a parody before the fact of "J'ai Baisé Ta Bouche, Iokanaan." Reade has detected Japanese influence and the mark of the French poster artist Jules Cheret; and more significantly reminiscence of Odilon Redon, an artist

of nightmare, whose huge spider is reproduced in "La Femme Incomprise" of slightly later date. Beardsley may not have allowed himself to see visions except on paper, whereas Redon leaves the impression of recording bad dreams, but here if anywhere the images seem to rise from masked anxieties, yet their projection is typically wry and ironic.

Allusion to other artists occurs: a costerlike figure in both subject and manner is pure Phil May; a Burne-Jones angel buds into demonic wings; and one girl in profile has touches of Kate Greenaway. A further fetus image, shaped like a prawn, coils into a serpent sting, the flat top of its head ending in what Reade terms a "corbel." Over all, the effect here is queerly art deco. And on the plateau of the head a skeleton waves an aesthetic peacock feather at a Whistlerian butterfly, cooling itself or more likely teasing.

With arrant economy the artist sometimes evades any pretence of realism or completeness; elsewhere he offers what Reade describes as "a doodle on the lines of least resistance."[10] The knotted swan (or, according to Reade, goose) neck, noted already in the *Morte Darthur* ending in a peacock's head, possesses a female torso. The feet are "evaded," the single arm ends in Beardsley's initials surmounting three dots, while the legs falter away in a double clef and a shape that echoes the twist of the neck. What appears to be a caricature of a naked Max Beerbohm, with batlike wings, a minuscular top hat and high-heeled shoes, leads a dog covered with a coat and reminds one of Max's own caricature of Beardsley. As in a nightmare, the imagery of the many cultural forces that shaped Beardsley's art present themselves in unexpected, mysterious, and sometimes horrifying forms. A head on a sunflower stalk with disks functioning as breasts has Whistler's butterfly hovering beneath to seek sustenance; a figure with female breasts is supported on a walking stick and with dog legs and a short tail and jutting lower lip, an uncontrollable architecture of breasts and nipples bulging at all points of the head.

Many of these grotesques appear to be caricatures, though some of the allusions remain obscure, but more are transmitted vividly, like the cross old topographical sun whose flames have been replaced by flailing sidebeards. Beardsley's wit attempts to overgo the sometimes rather stolid wit of the texts on the first page of the volume: three characters drop asleep to the vast annoyance of the Pierrot lecturer, presumably anaesthetized by the rival efforts of Foote, Lamb, Jerrold, and company. The Pre-Raphaelite models generally gaze fixedly into the distance, and although obviously frozen in some historical or myth-

ological tableaux especially constructed for the spectator, the specta-
tor's presence is never anywhere acknowledged. The atmosphere that
results is a strange and often absurd vacuum. With his ushering and
bowing showmanlike figures, borrowed from an alien culture, Beards-
ley injected the vigor of an essentially theatrical vulgarity into his art—
a concession to the audience perhaps, but one that avoids condescension
or sentimentality because of an intimidating strangeness. The *Yellow
Book* style in which this effect is most developed occurs in embryo, we
might say, in *Bon-Mots*, most elaborated here in the two excellent black
and white framed drawings and the café scene of the fat woman, where
Beardsley's ironic vision is recognizably directed to contemporary life.
The Pierrot costume itself seems to inspire some of the artist's finest
lines, unlike the experiments in calligraphic doodling which, though
interesting, constitute something of a blind alley.

A great part of the delight one gathers from a Beardsley drawing,
so obvious it sometimes escapes comment, lies in its simplicity, the
sleight of hand almost by which an instantly recognizable form is sug-
gested. A glance at the art of his contemporaries reveals how fresh
Beardsley's approach to illustration was. For decades draughtsmen had
slavishly established form by the modeling of light and shade with pen
strokes that evoked the lines of engravers. What this involved, of
course, was the extinction of line and contrast, so that we often per-
ceive a gray field from which the forms only slowly emerge. More
perhaps than *Morte Darthur*, the *Bon-Mots* represent a significant step
in Beardsley's art. This partly rises from his complete liberation from
his text, though there is no reason to suppose he was completely bored
by the wits. The return, however, to the "hair line" mode of "Siegfried,
Act II" may seem to cast doubts on the graphic presence of these
drawings.

The *Bon-Mots* series encouraged Beardsley in his habit as a "deca-
dent" illustrator; but they also permitted him to make a crucial dis-
covery, profoundly un-Victorian, profoundly liberating, manifested in
those images: the link between the grotesque and the erotic. His reper-
toire of images is extended, and we can recognize a number of antici-
pations of the next phase of his career.

Chapter Five
Salome

The suite of drawings illustrating Oscar Wilde's *Salome*, in its English version of 1894, are the most famous, arguably the finest, of Beardsley's designs and have had the most influence on subsequent artists and on the popular image of Beardsley. In these drawings he effectively combines earlier styles and borrowings, moving beyond imitation of Japanese conventions, and strikes a really original vein in his genius by abandoning in many cases a ground or horizon; as Haldane Macfall puts it: "groundless earth, the floating figures in the air, the vague intersweep of figures and draperies, the reckless lack of perspective."[1] A world, indeed, without reference to any objective reality. The draperies of the figures flow out like the peacock feathers in the *Morte Darthur* right beyond the picture frame. As Lord Clark pointed out, Beardsley comes near to abstract art in certain of the *Salome* illustrations: areas of black and white and long clean curves celebrated apparently for their own sake.[2] The earlier fine line, even the bristle hair style of "How King Arthur Saw the Questing Beast" and the *Bon-Mots* vignettes, designed to set one's teeth on edge, no less than the Japanese elements, are effortlessly synthesized.

These drawings dramatize an encouter between two of the determining artistic intelligences of the 1890s; the two who gave it cultural definition. Yet Wilde is reported to have had equivocal feelings about Beardsley's interpretation of his play: "I admire, I do not like Aubrey's illustrations. They are too Japanese, while my play is Byzantine."[3] Wilde's dubiety, the presence of caricatures of him in the drawings and what appears to be a general irrelevance to the text, has resulted in an orthodoxy of misunderstanding about the relation between Beardsley's images and Wilde's words.

Broadly there are two traditional arguments. First, that the drawings are parodic, mocking, satiric. Second, that they are purely irrelevant, ignoring the text, and by implication the artist regards that text as trivial, unintentionally comic, or, as Lord Clark puts it with fine

aristocratic bluntness, "rubbish."[4] Both views can, of course, be combined.

That the first argument was formulated as soon as *Salome* appeared may be gathered from an acute and malicious contributor to the *Saturday Review*:

Mr. Aubrey Beardsley is a very clever young man, but we cannot think that his cleverness is quite agreeable to Mr. Wilde. Illustration by means of derisive parody of Félicien Rops, embroidered on to Japanese themes, is a new form of literary torture; and no one can question that the author of *Salome* is on the rack. . . . Mr. Beardsley laughs at Mr. Wilde. . . . Let us turn to the "Toilette of Salome" . . . no wonder her conversation has an irreligious effect on the Tetrarch. But what a fantastic way of illustrating a Biblical Tragedy! We should like to test Mr. Aubrey Beardsley's *bona fides* by entrusting the *Athalie* of Racine to his care. Would he play the same pranks with *Samson Agonistes* as with *Salome*?[5]

Salome is not a biblical tragedy exactly and certainly not one in the sense of the other works adduced.

In 1905 Arthur Symons observed that none of the drawings seem to have any relation with the title of its subject: "its relation was of line to line within the limits of its own border, and to nothing else in the world."[6] And eight years later Holbrook Jackson, in what remains one of the authoritative works on the 1890s, draws the conclusion that "the Salome drawings seem to sneer at Oscar Wilde rather than to interpret the play. . . . Beardsley's designs overpower the text—not because they are greater but because they are inappropriate, sometimes even impertinent."[7] And in 1948, in the introduction to his collection *The Best of Beardsley*, R. A. Walker observes that "to the clear sighted Beardsley, it can be pretty well assumed, the poverty of the play was obvious from the start. Wilde himself, and the characters are gently derided throughout his astonishing designs. Never had a book been so illustrated with such irreverent and irrational drawings."[8] Walker slightly hedges his position by the use of "gently" and "assumed" but quite ignores Beardsley's admiration for Wilde's first, French version of the play that prompted the drawing "The Climax." Other critics know not seems: Brigid Brophy in 1968 closely echoes Symons but now applies the principle of the autonomy of the image to Beardsley's work in general: "The tension that dominates all Beardsley's compositions is entirely in the design or the medium. None of it is borrowed

from the incidents and still less the characters of any story he may adopt."[9]

Most criticism up to the 1970s echoes these judgments: the historians repeat one another; art criticism is merely circular. A last example may be given that manages bluntly to conflate most of the received opinions before 1972: Malcolm Easton in *Aubrey and the Dying Lady* asserts that "The embellishments he produced were almost totally off the point. But this disregard for the text ensured the preservation of [Beardsley's] artistic integrity."[10] Notions about Beardsley's low opinion of the play are without documentation and are if anything contradicted by evidence outside the actual drawings. Beardsley, for example, proposed to translate the French.

Since Easton's time, some hesitant protests have been heard. James G. Nelson in his admirable *The Early Nineties: A View from the Bodley Head* finds that Beardsley's art is "a perfect complement to the text . . . expressive of that same sense of strange beauty which Wilde's Salome and John embody."[11] Brian Reade observes that Beardsley seldom illustrated anything literally, rather, he made graphic comments on the text, and in the *Salome* drawings the artist immortalizes "those strains in the play which the author shared unconsciously with its illustrator."[12] What those strains are we are not told, and the comment, though just enough, does not perhaps sufficiently accent the degree to which Beardsley's art is both interpretative and critical, the one depending on and governing the other. A proper account of the illustrations must pay equal attention both to the text and to the designs. Two recent accounts enable us to do precisely this. Rodney Shewan in *Oscar Wilde, Art and Egotism* describes the heroine as "the supreme egotist of a cast imprisoned by indifference or introspection," and Elliot L. Gilbert in "'Tumult of Images': Wilde, Beardsley, and *Salome*" argues that in the 1894 volume we see "not the unfortunate dissociation of literature and art which has so often been alleged, but one of the most successful collaborations of poet and illustrator in history."[13]

Gilbert's argument begins with the claim that *Salome* itself "has its mocking and parodic elements."[14] And he quotes both Holbrook Jackson and Mario Praz to the effect that the effect of Wilde's play is humorous and preposterous in its keying still higher the shriller elements in the European decadence. A review of Wilde's French version of the play made the point: "If Flaubert had not written *La Tentation de Saint Antoine* [The temptation of Saint Antony]—above all, if Flaubert had not written *Herodias*, *Salome* might boast an originality to which she

cannot now lay claim."[15] But where the reviewer saw this as a defect, the modern critic recognizes it as a typical decadent procedure, one that Wilde intended and, it is the hinge of Gilbert's argument, one that Beardsley himself recognized for it was identical with Beardsley's own procedures with the Pre-Raphaelites, the Japanese, with Whistler, and other aggressive influences (though that may seem an odd epithet to impose on the attenuated images of Burne-Jones).

"*My* Herod is like the Herod of Gustave Moreau—wrapped in jewels and sorrows. *My* Salome is a mystic, the sister of Salammbo, a Saint Therese who worships the moon." Sir William Rothenstein, who reports the comment, continues, "Wilde knew at once that [Salome] put me in mind of Flaubert. He admitted he had not been able to resist the theft." "Remember," he said, "dans la littérature il faut toujours tuer son père" (in literature it is always necessary to kill one's father).[16] Harold Bloom could hardly have said it better. One kills one's father by overkilling him. However, at this point we might rehearse the history of Wilde's one act play and then look cursorily at his sources.

The Two *Salome*s

Wilde wrote his play in 1891 in French. There are three manuscript versions and from these it emerges, first, that Wilde actually wrote it. There has been a curious, grudging, and continuous refusal to admit this on the part of literary historians. Three of Wilde's French friends— Pierre Loüys, Alphonse Retté and Marcel Schwob—did indeed read through the play and suggested verbal changes here and there; some of these Wilde accepted, most he did not. Wilde possessed a keen control of colloquial French; but his French was thought to be too colloquial by his French friends. The Academy never sleeps in France. Gilbert, however, like most other critics, speaks of Louys assisting Wilde with the French of *Salome*,[17] a judgment simply not supported by the manuscripts. Second, the genesis of the play was the episode between Salome and the severed head, precisely that which Beardsley's first illustrated: "J'ai baisé ta bouche, Iokanaan, j'ai baisé ta bouche" ("I have kissed your mouth, Iokanaan, I have kissed your mouth"). In the Bodmer Library manuscript of the play, the earliest fragments focus on just this passage. The play was published in its French version in Paris in 1893, and Beardsley after reading it expressed his admiration by the drawing. He was invited to furnish illustrations for the translation that appeared in the following year. The name of the translator of the 1894

volume is given as Lord Alfred Douglas, Wilde's lover; however, Douglas later stated that the published translation was not his, but Wilde's, who had severely revised Douglas's version.[18] Both the sources adduced to make this attribution are highly suspect and in the absence of evidence it is probably better to take a middle course and assume that the translation is indeed Douglas's lightly touched by Wilde. The colloquial element in the French largely disappears in the English, which is unable to escape the hypnotic parallelism and archaism of the King James version of the Bible, a style that is also affined to the Wildean parody of Maurice Maeterlinck's lisping repetitions. The palimpsest effect (rather less dense than supposed) serves the main theme of the play: solipsistic isolation and self-reflexiveness.

An account of Wilde's play must begin by relating it to Wilde's intellectual history, and we may begin with a quotation from his "The Decay of Lying". "Try as we may we cannot get behind the appearances of things to reality. And the terrible reason may be that there is no reality in things apart from their appearance."[19] And as Gilbert reminds us, this must take us back to the first and indeed pervasive influence on Wilde, Walter Pater's *Studies in the History of the Renaissance*, patently in the famous "purple panel" that evokes Leonardo's image of La Gioconda, with its mention of "strange sins." Even more pertinent is the equally famous "Conclusion":

If we continue to dwell in thought on this world, not of objects in the solidity with which language invests them, but of impressions . . . which burn and are extinguished with our consciousness of them, it contracts still further. . . . Experience . . . is ringed round for each one of us by that thick world of personality through which no real voice has ever pierced on its way to us, or from us to what which we can only conjecture to be without. Every one of these impressions is the impression of the individual in his isolation, each mind keeping as a solitary prisoner its own dream of a world.[20]

The objects which are terribly only appearance may well include the self since the self cannot be verified by any objective test: "About [the] implications of the conclusion, Wilde was deeply ambivalent, pleased at the opportunities such a premise gave him to attack conventional behavior of all kinds, but horrified at his recognition that a universe in which we can hear only our own voice, in which actions evoke no external responses, is necessarily without consequence or meaning . . . in *Salome* we have a veritable taxonomy of solipsism."[21] The whole cast

is imprisoned in indifference or introspection and indeed the heroine is the supreme egotist. The theme is that of self-created reality, and at the very onset of the play this is accented by the discussion of the moon, which exists only as imagined by the persons of the drama and in the glare of their obsessions. *Salome* presents a chain of relationships demonstrating this solipsism: the Page's homosexual devotion, for example, to the young Syrian Captain, which Gilbert describes as a form of masturbatory self-love;[22] the Syrian's self-absorption, his narcissistic worship of his own image, and his suicide; Herod's paranoia; the prophet Iokanaan's physical and psychological imprisonment in his Pateresque solitary prison, the underground cistern, projecting his sexual panic on to the world and bringing about the death that he himself predicts; Herod's fratricide, the incestuous marriage with Herodias, his brother's wife, and his equally incestuous infatuation with his brother's child; the virginity and narcissism of Salome herself; the cannibalism of her passionate address to Iokanaan: "I will bite your mouth as one bites a ripe fruit."

The style of *Salome*, with its biblical cadences and parallelisms, the echoes of Maeterlinck's hypnotic repetitions, build self-reflexiveness into the body of the play. The nature of Wilde's world in *Salome* is indeed close to the visual world that Beardsley aimed to present in his images. Reade tells us that the artist was devoid of "an extraverted power of observation. . . . The first word that suggests itself in the context of his graphic art is Ideal. He had not been trained . . . in a long grueling process of observation, comparison, and the rationalization of what he saw before him."[23] Like Iokanaan, in Wilde's drama, Beardsley can "see" because he does not "look."

Beardsley recognized the autobiographical element in Herod particularly, but also in *Salome* as a whole. Given Wilde's premises, "the writer's mind" had to be "the true theatre in which the drama is being performed."[24] The caricatures of Wilde then move beyond mere lampoon to incisive comment on the implications within the play. Here, as in his more successful works, Beardsley is both interpreter and critic.

Was Beardsley indeed aware of Wilde's killing and indeed overkilling those, particularly Flaubert, who had touched the Salome story before him? and does the artist himself kill or overkill the author whose play he illustrates? Does Beardsley kill his father, too? To answer such a question, we must look at Beardsley's sources and probe Wilde's comment about Beardsley's images being too Japanese and quite devoid of the "Byzantine" element in the play.

Certainly Japanese influence on Beardsley was still distinct in 1893–94: we have only to recall "The Birthday of Madame Cigale" or the frontispiece to *The Wonderful History of Virgilius the Sorcerer of Rome* of about November 1893. Here peacocks, spermatic forms, and vulvas bud on the sorcerer's robe, and there is no doubt that Roman Virgil, Virgil in medieval myth, and the Japanese style itself are all being travestied. The London Japanese style is the target for satire, and Beardsley may of course be seeing the theatrical exoticism and demonism of *Salome* in a similar light. Virgilius, however, carries the neo-Japanese idiom even further than the images of *Salome*.

Beardsley and Moreau

By "Byzantine" Wilde presumably meant the exoticism of what the Victorians regarded as the frozen decadence of the historical Byzantium, a post-Gibbonian view. What might be regarded pejoratively ensures availability to the late Victorians as a symbol of the perfected city of art, the "life-in-death" of the sacred image, visual or literary; a clear analogy with W. B. Yeats's use of the term "Byzantine." Wilde intended an allusion to the most remarkable visual images of Salome available to the 1890s, those of the French painter Gustave Moreau (1826–98). Wilde knew about taste and its history, but what he knew of painting was strictly limited, as Whistler did not fail to remark, and his knowledge of Moreau was largely through *literature*, through Joris Karl Huysmans's eloquent descriptions of Moreau's Salome in *A Rebours*, possibly *the* book that poisoned the soul of Dorian Gray, and in *L'Art Moderne*. Had he known more of Moreau, Wilde would have known that the French painter was among Beardsley's sources, and in the *Salome* drawings in particular. Moreau was part also of the pantheon of the third generation of Pre-Raphaelites, and Beardsley's attitude to him was doubtless the same as his attitude to Burne-Jones, "creative swerve" in Harold Bloom's famous phrase.

What Beardsley took and distorted from Moreau was the notion of confrontation, and particularly confrontation between dominant female and androgynous male, expressed by a conflict of eyes. In such images as the Oedipus and the Sphinx (deriving from Ingres, but with a violent change of mood) and the Jason and Medea, Moreau shows us confrontation between forces of life and death, construed as male and female and finally as good and evil; confrontation in terms of arrested glance and profile. Numerous Moreau's images represent the defeat of

the male principle by the female, while the male assumes androgynous and the female virile characteristics. Salome the dancer was one of the painter's obsessive themes. Perhaps the most remarkable confrontation is *L'Apparition*, which however renders the conquest of female evil fluidity by male spiritual stasis. The differences between Moreau's image and those of Beardsley are, of course, obvious. Beardsley's economy of black and white sharply contrast with Moreau's "necessary richness": the altar piece and the effects, courtesy of Rembrandt van Rijn, while the stifling opulence of Herod's court, with all its accessories of dress, jewelry, architecture, and sculpture, is close to the atmosphere of Wilde's text. Salome's body is a reliquary, a holy ceremonial object. However, she is cold, without immediate sexual attraction, and with muscular arms. Beardsley's Salome (particularly in "The Stomach Dance") is also unattractive, and in other images has virile characteristics. Moreau's Salome is also a sacred enchantress, and the eye-shaped locket dangling from one of her bracelets represents the evil eye, capable of damning the object of its gaze; it partly explains the spell she casts on Herod and may be analogous to the manner in which Iokanaan in Beardsley and in Wilde attempts to avoid Salome's gaze, though Herod, of course, seeks it. There are numerous emblems here that do not connect with Beardsley's images, but in one of Moreau's Salomes the image of Diana of the Ephesians, fertility and the moon, connects with Beardsley's Salome by echo of hand movement and also with the role of Wilde's Salome as surrogate of the moon. Wilde was initially of opinion that Beardsley had captured the cold ritual icon of *Salome* when he inscribed a copy of the play to "Aubrey" who has seen "the invisible dance," the Ideal, that world beyond all contingency both dramatist and artist desired.

In this suite of drawings, Beardsley evades solidity and modeling. This originality lies not only in not looking, but in the short cuts he took through naturalism to create a self-subsistent world. The obverse of this eliding is the entry of symbolism, another feature that aligns him with Moreau, and symbolism is by nature ambiguous; in Beardsley's case ambiguity of technique supports ambiguity of meaning.

The principal images of the play certainly appear in the drawings and in that suggestive and deliberately adiaphonous mode of the symbolist movement to which both Moreau and *Salome* themselves belong: the moon, the kiss, the roses, the severed head. W. Graham Robertson in his memoirs *Time Was* (1931)[25] recalls a discussion with Wilde about his plans for Sarah Bernhardt's proposed production of *Salome*, a pro-

duction that the examiner of plays in the Lord Chamberlain's office proscribed. Wilde had in mind several integrated color schemes for the set and even suggested introducing perfumes on stage: a new perfume to correspond with every new emotion. It may be that some of Beardsley's images—"The Stomach Dance," for example—subvert the possibilities of the *symboliste* theater, but his other illustrations acknowledge the notion of unifying an audience and its response through union of the arts.

By stressing symbolism, though, there is perhaps some danger of ignoring Beardsley's own association with and predilection for the real theater, not simply the theater of the mind. Just that sense of theater is evident in the themes he chose to illustrate. In "The Dancer's Reward," "The Woman in the Moon," and "The Climax" he captures a moment of "paroxysm" quite beyond Moreau with his deliberate cultivation of "inertia" in confrontation.

Confrontation is largely through eye-contact. "Looking" and "seeing" determine the action of Wilde's play. To "look" is to wish to "see" the beautiful and sinful and possess that. All the characters (with the exception of Herodias who has passed beyond "looking" and "seeing" and who in Wilde's terms is "pure rationality") are united by the desire of looking and seeing. The Page is in love with and "looks" at Narraboth, the Syrian Captain; the Syrian Captain is in love with and "looks" at Salome; Salome falls in love with Iokanaan or John the Baptist and looks at him; John "looks" at himself, sees God, and refuses to "look" at Salome; while Herod "looks" at Salome, his stepdaughter inflamed by her adolescent charms. Virtually all the characters "look" at the moon, that dominant and pervasive symbol for Salome, and each "sees" something different: a yellow-veiled Princess, a drunken harlot, a corpse-like revenant. Herodias sees merely—the moon, though in a canceled passage she speaks of an "exhausted torch" and "a dead world." The act of looking reveals not the object only but the person who looks. John refuses to look at Salome; he descends into the darkness of the pit and denounces woman, quite in the spirit of those Fathers of the church for whom woman was at best "a desirable calamity," at more times the literal and figurative "gate of death," accomplice of the Evil One: "a temple built over a sewer." Salome looks where she will, and she "sees" John. Though she nominally dances for Herod and at her mother's instigation asks for John's head as her reward, it is actually John at whom her dance is directed, even though he cannot see it, and the rustling nebula of her veils, she hopes, is

sufficient to stir his senses. Herodias rationalistically avoids "seeing"; Herod finally sees too much and begs for darkness, and John dies apparently content at his own decollation. Salome goes beyond all the other figures of the drama "looks," "sees," possesses the head of John and achieves some species of consummation. But like Narraboth and John and, proleptically, Herod, she pays the price.

Beardsley does not then reduce the events of the drama to literalism; he goes beyond them, wittily seizes their implications. The black and white polarity of the play represents an apparent contrast between demonic and chaste, apparent because the white can as easily refer to "whited sepulchre," a disguise for the black particularly in the case of John and his not altogether achieved sublimation: his set speeches about Herodias are choked with sexuality. In the drawings, though, it is unlikely that the black and white have conceptual authority. As to the imagery, the peacock and rose that run through the suite of images, like those of Wilde, may well derive from general aesthetic-decadent vocabulary. The Peacock's connotations of androgyny, display, male aggression, expresses notions central to Wilde though not in a precisely similar manner. The phallic image predominates in Beardsley without authority from the text (though there are phallic suggestions in some of Moreau's architectural accessories).

That the phallic images predominate (however latent some of those may be) in the illustrations is Beardsley's gesture toward bringing to light what is the underlying theme of *Salome*.

Patriarchy, the New Woman, and the Homosexual Dandy

Both Wilde and Beardsley were deeply concerned with a primary cultural issue, one that is still troubling virtually a hundred years after the appearance of *Salome*. During the period of "Decadence"—that is, from, broadly, 1880 to the end of the century—there was a widespread, continuous, and intensifying reaction against high Victorian values. Those values included a determined optimism, a legal system devoted to the maintenance of property and patriarchy, conformity to the social and religious norms, the exaltation of nation, domesticity, the family, and the home regarded as a fortress that both kept disorder outside at bay and kept women inside imprisoned. Such notions can be conveniently summarized by the word "authority," threatened first by revolution, then by the extension of the franchise as far as the un-

hygienic zone of the lower-middle and skilled working classes and finally in 1888 to agricultural workers and the unskilled proletariat. Institutional religion and metaphysical assumptions about knowledge and conduct were also placed on the defensive by the prestige of the natural sciences: Darwin's work could be interpreted in several ways, but in general it was an unsettling activity. The decay of British agriculture, the decline of peasant culture, and the increasing economic insecurity of the aristocracy whose income largely came from land (unless they were clever enough to own property in cities or sites stuffed with minerals). From 1870 indeed the power of Britain was in decline, masked partially by the somewhat frenetic imperialism of the 1880s and 1890s (a substitute religion) but was perhaps subconsciously sensed so that the prevailing moods of the period ran to extremes: cosmic fatigue best expressed by such gloomy Teutonic philosophers as Arthur Schopenhauer and Edouard von Hartmann, whose message to the human race was a recommendation to mass suicide. It is precisely in response to such a gray climate that Wilde and Beardsley elaborated their notions of a self-created reality.

The culture that was being displaced may be described as "patriarchal": male-centered, inflexible, insisting on an unchanging order reflected in hierarchies of ideas, of society, of family: Notions of male primogeniture in title, for example. Aggregation as well as hierarchy was a sign of this culture: horizontality (the sun never set upon the British Empire) as well as verticality. Secession was unthought of, and even the partial divisiveness of Home Rule for Ireland could not be countenanced. In terms of hierarchy, any notion of the equality of women was equally dangerous, and the emergence of the suffrage movement and of what was called "The New Woman" in the 1890s was viewed as a lurid emblem of the possible dismantling of order and authority. "The New Woman" claimed the right to behave like men: to move about unchaperoned, to smoke, to violate the hypocritical double standard of sexual morality, to read and write at will. The particular anxieties about the age may have been conscious and articulate, but the diffused, subconscious, and inarticulate anxieties could only express themselves through symbols, and this accounts for the fact that the romantic image of "The Fatal Woman," older not merely than the rocks but older and more cunning than man, mysterious and destructive, acquired what might be termed a high visibility. Gilbert has summed up for us the pressures that lie behind her epiphanizing: "Authority in the West has traditionally been associated with . . . an his-

torical record, a controlling genealogy, a sense of the world as possessing an objective reality independent of, and more absolute than, any individual. The forces—natural, cyclical, ahistorical, subjective— commonly arrayed against such authority have long been connected with women and with female values, and never more so than during the *fin-de-siècle* period."

For both artist and dramatist this confrontation of man and woman becomes the hinge of their visual and literary argument. The course of the action in Salome clarifies the issue: "*Salome* is essentially a play about power; about who is to have it, who is to exercise it, how is it to be transmitted." Theoretically it is Herod who gives orders in his tetrarchy, but his orders are disobeyed, and from this antinomy between authority and act the drama emerges:

On one side, apparently at odds but deeply conspiratorial, are Caesar and Christ, Herod and Iokanaan, soldiers and Jews. . . . Plainly, it is gender more than any other consideration that determines admission to this establishment; even a despised and rejected prophet is more central to it, is taken more seriously by it, than is the nominally important "Princess of Judea," who, with her mother, represents the opposing side—the female side—in this struggle for power and influence, an embattled patriarchal culture, relying for strength on tradition, on genealogy, on a formal world order, under attack by a corrosive, disobedient, unbridled female sexuality.[26]

Differences between Herod and Iokanaan are superficial. Both are defined by their response to sexuality, though their response differs; both seek strength from transcendental order and the authority of legitimate descent: the order of kingship, the order of prophetic office. Both are destroyed by their weakening of such elements of authority. Herod has killed his brother for his throne and so has fractured the objective historical line of descent that is always a king's and also a patriarchal culture's greatest source of strength: "He thus must fall back on the subjective authority of his own word, which in the end traps him and renders him impotent before the remorseless demands of Herodias and her daughter."[27] Iokanaan, attempting to defend patriarchy against Herod's capitulation to destructive female power, may rely on his legitimacy as a prophet in the succession of Elijah and Ezekiel, but he makes the mistake of supposing that genealogy is possible without sexuality: "that culture can exist without nature." Iokanaan's assumptions must be placed in the context of John Stuart Mill's essay on nature

where the demands of nature are seen to be invariably inimical to culture, and of Thomas Henry Huxley's Romanes lecture on "Evolution and Ethics," which appeared in the same year as the English *Salome* was published and which elaborated further Mill's argument in a Darwinian frame of notions. Like Herod, Iokanaan is rendered powerless by the sexual fury of Herodias and her daughter, representing rejected sexuality and nature. He is ritually emasculated, and "castration and decapitation are the same fate."

Herodias is less sympathetic to Wilde than Salome for she has a public, political motive in resisting Herod and so by antithesis is caught up in the patriarchal power structure: "Salome's strength derives from a wholly apolitical self-indulgence, a total lack of concern for process and consequences. . . . ' *It is for my own pleasure* that I ask the head of Iokanaan on a silver charger.'" This is "a simple gratification of appetite accomplished with all the naive dangerous exhaustion of an animal." Such a self-absorption is "terrible but natural: Terrible *because* natural." It is quite unlike the rational maneuvering of Herodias. Gilbert describes Salome as a disciple of the Pater of *The Renaissance*: she "lives in an eternal present of the sensual (thus justifying Beardsley's anachronisms), existing moment to moment . . . to quote Pater . . . 'simply for those moments' sake.' In so doing, she becomes emblematic of nature and thus an affront to the intentionality, the historicity, the unity of culture."[28] However, as Gilbert notes, Wilde's attitude to order and culture remains ambiguous. On the one hand, he views his role as that of court jester, providing a Falstaffian All Fools' Day element to leaven middle-class values, and he was fascinated as well as repelled by the high society of his own day. But he did not follow the logic of his Falstaffian role to its end: the role does not furnish refreshment to the social order it challenges, but tends to the destruction of that order. Beardsley was less ambivalent than Wilde about the cultural establishment, but he too wished to be accepted as an artist in a not unconventional sense. His time, though, was, as he knew, to be brief, and he had to posture and to shock more violently than Wilde in the hope that his emaciated Falstaff would by a blaze of academic respectability turn into a King Hal. Wilde's pervasive tone, though not in *Salome*, is cajoling; Beardsley's is ruthless. Both attack the distinctions of gender. This blurring of gender distinctions can be read as a programmatic undermining of legitimism of power through male descent, primogeniture, and in a wider sense a solipsistic blurring of the "objective reality" of hierarchy and order.

The climax of *Salome* ascends through four episodes. Three are illus-
trated by Beardsley. These episodes are Salome's Dance of the Seven
Veils; the decollation of Iokanaan; Salome's holding and kissing the
head, her moment of orgasm; and Herod's command that his step-
daughter be executed. Herod's action is not a consequence of Salome's
overt murderousness and necrophilia but what is implied in her behav-
ior: the direct attack on the mediating function of culture and art. The
Platonic objection to art of the *Republic,* book 10, was renewed in the
nineteenth century by groups as varied as the utilitarians, the evangel-
icals, and the positivists: "a philosophy which asserts the objective real-
ity of the natural world and treats symbols as mere reflections of
something much more fundamental, the unmediated universe as in
itself it really is."[29]

The dance is connected with the famous metaphor of clothes and its
connection with art: the concealment of language and ceremony as pro-
tection against unmediated nature. Salome chooses to loose her veils to
stem her hunger for "naked unmediated experience": she is by far the
most radical of Wilde's characters in her desire both to "look" and to
"see." But one can only "look" by stripping reality of metaphor, cere-
mony, taboo (the averted gaze or the protective gesture). The alterna-
tive way is to avert one's gaze and "see" by not "looking," to see
the Ideal, the transcendent reality that Iokanaan wishes to perceive
and to make manifest. The irony of one who is a "seer" because he
does not "look," evades direct confrontation with the real world, is the
hinge of the drama. Iokanaan is "literally a mediating figure, prophe-
sying the arrival of yet another mediator, a king coming in the name
of his Father to make intercession, to defeat death through tran-
scendence, a virgin's son who will rescue humanity from a destructive
sexual nature."[30]

Herod obscurely recognizes at the end that transcendence is a defense
of patriarchy against unmediated nature which he has betrayed by
yielding to the absolute sexuality of his daughter, and by such betrayal
he empowers her to realize her own nihilistic ambition.[31] He offers in
the course of attempting to protect Iokanaan his peacocks whose vulval
eyes on the tail feathers are associated with looking and represent there-
fore a sanction for that direct apprehension of nature that the play also
associates with women. He also offers Jewish culture's "ultimate sym-
bol of mediation": the Veil of the Temple. Gilbert points to an ambiv-
alence between Salome as dancer, as "artist, a participator in culture
and Salome who, as remover of veils, is the enemy of that same art and

culture, single-mindedly pursuing pure experience, seeking what she has called 'her own pleasure.'"[32] Dropping the last of her veils, the girl advances to embrace "the mystery of death" and "the mystery of love" which she is now enabled to confront directly for the first time, mysteries that reveal themselves in the climactic moment of the kiss in a preternatural silence beyond language, "certainly beyond the elaborate metaphors with which she has habitually clothed the prophet, but which have now, like her veils, all fallen away":[33] "In her dance, Salome is both unveiler and unveiled, both seeker of a unmediated nature and her self the embodiment of that intolerable reality, fatal whether she looks or is looked at. . . . With the arrival of Herod, [Wilde] invokes a long-standing misogynist tradition of the female body itself as itself the threatening nature that must not be looked upon, that male culture must strive to conceal . . . the extraordinary value such culture places on the intact hymen as the veil of the sexual sanctuary . . . confirms that in patriarchal society . . . the veiled woman reflects male dread of women."[34] Such a fear is clearly evident in Beardsley's images of Herodias and the Salome of "J'ai baisé ta bouche" and "The Climax," but in spite of the artist's recognition of the thematic ironies of the play, his image of the dance is eccentric.

Gilbert's reading of the play develops beyond the feminist interpretations of, say, Kate Millett (who views *Salome* as embodying the homosexual dandy's fear of the virile woman and therefore as marginal to the patriarchal-feminist struggle). And it is certainly richer than the familiar reductive equations of the Freudian response.

Language, Silence, and the Dance

In the original, Iokanaan's denunciations are appropriately couched in the lyric parallels of sacred language while Herod's catalog of rarities is also beyond the spoken norm. Much of the other prose is contemporary and even colloquial if eccentric. Direct translation was probably not the best manner of rendering its Fr-Irlandais (The Franco-Irish) quality. Second, *Salome* is the first symbolist drama in English literature, even though it transgresses the canons of that species as practiced by Wilde's contemporary Maurice Maeterlinck and presented theoretically by Arthur Symons. The aim of the symbolist was, as Symons puts it, to evade "the old bondage of rhetoric, the old bondage of exteriority." Dramatic speech was intended to break down formal language and to stifle or suspend rather than to com-

municate thought. More positively, it attempted to create isolated movements that were to represent the pure emotions of the soul in *tableau-vivant* form, not movement in action, but in thought and feeling. Maeterlinck, particularly in his early play *L'Intruse* (The trespasser), presents symbolist drama at its more pure; a drama of active silence where dialogue exists, if at all, to disclose the subconscious, the spiritual force within the individual. Tension in such drama consists in "suspense," in waiting, in mounting expectancy, in subtle diminutions and renewed expectancies. Characters echo and reecho one another, suggesting that the characters are void of moral as well as physical progression. The invisible, the spiritual, death, for example, does not appear in emblematic form; its approach is sensed only by its effects on surrounding objects.

Maeterlinck's influence on Wilde is patent: the structure of *Salome* is musical with the moon in particular as leitmotiv; each event leads organically, inevitably, to the next; each is only relevant in the context of the whole: the characters appear to be puppets whose language and action are repetitive. The reflexive actions involve the Page (who desires Narraboth); Narraboth (who desires Salome); Salome (who desires Iokanaan); Iokannan (who desires God) are finely replicated in the second part of the drama that brings relationships between Herod (desiring Salome), Herodias (desiring no one), Salome, and Iokanaan to their crisis. The characters are types (Herod as wicked biblical king), Salome and Herodias (women as death-bringers), Iokanaan (seer) deliberately dissociated from quotidian reality; the action in spite of the typology takes place in a world unweighted by history.

The speakers' attitudes to the moon define their personality and the moon itself is transformed by interpretation, which in turn hints at the outcome of the plot. The color of the moon changes from pale to blood-red. The page sees the moon as predatory, "thirsting for death"; Narraboth as "a Princess"; Salome as "a virgin"; and Herod as a prefiguration of Salome: a madwoman seeking everywhere for lovers—"she is naked too." Iokanaan views the moon apocalyptically: the sun blackened, the moon like blood, while for Herodias, type of a positivist rationality, quite simply "the moon is like the moon." The tetrarch Herod's superstitious fear of the Prophet is emblematized by the Prophet's imprisonment below ground in a cistern. After cajoling Narraboth into letting her "look" at the Prophet, Salome lusts after his body, idolatrously worshipping it. Narraboth is appalled and

kills himself. The second "movement" begins with the entrance of
Herod and Herodias. When Herodias says to Herod, "You must not
look at her [Salome]! You are always looking at her," this precisely
repeats the Page's opening words to Narraboth, but the words also
point to the disbalance in Herod's mind. Formerly he has held con-
science, lust, spirit, and body, Iokanaan and Salome separately in
tension, and he now repeats Iokanaan's words about the wing beats
in the air. The tetrarch has already slipped in Narraboth's blood
but cannot read these omens. At this point Herod asks Salome to
dance, giving his word that he will offer her any gift that she de-
sires: his lingering depictions of his peacocks and his jewels freeze
the action and are a little embarrassing as too ostensibly Flau-
bertian, though clearly a parody of St. Anthony's temptations is
intended.

The Sacred Dance

Among the roles of the solitary dancer is union with God, "empty-
ing oneself out," and this was often the preliminary to the eating of
the flesh and the drinking of the blood of a sacrificial victim, recalling
Salome's urge to bite John's flesh as she would a ripe fruit. The sacri-
ficial victim represents the God to whom the sacrifice is offered, and
by receiving the God into oneself, one becomes identified with him.
The dancer rotated round a sacred object, in this case the body of
Iokanaan, and it was also customary for a bride to perform her dance
before the king. Salome is a priestess of the moon, and the moon pre-
viously half occulted blazes out when she achieves union with Iokanaan
and with the Moon Goddess in what is finally a junction with the
superlunary being of whom Iokanaan, in Salome's eyes, is the embodi-
ment. Herod prays for the moon to be covered; but Salome has found
that love has the "aise saveur" (the acrid taste) of the paradoxical kiss,
but she has had her will though without union with essence. As she is
irradiated by a white stem of moonlight, Herod orders her death: no
longer as Salome, princess of Judea, but "that woman," a distancing,
a relegation below her old status in the patriarchy.

The Drawings

Beardsley chooses the principal scenes for illustration (excepting of
the death of *Salome,* alluded to in the *cul de lampe*) that a conventional

draughtsman of the period might well have chosen. Second, Alan Life points out that "The illustrations, though arranged in a reasonably sequential order, have been almost arbitrarily placed throughout the volume; after 'The Eyes of Herod' the plates are invariably positioned eight pages apart and if the text opposite each bears any relation to it, this is certainly not the publisher's fault. In fact, only the final drawing 'The Climax' has been aligned with the passage to which it obviously refers.[35]

There is, of course, nothing unusual in this haphazard arrangement of illustrations; indeed, it actually predominates in the Dalziell gift books of the 1860s, but some relation between picture and letterpress is customarily implied by an appropriate textual quotation and page reference inserted beneath the plate, and no such captions are included in the *Salome*. Instead, they are separately listed on a decorated page, with the implicit understanding that the ten titles provided for them are generally irrelevant, just as the pictures themselves are generally irrelevant to the play.

Some drawings such as "The Black Cape" or "Maîtresse D'Orchèstre" appear to be self-evidently anachronistic. First, we may make the point that only a very gullible reader would take such drawings literally: a distinction can be sharply drawn between anachronism and misrepresentation. However gratuitous some of the designs appear to be, they do not of necessity amount to an attempt to "kidnap" *Salome* from the author or simply express an impatience with the project similar to that Beardsley undoubtedly felt with the *Morte Darthur* illustrations. Beardsley was easily irritated by interference and direction, and we know that he found himself on occasion the middle term in an unresolved argument between author and publisher. Lane was worried about Beardsley's shock tactics: he wished to exploit those, but only up to a point; while Wilde, regarding himself as a contemporary *arbiter elegantarium* (judge of tone and taste), doubtless made positive suggestions that infuriated the artist as much as the commercial prudence that dictated Lane's more negative interventions. Still the "irrelevant" drawings can as easily be accounted for by Beardsley's recognition of the modernity of Wilde's theme and the sempiternal nature of the Fatal Woman, an image independent of the imagers, autonomous. "Maîtresse D'Orchèstre" appeared for the first time in the 1907 edition, and "The Black Cape" was substituted for another drawing at the request of the publisher.

The cover design replaced an earlier attempt, possibly, as R. A. Walker suggested, because it was too sketchy. There can be no doubt of what Walker calls "the unpleasant vortex" of art nouveau as an influence: the swirling stems bisecting the feathers extend downward into coiling roots so that the feathers can be read as sperm and those eyed vulvas already discussed.

The Title Page

The title page suggests the complexity of the play's themes. The top right two thirds of the page are occupied by the traditional rectangular Renaissance design revived recently by the Century Guild circle of Selwyn Image and Herbert Horne. The enclosed space contains the title of the work, author, translator "with pictures by Aubrey Beardsley," and details of publisher and place of publication. The remaining space below is taken up by a slender terminal hermaphrodite with horns and wildly distended ears; the eyes are ferally curved upward and outward; the mouth is open preceding but never perhaps overtaken by the rictus of orgasm; the breasts are full and female and, like the Fatal Woman of D. G. Rossetti's poem, "The Orchard Pit" or the woman in Percy Bysshe Shelley's vision, have eyes in place of nipples, while an eye replaces the naval though all three can be read as peacock feathers (compare the rejected cover design). If the smile might suggest orgasm, the penis (in the uncensored version) is barely tumid, so that tensity suggests frustration rather. The truncated hips, line of the lower belly, and the pubic hair seem female rather than male. On either side of the term hang large candles while below an angel with ropelike hair and large insect wings, partially erect penis, and clasped hands, turns his head toward the viewer with a smile of complicity. We are being invited to share some secret rite into which the depraved acolyte has been already initiated. This episode occurs in a tangle of Burne-Jonesian roses, clearly a parodic Earthly Paradise and on lower drawing right hovers one of Beardsley's favored symbiotic emblems, half insect and half bat or possibly Whistler's stinging butterfly. The roses swirl in swags crisscrossed over the breasts of the term and in loops around the head.

The border for the list of pictures replaces the fully frontal hermaphrodite term with a pouting phallic beauty (related to several of later images of Salome), a large bush or roses suggesting a full wig or rococo hat. She is looking over her shoulder half at the spectator, her right

hip thrown out in a gesture faintly reminiscent of the unsatisfied sexual posture of John Millais's Mariana. A long clinging frock envelops her in which we may discern the beginnings of arms; this phallic formation has a pattern of lines and oval blossoms (or insects). A winged hermaphroditic satyr on his knees gives us a slant gaze and points to the woman. We are voyeurs; a drama has already begun.

The Toilet of Salome

There are two versions of this illustration. The first, a hymn to autoeroticism, was censored by Lane and Mathews. Salome in what seems to be a housecoat open along the front is attended by a bald Pierrot with a powder puff. The furnishings—dressing table and occasional table—are Godwinian Japanese and are hunched on the left of the drawing. Salome and her immediate surroundings are established by acute linear economy: she has no legs and sits on vacancy. The young man next to him has the buckling spine traditionally associated with waste of seminal fluid in masturbation and his hands are so positioned as to show him at work once more as he looks at the naked boy who has just entered balancing a tray with a coffee cup and cups at lower right. Salome's hands are also busily engaged like the young man, and the female attendant seems to be readying herself for the solitary act. Beardsley, as feminist criticism has observed, approves of masturbation as an act of self-definition sexually that does not depend on power over another.

The second version of the toilet scene is one of the artist's major images. The economy of line is carried further than in the earlier drawing. The princess is now quite without arms and her dress exists only as a tromp d'oeil: the bald attendant and the Godwinian table are retained but the chair now an essential part of the design is added. The room is otherwise empty and together with the window blinds accentuates the fact that line holds the whole unstable scene together. Salome wears more or less contemporary costuming and her face is shaded by a splendid large hat that to Lord Clark suggests the fashionable concourse at Ascot. Lord Clark continues by defining the "hard edged abstraction" and "the complete exclusion of any . . . conventions or probabilities which [do] not contribute to the essence of the design."[36] The way is clear for Klee and Kandinsky, and an image of Beardsley as a twentieth-century artist imprisoned in the 1890s by an unfortunate chronological blunder.

"The Woman in the Moon"

"The Woman in the Moon," the frontispiece, depicts the opening scene of the play: the Page of Herodias has a shadowy homosexual relationship with the young Syrian Captain, Narraboth, and expresses his apprehension at the portentous aspect of the moon. This relationship is the same in both text and image. The drama of the picture resides in the suddenly frozen gestures of apprehension. With the left arm, the Page tries to protect himself. In the structure of the whole design, these two gestures move against the main thrust, which is toward the moon. The gesture with the left arm suggests also a relationship between the two figures as does the enclosing sweep of Narraboth's robe. In the play, Narraboth with his flutelike voice and Narcissistic preoccupation with his own reflection in the water is effeminate enough, though this does not constrain his passion for Salome. The Page has given him a box of perfumes, an agate ring, and earrings as presents quite in the manner of Oscar's gifts of gold cigarette cases to "renters," male prostitutes, or of Reginald Turner's gifts to Max Beerbohm. After Narraboth's suicide, the Page laments: "Il était mon frère, et plus proche qu'un frère" (He was my brother and nearer to me than a brother). The graphic equivalent of this somewhat ambiguously sexed young man is an androgyne, that is, one whose sexuality is diffuse, does not challenge unlike the monstrously proliferating term of the centered frontispiece. Narraboth has a young girl's hair style, a full somewhat weak mouth, round shoulders (contrasting with the angularity of the page's shoulders), and a skirtlike robe. Such feminine qualities are, however, mainly suggested by one of Beardsley's favored formulas: the Page is naked and clearly male; Narraboth, draped and so possibly female. But lest the viewer might mistake Narraboth for a woman, his sex is betrayed by the bared right chest and the phallic tassel (perhaps brushed against by the Page's protective hand) dangling parallel to the Page's genitals.

This drawing is composed of two segments, fused but in opposition: on the right, the linked human figures, and on the left, the outsize moon whose sinister impact is reinforced by clouds and a sky that simulates its contours. The opposition, therefore, is between the linear (vertical and horizontal) and the circular, that is, a diagrammatic rather than a naturalistic image set in perspective against the environment. The menacing cast of the moon is created by its sidelong look and in particular by the hornlike protrusion above the upper cloud. Much has

been made of the face in the moon as a caricature of Wilde as it doubt-less is; but we should recall Brian Reade's comment that caricature in Beardsley is not invariably hostile. To insist solely on this level is to ignore the ambiguity of Beardsley's art. Malcolm Easton, for example, objects that for Wilde "the femininity of the moon was never in ques-tion. Yet it is the moon which Aubrey turns into a caricature of Wilde himself."[37] But the face in the moon is also very much the face of a woman, and perhaps it was fortunate for Beardsley that Wilde's fea-tures were themselves somewhat androgynous. As the moon governs the action of the play, so Wilde governs like some malign intelligence the moon. And the image furnishes another instance of Beardsley's formula that things above reflect things below; he is constantly secu-larizing and coarsening the spiritual. But the woman in the moon al-ludes also to Salome herself, the moon's surrogate. If Wilde is identified by his green carnation, Salome is identified by the icy rose of her virginity, often, though not exclusively, associated with her. In the text itself, Salome is identified by the page Narraboth, Herod, and by Salome herself with the moon. The moon is used indeed as a species of emotional litmus paper, though Herod's final cry, that the moon is a vessel of blood and asking for it to be blotted out, has an apocalyptic resonance. And with Salome's death, it is blotted out. "The Woman in the Moon" expresses precisely that sense of foreboding that pervades the play and associates Salome with the chaste and destructive moon.

"The Peacock Skirt"

It is typical of the usual loose manner of reading play and image that "The Peacock Skirt" is assumed to be another version of the en-counter between John and Salome, if indeed it has any precise source in the text at all. The ragged bottom edge of the male figure's gown is not precisely desert suiting. It may be a generalized image of en-counter through the eye; but any of the following lines spoken by Salome to the Captain of the Guard would be perfectly apt: "Regardez-moi, Narraboth, Regardez moi" (Look at me, Narraboth look at me); or again "Vous fera cela pour moi, Narraboth" (You will do this for me, Narraboth); or "Ah vous savez bien que vous allez faire ce que je vous demande" (You know well that you will do as I ask).[38] The stage direction "souriant" (smiling) is literally reproduced by Beardsley. In this scene, Salome cajoles and seduces the Syrian Captain into granting her wish to see John the Baptist face to face. Narraboth is torn between

duty and infatuation. In the drawing, Narraboth, if it is he, tries to wrench his eyes away from Salome's hypnotic gaze: "Regardez-moi, Narraboth." This conflict is dramatized by the opposition between, first, the turn of his head and his terrified look; second, by the turn of his body, gesture of his left arm, and the resisting curve of his right shoulder and arm. Salome is aggressively, phallicly, posed in sharp, armless profile, ready to engulf Narraboth altogether. Her enormous, curved and billowing skirt has already enveloped the lower portion of Narraboth's legs and, as subtly indicated by what at first glance might seem a purely decorative line ending in a peacock motif, threatens to swallow him from his knees. The skirt has the usual moon icons. The luxuriant and jagged bristling quality of the peacock motifs in the lower, densely blackened half of her skirt, picked up and partly balanced by her peacock headdress, contributes to the ambiguity of describing male and female "signs." Translated into human terms, the peacock design is an emblem both of the perverse display of the female and the threatened virility of the now unicolored male. No wonder, then, that Beardsley places an emblematic peacock strategically behind Salome, in a backing up role, as insidiously she leans over Narraboth.

"The Peacock Skirt" has been variously termed Whistlerian, Japanese, art nouveau—all of which doubtless it is—to demonstrate the abyss between Wilde's "Byzantine" world and Beardsley's. Stanley Weintraub, however, observes that the texture of the Peacock skirt appears to recall a passage from Joris Karl Huysmans's *A Rebours,* that "breviary of the decadence," where one of the paintings in the hero Des Esseintes's imaginary gallery is a Moreau *Salome.* Moreover, the walls of Beardsley's house in Pimlico, London, "were distempered in violent orange, the doors and skirting were painted black," a color scheme that echoes the color scheme (orange and indigo) of Des Esseintes's rooms in Fontenoy.[39] This again takes us to the complex of associations involved with symbolism, Moreau, and therefore the "Byzantine" element in late nineteenth-century culture.

"The Black Cape"

"The Black Cape," a brilliantly severe design, does not echo the text: it is one of Beardsley's images affected both by the Japanese and by fashion plates, though the familiar roses appear. Walker comments that it is "a clever burlesque on the fashions of the time, when few could see the absurdity of them. The many flounced or caped cloak, the very

small waists due to outrageous corsetting, and the long, wide skirt and numerous petticoats, gave women an odd appearance in the street. Of course only Beardsley would have put in the navel!" As usual Beardsley was attracted to what he burlesqued. This drawing was probably brought in to replace another, and Walker speculates that it might have been intended for some weekly, such as *To-Day*.[40] The necessity for rapidly making up the required number of illustrations furnishes sufficient reason to account for its anachronism; but the deeper reason is, as Gilbert suggests, to connect Wilde's exemplum of the Fatal Woman with contemporary counterparts. The general inspiration though comes from Japanese prints. Like "The Woman in White" the cape and skirt seem devoid of body, and the wedge of hair quite dwarfs the small white hat.

"Maîtresse D'Orchèstre"

The "Maîtresse D'Orchèstre" or "Salome on Settle" in which a large lady, more like Mrs. Marsuple than Salome, presents her back to us was suppressed perhaps because what looks like a baton in her right hand could possibly be interpreted as a dildo, though a rod as emblem of authority is more likely.

"John and Salome"

The powerful image of "John and Salome" was not, for some reason, included in the 1894 edition of Salome, being first published in that of 1907. It represents another confrontation of eyes. Invariably drawn to John, Salome cranes her neck for a closer look: "Il faut que je le regarde de près" (*S*, 28: I must see him close to); she attempts to freeze the prophet with a hypnotizing glare. Her right breast is aimed menacingly at John; her headdress effervesces with moons and horns like a Wagnerian hero; horns that are so shaped as to resemble scythes, introducing the theme of Salome's quest for identification with the moon goddess in her wane and for orgasm through castration of the male devotee of the goddess. Salome's aggression is reinforced by the prick bentwood rosebush that also seems to lean into attack, its thorns and serpentine tendrils paralleling the prophet's allusions in the play to the Fall of Man. The image altogether furnishes an eminent example of Beardsley's ability, as Brophy well puts it, to "tease material out from the image" (that is, the central image) "and spin it into a decorative

setting which because its metaphors repeat those of the image itself, intensifies the image it enshrines.[41] The sinister predatory insect or spider (though it resembles Beardsley's personal image of the navel) crawling over Salome's belly constitutes a metaphor that repeats and reinforces Salome's image as vampire femme fatale, but her mouth open in desire, wonder, and some species of horror is without teeth (contrast this with "The Climax"). As in the "Peacock Skirt," the insect comprises a centripetal image, for Salome's skirt resembles, more especially as her arms are hidden from view, an enormous insect wing.

John and Salome remain frozen in an attraction-repulsion relationship symmetrically represented by the confrontation of profiles and looks and by the incorporation into unity of their robes. The network of images operating in this image is indeed, as in the play, complex. As has been noted, Salome holds up the folds of her dress as if in the act virtually of spreading them like an insect, or a bat perhaps, to envelop the stubborn saint. Contrasting with the folds of Salome's robe is the sharp line of John's emaciated figure. Reade observes that here and there "the lines in the background . . . run through the figure of John, as if his thinness was near to transparency,"[42] enacting the insubstantiality of his fleshy nature. Salome exclaims in the play: "Comme il est maigre aussi! il ressemble à une mince image d'ivoire" (*S*, 27: How emaciated he is! he looks like a slender ivory image). Yet if John stands his ground, he flinches faintly under the onslaught of Salome's seduction, for Beardsley inclines John's body backward a fraction. Further, there is a quality in the saint that responds to Salome, betrayed by his perturbed expression: "Oui est cette femme qui me regard? Je ne veux pas qu'elle me regarde. Pourquoi me regarde t'elle" (*S*, 28: Who is this woman who looks at me? I do not wish her to look at me. Why does she look at me?). The two faces also have similarities, and it might seem as if Wilde's descriptions of John have been applied to Salome. That, morally speaking, John is placed off-balance becomes dramatized by the unnatural stance, the odd bend of the left arm and the suggestion that the face should be turned to the right. As with the figure of Narraboth in "The Peacock Skirt," there remains a sense of muscular imbalance, of clash between turn of the head and posture of the body. Salome's body is indeed a whited sepulchre, is death. Salome has described John's body as leprous, but her hard and flaring breasts suggest a corruption still deeper and denser than his, inner directed like that of the young Syrian; and the uneasy polarities of the doubles persist. Short bristlelike hairs on John's robe even if a glance at his

wild beast skins, also suggest corruption, disease, and worms. There is a momentary return here and elsewhere to the *Bon-Mots* style.

"A Platonic Lament"

In "A Platonic Lament" the Page of Herodias mourns over the dead body of his friend Narraboth, who has just killed himself from jealousy on discovering that Salome desires John. The homosexual emotion is suggested by the hermaphroditic features of the Page and by the tender embrace. Naturalistic details in the tableau are at a minimum. Brian Reade comments: "The clash of near-abstract forms, of topiary tree, of roses on espaliers, of leaning youth, and of the body at full length lying crosswise in front of all the rest, has in it the seeds of the inventions of Kandinsky, Picasso, Mondrian and many others to come, who were to reduce the content of their art to Studio arguments."[43]

This tableau as such does not exist in the play; but all its elements converge to elaborate in symbolic form the deeper tones in the scene of lament. For the Page, the moon has been already associated with foreboding and with death. It has already presided over Narraboth's death, has claimed him as victim: "Ah! pourquoi ne l'ai-je pas caché de la lune?" (*S*, 35: Ah! why did I not hide him from the moon?).

In the drawing, the moon glides beyond view, its dark mission accomplished. And if we conceive of the face in the moon as Salome's, it is indeed so that it has proved Narraboth's fate. The demonic image of the moon is picked up at the opposite corner of the drawing by a grotesque impish figure with peacock plumaged hair that appears to be growing out of an anemone ending in a pubic tuft—a version of the Beardsley dwarf, ferreting away under the corpse, as if undermining the noble pathos of the scene by suggesting the gruesome unnaturalness of the death and its consequences. It might almost be an image of the thwarted impulse that led to the suicide. Topiary trees and rose bush clearly demand more symbolic reading. The topiary could represent the male; the roses on the espaliers the androgynous (the Page) in this scene of homoerotic pathos. The falling rose could be viewed either as a poignant tribute by the rosebush: Nature (the pathetic fallacy) grieves with the Page, or as a parody, or as both. Or is it that Oscar Wilde as the moon pays his tribute (one gay to another) by dropping his green carnation from the moon on the corpse of Narraboth; or perhaps Salome aims her roses at her victim's head in a travesty of tribute. However, since Salome is not shown with roses when with

Narraboth, this mourning of the moon seems more persuasive here, particularly as the fallen flower so exactly duplicates the flower in "The Woman in the Moon" drawing, even in its relationship to the moon—that is, on the left side. Here as elsewhere Beardsley is possibly making a parodic allusion to a famous Victorian painting: in this case Augustus Egg's sequence *Past and Present* where the position of moon and attendant cloud is used to show the passage of time (left—right, east—west).

The passion of the Page was presumably not consummated. The title of this image recognizes that platonic love originally referred to the love of an older man which, though grounded in physical, nonetheless aspired to spiritual beauty and a union of souls. For that reason the name of this type of idealistic homosexual passion was in the later nineteenth century termed *Urning* (a German, Karl Heinrich Ulrichs, coined the name), connecting it with the notion of the Uranian Venus rather than the demotic Venus of a purely sensual passion. Wilde's Uranian views had already been expressed in his own circle, to the "Souls" at Wilfrid Scawen Blunt's Crabbet Park and finally to the public at large at his trial. In his love affair with Lord Alfred Douglas he no doubt followed the ladder of love upward, but his motions were conditional on gravity in the affairs with young male prostitutes or "renters." No doubt he would have claimed that there was a place for both supersensual and sensual passion if one had sufficient philosophy. Of course, Narraboth and the Page are probably of an age, but the Page is more sophisticated and more versed in the subtleties of the Herodian court (Narraboth is a foreigner). In the title Beardsley appears to be mocking Wilde's pretension to Uranian love, or again he may be suggesting that the Page mistook the nature of his passion. Since Wildean "Nature" is so equivocal in this situation, reading the drawing as homosexual-platonic seems undeniable. As usual, the artist vents the ambiguities present in the action.

"Enter Herodias"

In "Enter Herodias" Beardsley successfully reproduces the formidable, mondaine, corrupt character of Salome's mother. Otherwise the design evades the drama (and the comedy) of the corresponding scene in the play. When Herod and Herodias accomplish their grand entrance, Herod slips on the blood of the dead Narraboth that has stained the stairs. It strikes the tetrarch as an omen. He rapidly dissociates

himself from the cruel Pharaohs who never gave a feast without furnishing a corpse to regale their guests. He is also puzzled enough to speculate as to whom the blood might belong, as he cannot remember ordering anyone to be killed on the day in question, and when informed that the blood is Narraboth's he can only reply rather helplessly: "Pourquoi? Je l'ai fait capitaine!" (S, 41: Why? I made him captain of the guard).

Alongside Herodias's entrance, the drawing presents an intricate drama of sexual perversion, involving the attendant, a senile fetus whose neck is encompassed by the now familiar pattern roses, and the youth with mask and fig-leaf, which Beardsley was forced to add, an event he celebrated by a limerick:

> Because one figure was undressed
> This little drawing was suppressed
> It was unkind—
> But never mind
> Perhaps it all was for the best.

In a sense it was, as Reade brilliantly divines. In the amended image:

The youth with the powderpuff who has removed his mask, is not excited by Herodias, and possibly not by women at all; unlike the infantile monster opposite, whose excitement is covered by his clothing and whose hydrocephalous expression is fated to be lustful. The fetus's face therefore in so far as it looks infantile is a mask which is betrayed by his unsuccessfully concealed erection while the bare youth opposite unmasks his personality by displaying dormant genitalia, powder puff and effeminate smirk.[44]

The youth remains more not less suggestive in his masked state. Wilde appears at bottom lower right of the design, holding the prompt copy of the play, along with the caduceus of the physician, which alludes to the master's aphorism: "to cure the senses by means of the soul and the soul by means of the senses." Wilde additionally has the witch-doctor's helmet, bearing the bells of a jester's coxcomb, and there is a pun hidden in the "crutch." Wilde's mode of congress was not, as Easton appears to suppose, invariably anal, it was also intercrural.

But Wilde appears also as Herodias. Here, a less than agreeable pun types Oscar as an aging "queen." Herodias can also be construed as a caricatured Rossettish Janey Morris type with an elaborated hairdo re-

calling Fuseli and Romney, the eighteenth-century fine de siècle, when the femme fatale has flourished with something of a proto–art nouveau angularity, both the 1790s and the 1890s being periods acutely conscious of social degeneration (and of possible regeneration, the way down and out). A heavy emphasis falls, as in the encounter between Narraboth and the Baptist, on the malignant breasts: Beardsley's mode of recording opposition to the fructifying power of woman, viewed now as evil and an emblem of decay.

But Herodias's shape is also phallic, another example of the uneasy interchange of male-female characteristics. In "Enter Herodias," "The Eyes of Herod," and in the ensuing piece, "The Stomach Dance," Herodias and her daughter, breasts rhetorically exposed, dominate the compositions, nearer the upper frame than is altogether comfortable. And in all three drawings the smaller figures—Wilde himself, the two cherubs, a peacock, and an excited, almost effervescent lute player—cower enthralled or enervated at the spectacle of a malignant femininity. Salome's head holds that same high central position in the wittily funereal "The Black Cape," "The Dancer's Reward," and "The Climax."

"The Eyes of Herod"

In "The Eyes of Herod," Herod's path is illuminated by two putti bearing flambeaux that recall the sensual cherubs of the *Morte D'Arthur* (468). The King looks longingly at Salome (out of the picture, and Herodias glares slantingly at her husband, upbraiding him in Wilde's words: "Il ne faut pas la regarder. Vous la regardez toujours!" (*S*, 61: You must not look at her. You are always looking at her!). Herodias here physically resembles her daughter. Simon Wilson observes that Herod's fatal lust is expressed through a plurality of phallic symbols: the usual candelabrum and candles, held by the rampant peacock's head, the trees. "In spite of its purity of line . . . it has an appropriate hothouse lushness."[45] This drawing brings to its culmination the drama of looking present in the title page, the borders for the list of pictures, both of which involve ambiguous gestures inviting the reader to look into the text as though it were a forbidden book or a grimoire of sexual magic: in "The Woman in the Moon," "The Peacock Skirt," "John and Salome," "The Platonic Lament," and the images that are to follow—"The Dancer's Reward" and "The Climax." Looking acquires a keener symbolic force in "The Eyes of Herod." Whom he looks

at we may infer from the startled glance of the flambeau bearer on the left and the more knowing look of his companion. The look, then, is of supreme importance throughout Wilde's drama, a catalyst, a mode of creating and revealing identity and relationship. Looks invite disaster: "Il peut arriver un malheur" (*S*, 13: Something terrible may happen). The Syrian Captain's langorous, Herod's lascivious eyeing of Salome, Salome's predatory glare at John, prove to have perfidious effects. What John says of Herodias's lust for Chaldean youths pertains to all the characters in varying degrees: "celle s'est laissée emportér à la concupiscence de ses yeux" (*S*,253: She is carried away by the lust of the eyes): the biblical phrase "lust of the eyes" is altogether appropriate. Not only are the eyes and the act of looking the instruments or avenues of desire, they are also the objects of desire. What most fascinates Salome are the black holes of John's eyes, and what most disturbs John is Salome's gaze. "Je ne veux pas le regarder. Je ne te regarderai pas" (*S*, 37: I do not wish to look at him. I will not look at you). Only by turning away his eyes can John resist his desires. To Salome's chagrin: "Tu as mis sur tes yeux le bandeau de celui qui veut voir son dieu. Eh bien, tu l'as vu, ton Dieu, Iokanaan, mais moi . . . moi." (*S*, 76: You have put over your eyes the bandage of him who wishes only to see his God. Ah, well, you have seen him, but I . . . I). In looking at one another, Salome and John have released and discovered their true selves, their human nature (evil according to the Manichean view of the decadents).

But where Salome welcomes this revelation, John turns his back on it. The general reading of Moreau's "Oedipus and the Sphinx" is relevant here: this painting again and again suggests an ambiguous mirror image, two abstract entities, that confront each other and recognize themselves in one another, a discovery accentuated in the play by their identification with the moon. John and Salome have, as has been suggested, a sharp physical resemblance, only slightly reduced as in "The Dancer's Reward" by the comparative coarseness of Salome's features. That John should be somewhat effeminized need not surprise. A vein of androgyny runs through the iconographical tradition of John the Baptist. Both Wilde and Beardsley would have been familiar with Walter Pater's comment on Leonardo's naked image of the saint "whose delicate brown flesh and woman's hair no one would go out into the wilderness to seek and whose treacherous smile would have us understand something far beyond the outward gesture and circumstance."[46] Pater suggests corruption no less than androgyny.

"The Stomach Dance"

In "The Stomach Dance" the dancer's body is barely convulsed in the act of dance; the face (as in Moreau's Salome) is void of emotion. The agitation of the dance is suggested by the curve of the body throwing stomach and navel into prominence and by the outswung veils counterbalanced by the flight of pattern roses. Any emotion that is required is furnished by the dwarf who fingers an enormous lute, surrogate for a penis, though his pubic hair and erect penis are perfectly visible, while a bunch of penises dangle at his waist rather like a maintenance man with his bevy of keys. Salome appears as a belly dancer, and Walker remarks that the artist may well have seen "some Algerian French cocotte perform the stomach dance in Paris. The western shoes for an eastern dance seem to confirm this."[47] However malicious this subversion of one moment of climax in the play, Beardsley still alludes glancingly to the seven veils that Salome successively lets fall. He makes an abstract pattern from one of the veils that floats out from between Salome's clenched thighs while another sliver of veil, as the belly rotates, is flung rigidly upward suggesting a mock penis ejaculating roses. Wilson observes that the flowers that have fallen around Salome's feet echo Herod's anticipatory outburst as he watches Salome's slaves preparing for her dance: "Ah! vous allez danser pieds nus! C'est bien! C'est bien! Vos petits pieds seront commes des colombes blanches. Ils ressembleront à des petites fleurs blanches qui dansent sur un arbre" (*S*, 72: Ah, you are going to dance with naked feet. Well enough! Well enough! Your little feet will be like white doves. They will be like little white flowers that dance on a tree).

In choosing to illustrate a stomach dance rather than the mystical strip tease that Wilde (and later Richard Strauss) offers, Beardsley may be bypassing Wilde for one of the dramatist's sources: Flaubert's description of Salome's dance in "Herodias": "Les paupières entre-clos, elle se tordait la taille, balancait son ventre avec des ondulations de houle, faisait trembler ses deux seins, et son visage demeurent immobiles, et ses pieds n'arrotaient pas" (Her eyes were half-shut and her body writhed; she swayed her stomach like an undulating wave, made her breasts quiver. And yet her face remained motionless and her feet never stopped).[48] This iconography is repeated precisely in Beardsley's drawing. In Flaubert, she exchanges a look with Herod and lisps in childish cruelty her request for the head of the Baptist. Beardsley may well be accenting the deliberately parodic "tuer son père" role of

Wilde, recorded in the caricature that shows him at work with Flaubert and a French dictionary prominently to hand.

"The Dancer's Reward"

"The Dancer's Reward" is the most electrifying, the most rich in dramatic content of all Beardsley's drawings for *Salome*. The corresponding scene in the play is designated by the stage direction: "Un grand bras noir, le bras du bourreau, sort de la citerne apportant sur un bouclier d'argent la tête d'Iokanaan. Salomé la saisit" (*S*, 61: A great black arm, the arm of the Executioner, rises from the Cistern, bearing on a silver shield the head of Iokanaan. Salome seizes it).

Beardsley has frozen the action so that in place of Salome taking the head off the shield, she has seized it by the hair and erotically glowers over it. Furthermore, Beardsley has economically substituted the framework of the drawing itself for the rim of the cistern. His intention is to reproduce the stunning effect of the sharp emergence of a black arm into the spectator's field of vision bearing its appalling burden; he is not interested in naturalistic fidelity; if that were the case, he would barely have tucked away John's empty shoes on the floor level above the right-hand corner of the design. The function of the shoes is to render emblematically the martyr's death: Beardsley uses empty shoes to similar effect in "The Death of Pierrot": Pierrot lies dead on the bed, while in the foreground a forlorn robe hangs over the back of the chair and an equally forlorn pair of shoes is neatly placed together. But, as with all decadent emblems, ambiguity enters. If we remember Herod's promise of glass shoes to Salome, these shoes could be hers, with a ritual sexual-religious suggestion. (Compare "The Stomach Dance" where scalelike pattern and shape of vamp on the one shod foot clearly resemble the two shoes in "The Dancer's Reward.") As to the executioner's hand, that has wittily become the single leg of a dainty occasional table of which the platter forms the top. Salome's right hand arches over the head, the platter, and the black hand of the executioner, and her gaze forces ours down to the head, and the long drops of blood while the vertical of the executioner's hand forces the eye upward, creating an uneasy manneristic effect. While the vertical thrust is reinforced by the central rope of blood that falls from the platter and by the generally oppressive downward curve of Salome's body, the elongation of her robe, this too is counterbalanced by the two bands of white held together by the six roses just above the cleavage. Salome's

expression combines sadistic pleasure and incredulous horror "at the fulfillment of her impossible desire,"[49] as Wilson admirably puts it. With one hand she tugs back John's head by the forelock so that she can taunt him to his face, "Ouvre tex yeux! Soulève tes paupières, Iokanaan. Pourquoi ne me regardes-tu pas? (*S*, 88: Open your eyes! Lift your eyelids, Iokanaan. Why don't you look at me?), while she pushes her other hand hesitantly forward to touch the blood, "as if to make sure it is real, that she is not dreaming."[50] The fusing of the black of the hair with the black of the ropes and dots of blood creates a unity that intensifies drama. Salome as vampire femme fatale is equipped with a couple of sharp incisors that Beardsley has deftly flecked into the blackened mouth. In the play, vampirism emerges through the working out of a feasting motif, synonymous of sexual appetite. "J'ai faim de ton corps" (*S*, 90: I hunger for your body), Salome cries out. "Et ni le vin, ni les fruits ne peuvent apaiser mon désir" (*S*, 88: Neither wine nor fruit can stanch my desire). She devours his lips with kiss upon kiss. "J'ai baiserai ta bouche maintenant. Je la mordrai avec les dents comme on mord un fruit mer" (*S*, 89: I will kiss your mouth now. I will bite it with my teeth as one bites a ripe fruit), she has already declared. "Novalis," Friedrich von Hardenberg, one of the first of European decadents, had long before commented that perhaps sexual desire and religious communion are no more than the cannibal appetite for human flesh.[51]

Death and beheading are obvious emblems for orgasm and castration, more explicit in Beardsley than in the play. The black arm that seems to be organically attached to the head is itself a massive phallic symbol. Beheading as castration is therefore quite literally presented. A further emblem of castration may be found in Iokanaan's gaping toothless mouth. Beardsley, who sometimes alluded to himself as a eunuch, once drew a tooth with its three long roots and observed, "even my teeth are a little phallic." While much of Beardsley's imagery stresses rather the privilege of the voyeur, the isolation that is its condition; in this image at least the fear of being an outcast at life's feast is patent. John's toothlessness is thrust into relief by the teeth supplied for Salome (she is devoid of them in both "The Peacock Skirt" and "John and Salome"), and this in turn stresses her masculine qualities. Death as emblem of orgasm, the familiar love-as-death equation of love poetry and of mysticism—"the little death"—is clarified by the posture of John's head, closed eyes, and opened mouth. The femme fatale revenges herself on her recalcitrantly chaste victim and at the same time

acquires the object of her desire—the victim's head as symbolic phallus. She therefore undergoes a subliminal defloration, "J'étais une vierge, tu m'as déflorée" (*S*, 72: I was a virgin, thou hast deflowered me), and enjoys a real if sterile sexual climax: so the punning title of the next picture "The Climax."

"The Climax"

The first version of this drawing appeared in the *Studio* for April 1893, and the commission to illustrate *Salome* arose directly out of its publication. Wilde had sent the artist a copy of the French version of his play incribed "March 1893. For Aubrey: for the only artist who, besides myself, knows what the dance of the seven veils is, and can see that invisible dance. Oscar." Wilde appears to have divined a strong affinity between Beardsley's art and his own play. And Beardsley lost no time in furnishing an illustration to the play's climactic moment. After receiving the commission, between May and the end of November 1893, he had produced the illustrations that, as a group, are probably his highest achievement. "The Climax," however, was redrawn and much improved. Beardsley had included a motto, "J'ai baisé ta bouche, Iokanaan, j'ai baisé ta bouche" (*S*, 72: I have kissed your mouth, Iokanaan, I have kissed your mouth). Additionally, the linear patterning in the white (lunar?) space through which John and Salome float mutes the impact of the drawing as do the peacock feathers and the wings. Moreover, the ink drawing is tinted with green watercolor, an attempt to supply additional tone, but weakening in fact the arresting contrast of black and white.

The black arm of "The Dancer's Reward" is replaced here as phallic symbol by the column of blood. Blood and lunar motifs fuse emblematically behind Salome while her face, with the usual Pre-Raphaelite long thick neck, black hair, and full lips, assumes a coarse and feral quality. This is accentuated by the curving horns that grow from the back of her hair. A third and final climax in the play and in the drawing itself is the martyrdom ambiguously presented of the Baptist. In the drama, he resists Salome's temptation by driving his sexual desires underground, both psychically and physically, when quite literally he retreats into his tomblike cistern of a prison. The recognition of internal corruption is thus a common signature both of Salome and of John. After his disturbing encounter with the princess, John permits himself to be executed with no show of resistance or fear, in silence, so that

Salome misinterprets what is occurring and believes that the executioner has flinched from his task until the head rises dramatically into the light. Beardsley's presentation of the martyrdom consists in a tableau of emblems: water lilies (representing purity) grow out of John's blood. The thick falling blood, however, inverts gravity and seems to rise upward rather than fall, almost a naive emblematic depiction of the blood of the martyrs crying to heaven from the ground.

The blood helps to link the black ground that also curves upward alongside the white ground in which Salome kneels holding the head, whose hair falls in thick ropes (recalling images of the Medusa). In this altogether splendid drawing, Nature is broken up by a species of linear fusion. Objects lose the sharpness of their identity and swim into subjective unity antithetically responding to the chaos and disunity of the outer world. The flowing line that divides the dark ground from the centered white curve fuses into a liquid unity of all the elements. Salome's hair melts into clouds, water melts into the Baptist's hair, less ropes than thick slants of rain, a cycle of continuity. There is perhaps a tinge of naturalism in the presentation of Salome's gazing into the shut face of the Baptist (representing the summit of the erotic *frisson*). That summit is literally represented: Salome is floating on air; she appears to have achieved mystical union with the lunar principle in what amounts to some species of assumption (compare the image of Saint Rose of Lima). One can read the tableau in terms of confrontation of the fluid feminine and rigid masculine principles in which evil fluidity is opposed by the moral self-conquest of its opposite, a theme occurring in Wilde's text, in Moreau's "Oedipus and the Sphinx," and in the floating haloed head of the Baptist and the terrified stiff arm gesture with which Salome attempts to ward it off in "L'Apparition." By encapsulating and confronting Salome's consummation with John's martyrdom in the one frame, Beardsley has economically captured the irony of Salome's victory and the saint's defeat; for in spite of the visual suggestion of erotic and religious consummation, the power of this frozen moment is such that it chills consummation.

The lower half of the tableau derives perhaps from the analogy Salome herself draws between John and a lily: "Ton corps est blanc commes le lis d'un pré que le faucheur n'ai jamais fauché" (*S*, 30: Your body is white as the lilies of the field that the reaper has never reaped). The reaper here might be thought of as both Lawrentian "beaked sex" and Death. Association of lilies with purity is ambiguously presented by other decadents and symbolists. Moreau's "Fleur Mystique," for ex-

ample, depicts a massive lily drenched and fed by the blood of martyrs
who lie bearing haloes at the foot of the flower. The lily itself serves as
a throne for the Virgin. (The lily like the rose is one of her emblematic
flowers.) Beardsley's ambiguous John achieves martyrdom by evasion
rather than conquest of his sexuality. His moral denunciations of Her-
odias and of Salome betray, it could be argued, strong and repressed
sexual feelings. His own corruptibility may be implied by the thin
white lines on his head in "The Dancer's Reward" that suggest worms,
paralleled in the text by allusion to "the seed of the serpent," and
Herod himself was to be eaten alive by worms, the result of a chain of
lust and death that has led from Herod's desire for Herodias and his
murder of her husband to the nubility of Salome, an object for the lust
of the eye, while she herself radiates from all her flesh the *mal'occhio*,
the eye that infects, whomever it is thrown upon. The countercharm
is a phallus. And so the chain continues with the deaths of Narraboth,
of Iokanaan, of Salome, and by implication of Herod himself. Herodias
survives, psychologically inert, corroded by her positivism.

If John goes to his death, morally victorious but with still unpurged
desires, whatever casuists may murmur about martyrdom "bestowing
a plenary grace," then in light of Beardsley's iconography, the three
lilies in various stages of their growth may well represent erected phal-
loi as likely to spring as miraculous lilies from the blood of a martyr.

"Ideal communion with the divine," Moreau had written, "is a re-
found virginity, equating the ideal and the sexual."[52] So Salome's at-
tempted communion with the ever virginal and yet orgiastically
demonic Diana, but her crying out at her defloration is not ecstasy but
despair. We might find the intensifying feral coarseness of Salome's
representations as a projection of her inward moral depravity, an in-
version of the youthful and innocent looking Dorian Gray and his mon-
strous degenerating portrait. Or is it, as Gilbert suggests, that like
Wilde, Salome now knows that one cannot get beyond appearance to
reality; art is the only reality. Like her author, Salome discovers the
blankness of essence. Her silence is not that of union with essence,
beyond language and beyond the metaphors with which she has habit-
ually clothed the prophet, but which have now, like her veils, fallen
away. In "J'ai baisé ta bouche," as in "The Climax," Salome has as-
sumed in Beardsley's images the appearance of that central emblem of
romantic beauty and horror, the Medusa, whose snaky locks, Freud
suggested, represent the female genitals and the male horror of castra-

tion-decapitation. Medusa's face and hair can kill at a glance, and it is this power that Beardsley most dramatically portrays in Salome's hungry peering at Iokanaan's severed head and in the head's blind reciprocating gaze. But Salome's trophy in this drawing is now itself represented as a Medusa head: hermaphroditism, self-reflexiveness, and the fatality of unmediated nature are unforgettably focused here: Salome and John as mirror images of one another. Salome's fierce Medusa-like glare, depicted as kind of passionate self-regard, is simultaneously murderous and suicidal. Iokanaan's own Medusa head, deprived now of its male transcendence, peers sightlessly back at its tormentor, deadly emblem of the secret behind the veil. The images of *Salome* are themselves veiled, but their potency partly consists in that.

The Failed Union

"J'ai baisé ta bouche": but Salome does not achieve the kiss. She attempts three modes of union with the divine ground, which she first emblematizes as the moon, then as Iokanaan, as one who is a "seer": the dance, the sacrifice, and the kiss, *mors osculi* (the kiss of death). The notion of the kiss as a union of souls (and so a death of the individual body) with God or (as secularized whether platonically or in carnal terms) with the beloved, stems from antiquity and is present in Judaism, Christianity, and Sufism. In its romantic transformation it acquires strong sadomasochistic overtones; in, for example, Jean-Jacques Rousseau's "baiser acre" (acrid kiss) from *La Nouvelle Heloise* mutating into *cosi saporito* (so savory) and becoming in doomed lovers who die physically and metaphysically for and with one another the "baiser funeste" (the fatal kiss). Wagner's Tristan and Isolde (associated with Salome by her Medusan hair style) are a later and nearer example. Salome eroticizes death, and hers is an inverted and demonic version of that holy osculation. In her final transactions with Iokanaan, she has performed her parodic interpretation of St. Augustine's *Confessions,* book 1, chapter 5: "Hide not thy face from me; let me die that I may see it, lest otherwise I die because I see it not." She sees the face; she is seen, and Herod orders her death. "Kill that woman" distances her from human order, as she has distanced herself and at the same time reduces her from her hermaphroditic (and therefore monstrous and unsatisfied singularity) exaltation to the nullity of her gender. Just that reduction is registered in the final drawing.

The Cul de Lampe

Salome's angular bone structure and masculine emblems strangely contrast with her image in the *cul de lampe* that registers her death and where she appears as slender, feminine, with the familiar moon, water vapor, or peacock-eyed hair. A Pierrot and a satyr (artist and author?) are poised to lay her in her coffin, a rose-decorated powder box, a frivolous pietà. Commenting perhaps on the triviality of the play; an anticlimax generated by her failed consummation, her reversion to gender. Even here, Beardsley cannot resist a visual pun. Salome's left leg is missing; it has modulated into the left arm of the satyr, a distinct necrophiliac touch, while the fluff of the power puff merges into the satyr's pubic hair. Walker observes that "the laxity of the dead figure is beautifully drawn and rendered more lifeless by the overdrawing of the hand. . . . The signature device of the artist critic stares at us— almost intrudes since the three candles are centered on a level with the faces of Salome's two undertakers."[53]

In any conspectus of Beardsley's work, the critic constantly has to remind himself of how early these drawings are. Their boldness of design and the dramatic economy they exhibit may be occasionally betrayed by uncertainty in execution. It may be that there is more acute a sense of evil in the images of Messalina, and that Beardsley's penmanship becomes more consistently assured as he proceeds from the drawings of the *Yellow Book* period to the *Lysistrata* and the last works. Yet it was the *Salome* images that had the deepest effect on European art and which have seized the popular eye; so it is the drama of the black and white, contributing most to the artist's legend, his afterlife, that triumphantly survives. And if the images survive, we might well add, it is rather because than in spite of Beardsley's association with Wilde.

Chapter Six
Drawings of the
Yellow Book Period

The *Yellow Book* was planned at the turn of 1893 and the first issue appeared in April 1894. The story of its inception, success of scandal, of Beardsley's dismissal from his post as art editor in April 1895 in the wake of Oscar Wilde's arrest, and of how it "turned grey in a single night," has been endlessly repeated. Here we may concern ourselves purely with the drawings included in the periodical and with some belonging to the same period extending from 1893 to 1895 and broadly in the same style.

This style is a prolongation of the black and white mode of the *Salome* illustrations. There are none the less distinct shifts of emphasis. Where the *Salome* drawings subsist in some weightless void, keyed by floating objects, Beardsley's world now is recognizably solid; it is urban, bohemian, often nocturnal and sharply contemporary, while the artist finds new and ingenious appositions of black and white. The fascination with the fantasy toilette scene as theater, the manufacturing of the mask of society persists, but the night world is now peopled by elegant prostitutes, sodalities of the half-world of shadows, seated at café tables; theatergoers in evening dress, the ambience being as much redolent of Paris as of London. And even in those drawings where he does not appear, we sense throughout the *Yellow Book* period the presence of one of Beardsley's favored emblems, the white and tragic clown Pierrot, recognizably sad, sometimes sinister, frivolous sometimes, of the end of century. In pictures from which Pierrot is formally absent, ironic distortions of the pen itself appear to correspond subliminally with the Mask's ironic smile, a smile of acrid insight. Beardsley abandons more or less completely at this time his old emblem, the three candles, as if to insist on the dynamism of his art.

In the *Salome* drawings we have noticed the uneasiness kindled in the spectator by placing a major figure too near the frame of the drawing, while minor characters are sometimes precariously stationed on its

very edge. In the *Yellow Book* period, this disbalance is continuously stabilized by the curves of art nouveau. This programmatic device may be compared with the spectatorial uneasiness induced by sixteenth-century mannerism, an uneasiness achieved by different moods. It may be a playfulness, audaciously amusing and grotesquely appropriate for pavilions of pleasure, such as Giulio Romano impresses on the facade and interior of the Palazzo del Te at Mantua; a beauty wrenched out of distortion as in Francesco Mazzola or Parmigianino's *Madonna con collo lungo* (the Madonna with the long neck) by all the morbid elegance of the Madonna's long hands and serpentine neck, or by covertly expressing some vein of irritable malice. Beardsley lived before the revived taste for mannerist painting in the later 1920s, and even his acquaintance with them through engravings may have been slender, but his technique of this phase seems to be directed toward not dissimilar ends. Immediate sources for him, though, were Rowlandson's caricatures and the elongated ladies of Fuseli and Romney. The spectatorial unease fomented by mocking ocular expectations, anamorphosis, is analogous to Beardsley's clarification of obscurely subversive themes in the texts and situations he presents. It is also perhaps a persistence of the oblique child's eye view of objects; particularly a child carried by its mother.

The *Yellow Book*

The cover design of the *Yellow Book* for April 1894 brilliantly epitomizes the hieroglyphics of nightmare. A fawning masked male face (we may compare "The Kiss of Judas") of an earlier phase appears to be sharing an occult joke with a gross bewarted woman (or is the wart a beauty spot?) also masked, and we can barely evade the possibility that they laugh at us, the spectators. Persons behind masks tend to be unnerving always; their identity being equivocal they can behave with an entire impunity. How can we avoid feeling naive and excluded? By opening the book of course with its French, and therefore naughty, cover; a grimoire of vice. Beardsley was a glittering showman; he retained a professional detachment from the show itself and never forgot the curtain, the costumes, and the dressing room, like Pierrot and Harlequin who remain accessories rotating round some more central but hidden action. Besides its Beardsleyesque aggression, the image has something of the seductiveness of Wilde, that archest of tempters. Besides being laughed at by the fat lady in the mask, how can we avoid

smiling at the blunt snouted appearance that so subverts her sense of superiority? She is one in a garrison of fat women, and her role will be looked at later. Responding complexly to this image, we are at once attracted by the promise of illicit mysteries and repulsed by its hiero-phants, remaining awkwardly suspended in a vacuum between the cheery and the sinister.

The masked woman's black hat, bounded by thin bold curves of light lines contrasting rhetorically with the glaring blankness of what could be a wig, seems itself to be a portion literally of the surrounding darkness, an unstable black halo. As Reade observes, "The balancing of hat, hair and shoulders in this figure inside a rectangle of such a shape, the exceptionally hard, flat, jagged treatment of the gown, dif-ferentiated by heavy dots: the dots themselves–vestigial or pointilliste spots or of the spatter on Toulouse-Lautrec's posters–all contribute to a startling design which appears to have in it the seeds of Cubism and of many kinds of abstract art."[1]

In the design for the front cover of the prospectus for the *Yellow Book* a spectacled Pierrot (identified traditionally with Lane's more timid partner, Charles Elkin Mathews) peers with nervous disapproval from the doorway of Mathews's and Lane's Vigo Street bookshop at a young woman who leans toward the outside book bins, lit by a London street lamp. She is clearly, like so many of the women in the drawings of this period, a creature of the night, though not a streetwalker so much as an emancipated young person who hardly depends on the circulating libraries for her reading matter and will certainly read and possibly even contribute to the periodical itself. Her right hand in its long glove is thrust forward; the index and little fingers project, the middle finger is knuckled backward, and three white lines on the glove lend a faintly skeletal touch. The lines of cloak, hair, and hat are somewhat joined as they rise and disappear at the top left of the frame. The design is not quite square, an obscure geometry that disappoints the viewer's expectation of the familiar rectangular design deriving from Renais-sance title pages, an idiom according with the tailed *r*'s and roman V of the subtitle. Along with the truncation of the cloak, hair, and hat continuum and the spectrally lit gloves this contributes to the viewer's discomfiture. But the main source may be the interplay of glances that remain opaque to interpretation. The Pierrot's arms akimbo do not suggest nervousness. The woman's rather sinister, almost horned or *mal'occhio* (evil eye) gesture with the hand indicates desire and hesita-tion, two fingers advance, two fingers retreat. Her parted lips register

astonishment—but about what? At Elkin Mathews as the source of all
dubious things? As a creature of the night she is taken by "good," that
is, moralizing books? Or is the implication that books of the sort sold
by the Bodley Head might alarm even a prostitute? Does the Pierrot-
proprietor disapprove of her presence outside the shop? or disapprove
of her disapproval? The more one looks at the drawings the more it
turns into an unreadable hieroglyph.

The decoration of the back cover of this first issue subsisted, like the
spine, unchanged through succeeding volumes and like the spine was
inadvertently overlooked in the issue for April 1895, though Beards-
ley's other contributions were removed. In the top panel a Pierrot, a
masked and two unmasked women all cut off by the bottom frame
from beneath the shoulders: The effect mimes the box of a Punch and
Judy show.

The title page of the first issue depicts a woman with a plumed hat
playing a piano in a field, furnished by two slanting trees. The theme
is repeated in the less interesting, if as nonchalantly irrelevant, poster
for Singer Sewing Machines, also of this period, where some parallel
may be projected between the lady's tuneful leisure and the rickety
music of the machine. Perhaps the leisure is assured by possession of
the machine, or perhaps her touch is worthy of Messrs. Singer's best
model. Reade suggests that the title page would have pleased the sur-
realists of the 1930s. It did not please the contemporary audience.
Beardsley replied with one of his severely insolent letters, recording
historically how the eighteenth-century composer Christoph Willibald
von Gluck habitually composed at a piano set up in a field with a
champagne bottle on either side of him. "What critics would say had
I introduced those bottles," Beardsley enquired, "and yet we do not
call Gluck a *décadent*." (*L*, 65) The story is, needless to remark,
apocryphal.

"L'Education Sentimentale," presumed to have some connection
with Gustave Flaubert's famous novel of that same title, furnishes a
further example of the Fat Woman image. A grossly corrupt looking
governess stands mercifully absorbed in her book, given a whimsically
menacing touch (like Beardsley's images of Mrs. Whistler and Messal-
ina) by her flamboyant headgear. She is the more hideous for being
covered all over with the subtlest of lines that suggest the grossest
corporeality underneath. One pointed foot protrudes from under her
ankle-concealing skirt. This is the masterful female of the species,

affined to Mrs. Marsuple, Messalina, and the *fardeuse* in the illustration
to *Mademoiselle de Maupin,* and with the same spinosities. To the right,
her more décolleté charge smiles knowingly at us: she has somehow
clearly subverted her companion's authority. This is no sentimental
celebration of youth outwitting the conventional or hypocritical tyr-
anny of age, for the girl appears as corrupt as her governess: both are
frightening viragos. They are also, of course, funny, for this drawing
recalls the old-fashioned satirical misogyny of English humor dating at
least as far back as Chaucer's Wife of Bath, given a French gloss like
the *Yellow Book* itself: "a combination of English rowdiness with French
lubricity," as the London *Times* observed. In its conception and in cer-
tain details—the background hangings, the elaborate hat of the elder
woman—"L'Education Sentimentale" echoes a drawing "The Power of
Reflection" by that most English of artists, Thomas Rowlandson.

Max Beerbohm's comment embodies the avant-garde response of its
time: "A fat elderly whore in a dressing-gown and huge hat of many
feathers is reading from a book to the sweetest imaginable little young
girl, who looks before her, with hands clasped behind her back, rogu-
ishly winking. Such a strangely curved attitude, and she wears a long
pinafore of black silk, quite tight, with the frills of a petticoat showing
at the ankles and shoulders. . . . You must see it. It haunts me."[2] Max
seizes and lingers over the child's gesture of the hands clasped behind
the back and over the pinafore and its tightness and the floriations of
the petticoat. We remember his cult of such youthful music hall stars
as Cissie Loftus whose innocent, barely adolescent appearance con-
trasted with the suggestiveness of their songs. When Cissie took to
heavy makeup, for Max her magic was gone. All such details are enum-
erated with the voyeuristic enthusiasm of one fifty years older than the
youthful Max. Perhaps this is what Wilde meant when he said that the
gods had given to Max the gift of perpetual old age.

The 1890s was very much a decade of forbidden books. Under-
ground literature flourished, and Beardsley's future publisher Leonard
Smithers gained much of his income from the production of obscene
texts. Max assumes that the governess is reading a dubious volume,
perhaps an "advanced" French novel to the girl, whom it has nothing
to teach, but it might be that the girl has been discovered reading it
for herself. The difficulty of preserving the marriageable "innocence"
of the young person is itself a theme of contemporary novels, and in
one of those, Henry James's *The Awkward Age,* a young girl, recently

"sold" into marriage, conceals, more in fun than in fear, a lubricious romance under her person, tacitly inviting some of her male friends to "come and get it."

"A Night Piece," an ink drawing with tonal washes is unusual, as Reade observes, from the fact of a form being raised by a few white lines out of a black background. The lines were established, it seems, partly by knife and partly by erasure. Another equivocal "lady of the night" with a low line to her dress is presented off center to the left in profile against the background of an early eighteenth-century church and the facade of another eighteenth-century building along whose cornice line the words "the Costumes" appear to be incised. This setting is said to be Leicester Square, though the architecture barely suggests that; it is probably a London scene and may bear some relationship to a poem printed immediately after it, Arthur Symons's "naughty" "Stella Maris," which effervesces in such lines as "The chance romances of the streets, / The Juliet of a night."[3] As in the caricature of Mrs. Patrick Campbell, in this same issue, Beardsley has here stylized the human frame by elongating it. The caricature, the frontispiece to John Davidson's *The Wonderful Mission of Earl Lavender,* "The Mysterious Rose Garden," and "Atalanta," all drawings of this phase, all of them among Beardsley's finer work, rigid mannerist verticality, ironize potentially sensational and baroque subjects: a society portrait, a low-life study, subtly coalescing through a mirroring motif, a blasphemous parody, a scourging, and an amazon, so achieving a virtually poetic elegance and understatement. These images give us a glimpse also of Beardsley's own dry, strangely detached personality.

Connected with "A Night Piece" is "Les Passades." The darkness, though Beardsley introduced grey Indian wash into parts of the image, is more extreme than the other drawing. Space is lit only by the faces of two prostitutes on their beat and by the well exposed bosom of the nearer. Scattered disks of light and thin white lines define their bodies and hats, evoking an even more inhospitable context than that of "A Night Piece."

The economy in the caricature of Mrs. Campbell roused contemporaries to the higher fury. Beardsley was for once outmaneuvered. One reviewer observed that the portrait was "not present" in his copy of the *Yellow Book.* The artist protested and the editor replied that "our own copy it is true contained a female figure in the space thus described, but we rated Mr. Beardsley's talent far too high to suppose they were united on this occasion." This drawing is about as near to straight

portraiture as Beardsley ever got, but remains caricature, the essential note of the 1890s. John Leech had first used the word "cartoon" to carry a new significance in the year 1842.

Disbalance is once more marked in the erotic urban woman, the latest version of the femme fatale who inhabits the front cover of the July 1894 issue of the *Yellow Book.* Criticism has observed the cup-shaped flowers that anticipate the art nouveau designs of a few years later and the visual jokes: the exaggerated perspective of the bookcase and the drawing of the bowl of flowers it supports which is not in perspective at all.

The imagery of the back cover is elaborated in "The Comedy Ballet of Marionettes," three drawings not among Beardsley's best but of considerable interest in the development of his *commedia dell'arte* imagery. Here Pierrot operates as a freak show proprietor, like Beardsley himself in the *Bon-Mots,* and like the turbaned little character here who entices fashionable ladies from the auditorium, gestures obscenely, and obliges them to join his troupe in a dance to a tune he calls. The ladies smile, but their conductor-pandar smiles more knowingly and covertly at the audience, which however, is barely immune from Pierrot-Beardsley's ironic gaze.

The accompanying players are not altogether reassuring: an orchestra of dwarfs, a female dwarf, an elderly clown with dainty satyr horns and a chinless effeminate clown who may well be related to the prancing female in baggy pantaloons in the third drawing. Reade describes her as a lesbian and remarks that the absolute absence of her chin reflects the Victorian view that this was the outward and visible sign of a lack of moral fiber. Certainly she parodies the many mannish new women of the period, severely habited in knickerbockers or some other version of male clothing, who were often accompanied by a petite fluttering companion of the same gender.

A comparable note of mischieviously sinister perversion appears in "The Scarlet Pastorale" of 1895 in which a masked clown in a costume reminiscent of logenzes, flagstones, or a chess board is suddenly arrested in the middle of his movements. Behind him other more disquieting masked grotesques in postures of quest or of hunting are outlined against a stage curtain. Two large candlesticks, hanging and resting on nothing, are depicted higher up the curtain. The achievement of the drawing lies in the monochromous solidity, the sense of spatial configuration in a pattern without shading. In all four drawings the line between stage illusion and life has been fractured, but the

"Scarlet Pastorale" hints of still more disturbing fictions behind the
veil.

Besides Mrs. Patrick Campbell, Beardsley furnished two other im-
ages of actresses for the *Yellow Book*. The French Madame Réjane was
popular in England; she had performed at the Gaiety theater in June
1894 and was a topical presence. Altogether Beardsley drew her six
times. The figure of the actress, a role like that of the diva in which
women could, if sufficiently talented, lead a public life and extort some
respect from the middle classes, fascinated poets and novelists of the
end of the century. Mrs. Humphry Ward (soon to impinge on Beards-
ley's career like a Nemesis in corsage) and Henry James, in *The Tragic
Muse,* had both made an actress the hinge of a novel, James sensing an
analogue between the hidden discipline of the actress's very public life
and the solitude and dedication of the literary artist. But Beardsley's
interest in Réjane derived from her physical appearance. William
Archer, the dramatic critic, ironically explained away the success of
Beardsley's *Yellow Book* drawing: "Mme. Réjane happens to be the one
woman in the world with a Beardsley mouth." Nature had anticipated
Beardsley's art. "Graceful if ugly" according to contemporary standards
of judgment, she is shown in the *Yellow Book* in profile; but in a draw-
ing of 1893, where her face is half turned toward the viewer, Beardsley
hints at the squint she is supposed to have possessed, though this
would be a grace rather than a blemish for decadent amateurs of the
beautiful, which they hunted and found in the bizarre or even in the
ugly. Here Beardsley is deploying naturalism. In the earlier drawing,
Réjane is revealed as the dominating Beardsleyesque female, a madame
in both senses of the word. Despite the artist's acts of *hommage,* Réjane
is reported to have wept and screamed when she encountered herself in
a Beardsley poster with "its Cytherean grin."

Realism in another urban subject, "Garçons du Café"—three waiters
with aprons and napkins under arm—is paradoxically produced by ap-
pearance. In his earlier work Beardsley had not altogether resolved the
opposition between functional and decorative. Here, there are no half-
tones or shadings and the important lines are absent. What are present
are the shapes of spaces, the opposite of a more natural mode of mod-
eling: the spectator "in the best modern way" is invited to create the
contours for himself. Lines actually force the spaces into shapes, the
pot bellies, for example, of two of the waiters. Space is deployed to
establish solidity. Though Beardsley originally called this drawing "Les
Garçons du Café Royal," the subject seems rather urban French.

Reade notes that "from the head of the waiter on the left to the end of the sleeve of the waiter on the right there is a continuous black continent absorbing all details within it in the same tone." In this, Beardsley connects with the Beggerstaff brothers (James Pryde and James Guthrie) and their photographic caricature poster style, though Reade rather relates it to the "saturation effect" and the realism of Felix Vallotton, whose work Beardsley might have encountered on his visits to Paris of 1892 and 1893 and, more certainly, through reproduction in the first issue of the *Studio* of 1893 in which Beardsley's own work prominently figured.[4]

The design for the front cover of the October 1894 issue of the *Yellow Book* involves another toilette scene connected as usual with theater, make-believe, the manufacturing of the mask of society. And here particularly it suggests also the commission of erotic acts, dressing and undressing, sexual cults and rites. A woman leans toward her dresssing table mirror, posing a stemmed powder puff enclosed in a flower cup in her left hand rather as if she were offering a rose to a mirror that is devoid of any image. About the mirror parasitic tendrils twine and lighting is furnished by two London gas lamps. Reade notes the heavy outline of the lining of the woman's gown and describes her features as "weak, pert, and narcissistic" relating this to the absence of an image in the glass.[5] She is bending toward the absent shape so that she can adore, like Pope's Belinda in *The Rape of the Lock,* what the cosmetic powers should have accomplished. Narcissus was a dominant image of the 1890s: Dorian Gray's picture, Max's Zuleika Dobson performing her "rites of pride"; the whole theme of the Double.

To the "Portrait of Himself" Beardsley attached the epigraph: "Par Les Dieux Jumeaux Tous Les Monstres Ne Sont Pas En Afrique" (By the twin gods not all monsters are in Africa), presenting himself as a tiny creature in a mob-cap lying alone in a large eighteenth-century bed. He is accompanied by the artist's repertoire of imagery, particularly the satyress he derived from engravings of Tiepoli's *Capricci.* This specimen acts as a caryatid for the bed post and is furnished with vast, dropsical dugs falling direct from the chin while leaves and fruit of pudendal shape replace the usual satyrine hairy flanks and lower belly. Though he describes himself as a monster, Beardsley's loneliness and weakness is registered here without self-pity, though "monsters" may simply refer to the apparitions of nightmare which the enclosing, black, figured bed-canopy is intended to suggest. We must distinguish this image, though, from some of the more grotesque autobiographical

surrogates: the mood here while certainly not one of fearing life (as has been suggested so often of the fetus image) is resigned rather than celebratory of the advantages of being a spectator from without.

Volume 3 also contains two of Beardsley's mischievous pieces of critic-baiting. He contributed two drawings pseudonymously: "Mantegna" by Philip Broughton and "From a Pastel" by Albert Foschter, both of which were much approved by the reviewers of the third volume, while the drawings Beardsley had signed with his own name were treated to the familiar outrage and ridicule. The author of one article, according to Max Beerbohm, suggested that Beardsley might take a lesson in sound draftsmanship from "Philip Broughton." "Broughton" had indeed drawn a stylized cup-shaped pair of blossoms at the left side of his offering which had appeared in rather similar form in "Siegfried, Act II" but the background was innocently quattrocento. In what is too suspiciously rich an irony, Max Beerbohm records that the anonymous critic who praised Philip Broughton concluded by referring to Mr. Foschter furnishing "another example in his familiar manner."

The problem of accenting figures in darkness inevitably accompanied the urban night topics in the drawings of 1894. Beardsley's capital inspiration may have been Whistler, who had evoked the poetry of the city in his "Nocturnes," but for Beardsley, the poetry of darkness was hard and sinister, if, as in "Lady Gold's Escort," patient of satire. A group of dandies with distinctly foreign faces, in evening dress, tall hats, canes, and muffs under the portico of Sir Henry Irving's Lyceum Theater forms a guard of honor for a small bowed elderly female with a folded fan that projects like a bone. Behind her slender white lines and dots skillfully suggest the cab and the immense epaulettes of the coachman.

It was in Paris that Beardsley again directly encountered Wagner, and the famous drawing "The Wagnerites" represents what is possibly a French rather than an English audience. Like "A Night Piece" and "Les Passades" the idiom of "The Wagnerites" sets small areas of white among large masses of black. Normally, Beardsley simply creates white space by leaving the paper free of ink, but here, somewhat unusually, he uses touches of Chinese white. The blacks run into one another. Fragmentary white lines assist the imagination to articulate. The drawing depicts the audience, not the stage, and it is an odd audience: caricature has been applied to society types. Its members are, with one exception, all women, all past their first youth, and all ugly and in décolleté. The one man, in later middle age, has a hooked nose while

the women have noses that are either hooked or porcinely retroussés; their mouths pout out like fishes or those at the zenith of their pleasure. The large fleshy female to the right represents a cultural feature of the times, more appropriate to London than to Paris, the "aesthetic" female. In the *Punch* caricatures of about 1880, the aesthetic female is presented as lank and soulful, but by the 1890s she has become aggressive. This specimen suggests Rossetti's late period female, such as "Astarte Syriaca" or "Proserpina," by subject as well as image, associated with woman as Muse figure, created by and creating her devotee and impelling him, inadvertently or unwillingly, to destruction. The image is associated with Jane Morris and her supposed gypsy blood, and represents the decay of Rossetti's personality and his art. In Rossetti's attitude to women there is a vein of the tragic that is absent from Beardsley's. Beardsley's lady is a playful parody of the Rossetti type (life imitating art) and as with his fat women, he subverts the dominant female by laughing at her, though the laughter in "The Wagnerites" is sardonic. The subject of the audience's attention is "Tristan and Isolde," a tale, ironically enough, of high romantic obsession, into which the audience enters, all of the women equating themselves with Isolde. Beardsley ambiguously entertains his own past (the *Morte Darthur*) and his admiration for Wagner.

Among the drawings in volume 4, "The Mysterious Rose Garden" belongs to iconographical rather than stylistic parody: a burlesque annunciation as it was termed by Beardsley's friend Aymer Vallance. At dusk, before a rose trellis possibly deriving from Morris wallpapers or perhaps a version of the roseal arbors and dense alleys of the rather formalized Luxembourg Gardens Beardsley had studied on his Paris visit of 1893, a naked girl in later adolescence stands over a few fallen rose heads. Her figure has the same elongation as female figures in the other drawings of this period. She holds a strand of hair between her breast as if in some absent-minded and rather ineffectual gesture of modesty, and she contrasts with the voluminously clothed heavenly or infernal messenger with his long ripples of hair and the winged sandals of Hermes, messenger of the Pagan gods. His robe is fringed with fire like the figure of Loge in the "The Tableau of the Rhinegold," a mode of dress that bears perhaps on his origin; there is also the Freudian association of flames with sexuality. He whispers into her ear, and while his right hand grasps a long wand from which a lantern is suspended, his other with open palm appears to be motioning any possible listeners to a distance, but the hand rests some inches from his mouth

and, like the self-protective gesture of the girl, seems less functional then elegantly stylized. The discarded drawing for this design shows the messenger whispering behind his hand, the classic gesture of secret communication. As with "L'Education Sentimentale," some species of sexual initiation is being projected, but the girl is not as knowing as her predecessor. *Rosa Mystica,* the rose is both sexual and one of the mystical emblems of Mary; the garden is the *hortus conclusus,* the enclosed garden of Mary's virgin body through which the wind blows in the Song of Solomon, 4:12–16. The picture remains equivocal. Hermes is also the god of liars and thieves. Reade indeed goes so far as to suggest that the girl is already pregnant. Certainly Gabriel suggests rather Gabriel Horner, the remorseless sexual machine of William Wycherley's *The Country Wife.* Arthur Symons observes that the "cavalier-like angel whispers tidings of more than pleasant sin." Criticism has also noted that the Madonna is normally seated when she receives the message of the Most High. It is amusing to look back to the 1891 *Hail Mary,* a Burne-Jones head, a lily crawling over the back of the hair, witness to the candid naiveties of Beardsley's Anglo-Catholic nonage.

We are certainly invited to recall the conventional iconography of daylight annunciations, which have now been transformed into a nocturnal pagan tryst. Apparently Beardsley intended "The Mysterious Rose Garden" as the first of a series of biblical illustrations. He had perhaps decided to take up the challenge thrown down by the reviewer of his *Salome* drawings who had mockingly wondered how he would treat of Jean Racine's *Athalie* or John Milton's *Samson Agonistes.*

From the fifth issue of the *Yellow Book* (April 1895) all of the Beardsley plates were removed, but presumably through oversight his spine and the back cover of masks and pierrots remained as a last mocking echo of the acrid genius that had fallen to the Philistine.

Some Other Drawings of the Period

One of his major drawings "The Fat Woman" had been intended for the *Yellow Book,* but Lane recognized it as a caricature of the painter Whistler's wife. The artist blandly denied the charge, though he referred to it under the Whistlerian title "A Study in Major Lines." Whistler's art, Beardsley still hugely admired, but he now thoroughly disliked the man for his arrogance and malice.

Beardsley loved to draw fat women (every freak show had its fat

woman), and they are as much a theme in his work as Pierrot, fetus, the dwarf, or the toilette. Herodias, Mrs. Whistler, Mrs. Marsuple, and Messalina surely reflect something of the schoolboy's amazement at and fascination with the embonpoint of middle-aged ladies. Popular cartoonists and seaside postcard artists had for years realized that there was something irresistibly comic about mature women with huge breasts; the plunging necklines of the Wagnerite audience or of Mrs. Whistler herself—so fetching on Beardsley's younger subjects—are amusing because they show an absurd overconfidence in the authority of their charms. We may note the delicate little bow that dangles teasingly over Mrs. Whistler's majestic cleavage. Such women are by tradition domineering; the set of Mrs. Whistler's mouth is cruel and complacent; her gaze is coolly authoritative. By smiling or laughing at them we can subvert the large ladies' power. Mrs. Whistler sits at a café table with black gloves (a favorite Beardsley device) that extend well beyond the elbow posed against a painting of a river scene which has distinct echoes of Whistler's Old Battersea Bridge. One large index finger rests on the empty glass in front of her, a mute command to a waiter or perhaps a client to fill it, for the fat lady too is a demimondaine, especially built for businessmen visiting the big city who like ample value for their money. Wilson remarks the classical order of the composition, "monumental in effect in spite of its small scale . . . one of Beardsley's greatest drawings of any period of his career."[6] The figure is centrally placed, unlike many of the other drawings of the period, and looks forward to the compositions in the next phase of Beardsley's art. An earlier version of this image called "Woman in Cafe or Waiting" shows a haggard demimondaine, but here the figure is placed to the left of the drawing space. The topic was popular with impressionist painters of the urban scene, and Beardsley would have been well aware of the newspaper controversy engineered round the showing of Edgar Degas's *Au Café* in 1891, a title which English moralists changed to *L'Absinthe*. Degas had intended a study of café life, using friends as models; but the English critics were unable to respond to the poetry of the quotidian and changed the mood into a Zolaesque tract. Beardsley in his way also moralizes.

Rather than discussing the frontispiece to John Davidson's *Earl Lavender* under the chapter that deals with book design and illustration, it is more appropriate to mention it here, for it securely relates to other important drawings of the *Yellow Book* phase. In chapter 6 of Davidson's odd humorous fantasy satirizing end of century moods and modes

such as Darwinian evolution and flagellation, the hero and his Sancho
Panza–like companion are conducted to luxurious underground cham-
bers consisting of the bath, and the temple, etc., where flagellation is
practiced as a solemn art and rite by upper-class men and women, men
whipping women on their bared backs and vice versa. Davidson makes
it clear that these are overrefined but idealistic devotees, not inhabit-
ants of any vulgar sadomasochistic brothel such as the poet Algernon
Charles Swinburne had frequented in a bijou villa at St. John's Wood
in London. They are contemptuous of the usual ideals that unify vulgar
lives: love, marriage, procreation, and the rearing of children. This
was the pessimistic age of Schopenhauer and of Hartmann who advo-
cated mass racial suicide. The erotic aspects of the art if not accented,
are not altogether muted. Still, the narrator appears to recognize the
art's "radiant seriousness." Allusions are touched in to the religious
flagellants of the Middle Ages rather than to the sadomasochistic de-
lights of what was generally regarded, particularly in the nineteenth
century, as "The English Vice."

In his frontispiece Beardsley has precisely captured the spirit of the
text. The moment he selects, a beautiful young woman whipping a
man on his naked back, is stylized, drained of all sensationalism,
though erotic undertones are present. The drawing space is white tra-
versed by thin black lines. The action occurs in a bare, elegant drawing
room with a chimneypiece cut by the left border and supported by a
pilaster crowned by an Ionic capital whose volutes are joined by a del-
icately petaled swag. Above it a snubbed three-branched candlestick is
surmounted by three emaciated candles fronting a mirror with an
equally emaciated pilaster topped by a Corinthian capital. The fireplace
is defined by a riot of Chinese rococo, and this rocking but not agitated
rhythm is echoed in the contour of the fender, for the two fire irons
echo the shape of the candlesticks. The male victim's head is sliced
through by the left border. He kneels slightly facing away from us
with loose indeterminate garments exposing the whole of the back,
while round his waist sags a rosary or what may be worry beads. Just
right of center, a young woman with doubly filleted hair holds a whip
with three long filaments above her head. Her face is unexpressive, and
she presses a hand between her breasts to contain her off-the-shoulder
dress from slipping. Though there is a certain disbalance about the
position of the two figures, the echoing patterns of the furniture, the
woman's elongated body and her Greek styled hair recalling antique
statuary, all accentuate the frigid and ritual note; but the ritual appears

to depress rather than exalt physical passion; Davidson's text insists on the mental stimulus that flagellation induces.

Beardsley had little access to women, and it has been opined that like the naked girl of the frontispiece to Davidson's *Plays* (1895), this figure is a version of Mabel Beardsley. Similarly, Mrs. Beardsley— "bottomless Pitt" has been proposed as model for the caricature of Mrs. Patrick Campbell.

Chapter Seven
The *Savoy* Period

The drawings of this phase include the artwork for the magazine itself which ran for a year from January to December 1896; the illustrations to Alexander Pope's *The Rape of the Lock,* to Juvenal, to Aristophanes' *Lysistrata,* and to the illustrations Beardsley furnished for his own romance "Under the Hill." These last four are discussed elsewhere.

The later part of the year represented as much of a leap in Beardsley's art as the moment of "Siegfried" in early 1893, though there are reprises in style as well as topic. It was perhaps a reaction against everything connected with the unhappy events of April and May 1895: the desire to establish a new image of himself in opposition to the "decadent" past as well as the "fatal speed," as Arthur Symons puts it, of one who needed to telescope the future. Beardsley's health indeed was already past hope; it had once more collapsed in March 1896 after a visit to Belgium with Leonard Smithers; and by the end of that year he was a dying man, though the event was still fifteen months further off. The superficial marks of a willed change in his art are the elimination of the emblematic signature of three candlesticks, the continued recourse to the use of tonal washes, and a critical attitude to all that might be associated with the decayed romanticism of the 1890s: art nouveau, for example. That the general idiom of his art should tend to become more classical was, in these circumstances, not precisely unexpected, though that did not involve an entire turning away from the contemporary scene. Nonetheless, those art historians who defend Beardsley on the ground that he significantly anticipates the radical developments in twentieth-century art will find less to support their views in these later drawings.

The *Savoy*

The *Savoy* was largely planned in France and has a distinctly French orientation, though it includes such distinguished names as Bernard Shaw, Havelock Ellis, Joseph Conrad, Edward Carpenter, and W. B.

Yeats in its letterpress. The literary editor, Arthur Symons, was a man of deeper culture than Henry Harland, the literary editor of the *Yellow Book*. A distinguished translator of French verse and prose, Symons was also aware of cultural events in Paris almost as soon as they happened. Beardsley's role as art editor appears to have been somewhat muted in between the first advertisement and the appearance of the first issue. His drawings also took on a strong French tinge in this phase of his career. The model is the art of the seventeenth and eighteenth centuries as widely reproduced and disseminated in engravings, some of which Beardsley possessed: Claude Lorraine, Nicolas Poussin, Jean-Honoré Fragonard, St. Aubyn, and the rococo illustrators. This is not to suggest that Beardsley had not given the same attention to the original objects where he could see them, in London and in Paris, as he had given, for example, to the Mantegna cartoons at Hampton Court.

As a consequence of such influences, the polarity of black and white tends to disappear; principal figures become more centralized or if off-centered elaborate counterbalancing is introduced; the offscape is either blank or surprisingly an *horror vacui* (fear of the void) predominates: the sinuosities of the pen consume space to such effect indeed in the illustrations to "Under the Hill" that the effect becomes stifling, even if in some drawings harmonious. Such effects of enclosure are obtained by a comingling of garden statuary and vegetation, though the move from the dark urban spaces of the *Yellow Book* phase is far from representing a return to Nature in any absolute or simple sense. A vein of pastoral had always run in Beardsley's art; but pastoral is itself after all a highly stylized genre, and Nature in the drawings of the *Savoy* period is far from wild; it is rather *la belle nature,* nature as seen and aestheticized by man; nature as rendered, say, in the landscapes of Claude and translated later into the gardening art of the eighteenth century when the formal baroque garden gives way to romantic unevenness and surprise. Perhaps the most haunting of images for Beardsley were the backgrounds of Watteau's paintings and Beardsley's own memories of French gardens. The great formal constructions of Louis XIV's France required a corps of gardeners and high financing to assert their total independence of Nature. As soon as their maintenance declined, Nature began to "reassume the land," and the gardens themselves took on all the evocative power of great ruins. Straight alleys began to waver into irregularity; exact lines and regulated trees to be muffled with a slow voluptuousness of growth and temples, pavilions and terms to be masked and insensibly dilapidate. Like Watteau, though, Beardsley

does not delineate actual ruins; the nostalgia would be too patent. And the pathos of these scenes is accented more by dreams of the elegant picnics, intervals of music, masking, and lovemaking played out in such theaters. Beardsley may not have encountered the formal gardens directly or even in their decayed form, but indirectly, and more piercingly because such were involved with theater, mask, and carnival, particularly in the work of Watteau, so that the figures from the *commedia dell'arte* impress themselves on his memory in, for example, the illustrations to Ernest Dowson's *Pierrot of the Minute.* These concerns represent modes of aestheticizing death, and the drawings of this period contain statements about its nearness and the need for self-transcendence.

The design of the front cover of the *Savoy* exists in two states. The original drawing in indian ink and pencil presents to the left a young woman somewhat elongated in the mode of the *Yellow Book* phase drawings, but this effect though accented by the tiny pudgy naked putto with his elaborate hat and rampant feather remains muted by the severe half-buttoned coat and voluminous skirt of the lady. Her figure is unequivocally solid and actual, the hidden body assured by the plastic reality of the drapery while the dress has subtle effects of chiaroscuro. Although the lady here is past adolescence, the solidity of her clothing, the sense of actual body surrounded by the voluminous protective materials of the Victorian world, look forward to such drawings as "The Coiffure." The clothes mirror the concealment of an object of desire, its real presence, and its inaccessibility, an emblem of the severe English nineteenth-century taboos on sex. The lady holds a riding whip in one white gloved hand, but there is no overt suggestion of the organic, voluptuous whiplash line of art nouveau so contrasting with the flagellateuse of the frontispiece to *Earl Lavender.* The putto is also somewhat unusually shaded. The background is parklike: three satyrs connected by a floral swag support a sundial; a lake; a garden temple; pillars with Ionic capitals; and behind the lady a satyr term suggest a romantically unkempt landscape garden; a tattered Elysium. The architectural detail is less precisely focused than in the *Salome* drawings. The Cupidon carries a knobbed cane of adult size with two tassels. In the original drawing he was shown urinating on a copy of the *Yellow Book,* and his governess did not altogether disapprove if we may judge by the ported angle of her whip. George Moore sensibly objected to the gesture of contempt as needlessly provocative, and both magazine and exterior organs were removed so that in the *Savoy* the Cupid be-

comes a little girl. Space in the drawing is harmonized by the central position of the sundial and the balance in the relation of woman, putto, and temple. Beardsley managed to retain some discreetly pubic vegetation. The background of trees is minutely dotted in black and white and established by a species of woolly proliferation, but despite such a sparkling use of light and shade, the landscape remains flat. Sources have been suggested in eighteenth century and earlier nineteenth century art: John Glover, and Francis Finch along with such English contemporaries as Charles Ricketts and Laurence Housman. With the removal of the offending magazine and genitals the front cover unwittingly assumes a moral tone: the magazine will chasten the wayward child of the age.

The design for the violet cases provided for binding the eight numbers of the powdered is rococo in inspiration and relates to the "embroideries" of *The Rape of the Lock* with flat patterns little fettered by functional demands. Under a curtain patterned with large roses, a mirror clenched in by undulating woodwork and a riot of scrolls and knobs has heavy, incongruously mid-Victorian supports that suggest inevitable mahogany. A swag of roses, flowers, and leaves droops over the mirror. Behind and below the mirror hangs a wallpaper with a three-lined vertical pattern. The table displays a pair of triple goat's feet three-branched candlesticks, a mask, and a folded fan. In front of the furniture and the stage curtain a woman dances with a swag of roses and leaves coiled from neck to ankle. Her white coat puckers up at the shoulder in form of a grotesque face; the lower back suggests the form of the derrière. To the right a Pierrot holds a fan in an invisible right hand. Both figures are masked: the clown by a large semitranspicuous scarf that hangs over the left shoulder and is knotted at the back of the head; the woman by a spotted veil beneath which knots of hair are brilliantly established, and above the veil what may be plumes or an elaborate hair style through unhatched lines furnishes a continuum. The title of the periodical is superimposed on the design at the top of the page and the publisher's imprint in three different types at the bottom; both seem extraneous. In spite of occasional felicities this is not a satisfactory design.

The contents page possesses its own frontispiece. The figure of a large John Bull in Regency dress with winged top hat and coaching boots plumed with wings holds a quill pen (*une plume*) and an equally oversized pencil in his right while he gestures with a bluntly drawn left hand under the word "Contents" in gothic lettering. This feature

suggests *Punch,* the organ of the middle-class Victorian *paterfamilias,* distilling the pure milk of the philistine.

The image is a revised version of that furnished by Beardsley for the second prospectus of the *Savoy,* which showed John Bull with a miniscule erection under his breeches. Bull does not resemble the squat farmer who frequently appears in *Punch* cartoons, but like that figure Beardsley's personage represents the essential bourgeois Englishman full of "character" and insular prejudice, all of which gets higher definition by the Anglo-French context of the magazine. By the late nineteenth century, rural economy and culture in Britain had decayed and the farmer is now replaced by the urban philistine. The original image reveals Bull as titillated at the thought of being roused and shocked by a successor to the *Yellow Book.* The second version shows him less pointedly in the role of lumpishly winged herald approving the contents of the first issue; he is now a dandy in Regency style with full repertoire, elaborate boutonnière, etc. The *Savoy,* though "advanced," was less decadent than symbolist and not really shocking except for Beardsley's images, and the irony is that the audience often read into those what was not there but often missed what covertly was there.

"The Bathers" in the first issue derives directly from the artist's stay with Arthur Symons at Dieppe. Beardsley had spent much of his time there indoors, either in his rooms or watching gamblers at the casino. Symons, on the other hand, delighted in watching, if that is not too neutral a word, the women bathers. He has a lyrical passage on the Dieppe *plage* in this first issue that Beardsley in his own way illustrates. The *plage* was a favorite space for various impressionist painters, combining color, gaiety, and the instant effects of water and light. Beardsley, on the other hand, presents what Brian Reade[1] terms a "moonscape" with a stylized arc of flying birds to suggest both the sea and the drawing's programmatic distance from nature. In his article, Symons speaks of the beach as microcosm of society, indeed, his references to "private boxes" and the women "on exhibition" suggest the world of the theater. Symons is alert also to the color of the beach: "The bright dresses glitter in the sunlight, like a flower garden; white *peignoirs,* bright and dark bathing costumes, the white and rose of bare and streaming flesh. . . ."[2] But he insists also on the difficulty of women looking elegant in bathing costumes. One of the three women in Beardsley's drawing tends to the formidable matriarch type, dressed in formal splendor with frilled hat, elaborate bow, and puffed sleeves. The two bathers have the elongated bodies of the *Yellow Book* period

drawings. The figure to the right has a plain white dress and what Symons describes as "a sort of nightgown" draped over her left arm. The central figure in an elaborately patterned bathing dress with drawers and bodice that resembles coquettish underclothing is wearing stockings held up by garters with bows and a small white mob cap that is almost papal. Amelia Bloomer's invention is taken over at this time for a species of bathing costume; it is difficult to list any late Victorian dress that would end above the knees. Perhaps the resemblance to underclothes is indeed the visual point of the design: the frou-frou of feminine, intimate garments set against the uncomfortable cruelty of the stony beach. The central figure, as Reade stresses,[3] is odd: high shoulders, breasts that have little contour (the same is true of the woman on her right), a long sixteenth-century waist; long slender arms, a wide pelvis so that the effect is at once to proclaim and deny femininity (perhaps because traditional femininity is denied by these new athletic pursuits). The thin many twisted golden chain that hangs from her neck suggests Symons's description of Cleo de Merode "the beauty of the Opera," though Cleo takes her bath in "little black socks and yellow gloves." As with the images of other actresses and divas, there is an element of caricature about the central figure. Beardsley has seized on Symons's suggestion of the awkwardness necessarily implicit in the situation of these northern bathers.

The three illustrations to the first three chapters of "Under the Hill" along with "St. Rose of Lima" and "The Rape of the Lock" are all reproduced in this issue. As a supplement, Beardsley drew a Christmas card of the Virgin and Child. For this design, the artist himself did not care and justly. The Madonna is oddly insipid and self-consciously arch, the oversized child, cute merely, a Kate Greenaway creature.

The title page is also iconographical caricature of the genre "Choosing a New Hat." Reade suggests[4] a course in French prints of the 1780s, though the clothes of the two friends are of Beardsley's own time, if not manifestly incongrous. The standing woman with mantle and hat suggest that she is ready to go outside and waits for her friend to choose appropriate head gear for the excursion. They are seemingly in a boudoir: the unmade bed is visible at the right; the hats and boxes could be from a shopping expedition or simply stored and bought out by the bizarre domestic. A fetus-faced youth with the pigtails of the rococo French aristocracy hands out hats from a large box. It is not, Beardsley was careful to inform Smithers, "an infant, but an unstrangled abortion." The room itself is again not precisely rococo. The band

separating the title from the body of the design is gently curvilinear and breaks into sprays so that it serves also as the molded projection between wall and cornice, acting also as the top of a convex mirror with the center marked by a shell. Virtually all rococo mirrors are concave or straight at the top. The door extended beyond the right frame is flanked by a pilaster with an Ionic capital and a straight lintel, whereas a curved lintel would be a more archaeologically accurate reflection of the rococo style. Further details that seem barely rococo are a single rather than a double door while there is no over door or roundel above. An oval portrait with garlanded frame and an oval mirror of starved proportion are in period. The problem of anachronism did not arise with the title page of the first issue owing to the use of the stage curtain that masked the ceiling and upper part of the wall.

Beardsley's other offerings in this issue are discussed in chapter 8. "A Footnote" that accompanies the second installment of "Under the Hill" bears no direct relationship to the narrative, though it may have underscored the connection with the Abbé "Aubrey" in the manuscript version of the story. The spavined legs of the figure here certainly resemble those of "The Abbe" (and the 1893 "Siegfried"). The artist is dressed in an eccentric upper costume that is neither coat nor shirt nor smock, though it may retain despite its hatching some vestige of the Pierrot outfit with enormous rose blossoms masquerading as buttons, tight white trousers, and carpet slippers; blossoms also compose his belt and cross his knees. He has faun's ears and ports under his left arm a draftsman's pen as large as a billiard cue: Beardsley's ears *were* rather pointed. The artist is bound to the god of limits and is tethered by both feet to a slender term of Pan whose head is half turned from the spectator. The term is an inverted penis, Pan's haunches providing the scrotal element. Trees in the artist's eighteenth-century manner furnish the left background.

In July the *Savoy* was transformed, with unfortunate economic consequences, from a quarterly into a monthly. The change also placed more strain on Beardsley. The only distinguished drawings contributed by Beardsley to this issue "The Coiffing" and "The Cul de Lampe" are discussed in chapter 8.

With the cover design for the September issue, Beardsley resumes the style of the cover design of the first. At the extreme right, two figures, a somewhat effeminized male in white with a seventeenth-century style hat and a woman in black, appear to be caught in wordless colloquy. The man's right hand with its double jointed fingers

points down in a gesture that may as in "The Mysterious Rose Garden" command silence and suggest mystery. Behind the figures along the upper frame reach giant trees and, half masked by this romantic vegetation, a large urn on a pediment can be glimpsed at the extreme left with a repulsive mask in profile with open mouth halfway up the flank. Behind and extending along the center of the drawing space is a lake with a pure black background of what are either low hills or dense trees with one cadaverous term on the farther shore standing in rather odd perspective before the boughs of the large trees on the right of the drawing. Unlike the cover design of the first issue, this is somewhat perfunctorily drawn and may not be unrelated to the bogus signature "Guilio Floriani." Here the weight of natural growth assumes a faintly sinister aspect. If not one of Beardsley's more eloquent images, the design remains evocative.

Beardsley's one other contribution is a half-tone reproduction: "The Woman in White," which Reade[5] relates drawings from the *Bon-Mots* series. Here we see a woman in back view with hat, coat, and frock, arms concealed, body so attenuated as to suggest some more refined medium than flesh or at the other extreme a scarecrow, set against a totally black ground. There has been some discussion as to whether this drawing has a discursive content, for it suggests the girl who gives her name to Wilkie Collins's novel of the same name. Beautiful and unstable, she wanders mysteriously in and out of the narrative, carrying vague and dangerous secrets with her. Through much of the book she is in flight from villains and would-be friends and her flitting barely defined figure mutates into darkening landscapes so that Beardsley could indeed have intended to produce some such effect in his drawing. On the other hand, the title could be Whistlerian and function as caricature. The image is not altogether without drama and indeed if we sense it as an empty frock and hat hanging on a peg, we may be reminded of various poems of absence, or even of Yeats's lines: "Fifteen apparitions have I seen; / The worst a coat upon a coat-hanger."[6]

The topic of the cover design of October issue is culled from Wagner, "The Fourth Tableau of *Das Rheingold*," and has been addressed with the other Wagnerian images in chapter 8. These formed part of an unachieved notion of illustrating the whole of *The Ring*. Here Wotan, with unseen arms folded and head cut off by the top frame, stands on a dotted rococo cloud. One horn projects from his stylized female hair in less fetishistic mode than contemporaneous art nouveau. Loge is calligraphically lined with spires of curvilinear flame, and the hair

on his chest flame-shaped also runs vertically, while the pyramidal shapes on Wotan and the mountains in the background contrast with Loge's art nouveau curvilinear apparel. The forms of Loge in both third and fourth tableaux are, as Reade remarks,[7] quite without precedent in the art of Europe, and the fourth tableau is also boldly disbalanced in the manner of Beardsley's previous phase. Both images closely illustrate Wagner's libretto and his music (the flickering flame motif), and if, like most of Beardsley's finest work, they can exist independently, they also enhance and are enhanced by the text from which finally they evolve. Beardsley's most extravagant flights are, as often, devoted to the figures of evil.

Beardsley's illness was intensifying, and as he self-consciously approached his own death this inspired a different species of irony. "The Return of Tannhauser," "Ave Atque Vale," "Et in Arcadia Ego," and a second version of "The Death of Pierrot" all reveal his concern to make some final statement about that forthcoming event and with varying degrees of seriousness. Beardsley's letters show him postponing "The Death of Pierrot" for one issue of the *Savoy* and a concern that "The Return of Tannhauser" should occur at the end of the collection *Fifty Drawings*—death too was a near and consistently postponed event. Rather like Carrousel, Beardsley seems to conceive of himself *as* his art: hence the famous letter imploring the destruction of the *Lysistrata* drawings, which shows a concern for his name with posterity as much as a religious revaluation, implying that by destroying certain of his drawings both his public character and his soul will somehow be purged. Another covert reference to himself and to his art occurs in the references in "Under the Hill" to the art of Dorat, the late eighteenth-century French author: "Within the delicate curved frames lived the corrupt and gracious creatures of Dorat and his school, slender children in masque and domino smiling horribly, exquisite letchers leaning over the shoulders of smooth doll-like girls and doing nothing in particular, terrible little Pierrots posing as lady lovers and pointing at something outside the picture, and unearthly fops and huge bird-like women mingling in some rococo room, lighted mysteriously by the flicker of a dying fire that throws great shadows upon wall and ceiling.[8] Beardsley seems to ironize the strangeness of his own career, the opacity of objects when silhouetted in prose "doing nothing in particular" yet with their radiating suggestiveness reflected in all the lavish adjectives. However, the last clause remains puzzling: Beardsley rarely drew a shadow or a ceiling in his life so that the reference must be metaphorical. Beardsley

himself is that mysterious "dying fire," so aligning himself with Wagner's Loge who disappears also like a last flicker of fire.

Such speculations naturally become more pointed when we turn to "The Death of Pierrot" which carries too an inscription like the earlier "Portrait of Himself" (*Yellow Book,* vol. 3) where he lies tiny and vulnerable in a large bed. The program note of the "Death of Pierrot" runs: "As the dawn broke, Pierrot fell into his last sleep. Then upon tip-toe, silently up the stair, noiselessly into the room, came the comedians, Arlecchino, Pantaleone, il Dottore and Columbina, the white frocked clown of Bergamo; whither, we know not."[9] The Italian forms of the names are for Beardsley unusual, but we may presume that the prose is his own. Pierrot is once more shown, tiny head in vast canopied bed, not this time asleep but dead, with a bulging forehead that suggests the fetus image (soon to be discarded forever in Beardsley's oeuvre) with a bandage for headdress round the sharp contoured features of the dead face. Over a chair to the lower left hang the Zanni's hat and robes while the familiar poignantly empty slippers found in "The Dancer's Reward" are placed side by side on the floor. Here the identification of Beardsley with Pierrot is complete, as is his identification with his doomed contemporaries, whose emblem Pierrot was, and the identification with his own works is consummated by the entry of the other *commedia dell'arte* figures that had been prominent in his iconography—identification also, therefore, with his "afterlife," his reputation. The procession of mourners is led by Columbina with index finger to mouth in the by now familiar ritual gesture of silence, initiation, on this occasion into death and fame. She is followed by Arlecchino, with finger to mouth also, il Dottore and Pantaleone in a line, so forming an echo of the valance and architrave of the bed, and this horizontality contrasts with the verticals of chair, curtains, and implied bedposts. Reade[10] praises the brilliance of the composition; certainly and appropriately it uses the artist's full range of resource to express patterns and textures. The comedians are all on tip toe so that the feet of this band of figures slant upward. The injunction to silence spells respect for the dead and fear of waking him once more to the fever of life, but the last note is not one of self-pity. Columbina's voluminous skirts up against Pierrot's dotted hat readily group themselves into the familiar theater of penis and testicles.

The final contribution to the November 1896 issue is a pen and ink sketch of Tristan and Isolde, both parties with the familiar fetishistic hair-do and with the taller Isolde as usual dominating the situation as

she watches Tristan drink from what she assumes to be a poisoned chalice. The drawing is a reduced version of the *Morte Darthur* image. We may associate it with the more striking version of Isolde, a drawing in gray washes, which was translated into a color lithograph in the *Studio* for October 1895. It is not, however, certain that Beardsley would himself have determined the colors, black, strong red, and white, with the pleats and folds of Isolde's garment picked out in muted gold. These are the simple bold colors of Beardsley's poster work, and are in agreement with the colors he chose for the few of his original drawings to which he added color. Isolde's dress in the *Studio* image appears to be contemporary and, as in the *Savoy* version, the act of drinking from the chalice occurs before a red (lurid even) stage curtain, accenting the Wagnerian context and the tragic inevitability. But the differences are revealing. In the *Morte Darthur* image the chalice appears to be incised with Celtic decoration; Tristram is clearly Japanese, and there is much floral elaboration. In the *Savoy* drawing a floriated console of an equal elaboration hangs over Isolde's head, and three defunct petals litter the ground between the two figures (with a significance similar perhaps to the petals in "The Mysterious Rose Garden"). There is no stage curtain in the *Morte Darthur* and in the later drawing the modeling of the robes is somewhat complexly sculptural. In its union of love and death, the espisode, the music drama itself, remained a constant preoccupation of the artist. It is one of the features of his art that he returns again and again to specific subjects, never more so than in this phase, and repeats the same moment of the drama. He does so yet again in the last issue of the *Savoy*.

This appeared on 8 December 1896. Symons and Beardsley between them furnished the entire letterpress and artwork. The cover design shows a figure in a mob cap and baggy Oriental trousers on a tilting stool; that, so Reade suggests,[11] was intended for the Ali Baba series of illustrations broadly of the same period. Those will be glanced at later. Beardsley returned yet again to *Tristan and Isolde* which had featured in the seventh issue. It is prefaced by a bar of Wagnerian music, the *Sessnücht*.

"Mrs. Pinchwife," part of an abortive design also for a set of illustrations, shows William Wycherley's naive "country wife" learning the customs of the town in her male disguise. The theme reminds us that Aubrey and his sister enjoyed dressing up in the clothes of the other sex, and on one occasion the brother thought it would be a lark to costume himself as a tart and haunt the bar at the Criterion. Manifes-

tations of transvestism in art also attracted him from the element of theater in the procedure. Boy actors' impersonation of female roles in the Elizabethan and Jacobean theater is as well known as the puns and ironies (in Shakespeare especially) associated with the practice. Since the eighteenth century, adult female representations of males had been a theatrical convention and not necessarily burlesque; in the Victorian period, though, males impersonating females had become "largely an excuse for the soothing of unnecessary ambivalence by laughter." In his drawing of Mrs. Pinchwife Beardsley insists on charms of plump thighs and high ripe derriere accented by trousers. Wycherley, like Shakespeare, accepts the convention that masks are rarely pierced, so the country wife like Horner, the ruthless sexual-machine hero of the comedy, in his disguise as eunuch remains impenetrable: she to her husband, he to the husbands and lovers he cuckolds. As the "sign of a man" he appears more attractive to the opposite sex, so too a woman in disguise, whether Mrs. Pinchwife or Mademoiselle de Maupin, will appear more attractive to men.

If we except the cover design of *The Book of Fifty Drawings* that appears in the advertisements, Beardsley's last contribution to the *Savoy* is another comment on death. "Et Ego in Arcadia" is a famous formula found frequently on tombs. The word "sum" can be understood and Erwin Panofsky has argued that "Et" modifies "Ego" so the phrase can be construed as "Even in Arcadia, there am I" that is, Death. It is the tomb that speaks, not the occupant as is more usual. But "fui" can also be understood, "I too [i.e., the corpse] was once in Arcadia [where you the reader live now]," a more conventional reading. Beardsley's drawing shows an elderly dandy holding a diminutive cane and gloves in his left hand while his right hand is pressed into the small of his back or perhaps holding an invisible hat. A long coat, button boots, cravat, spats, and a waxed moustache contribute to the suggestion of a retired army officer paying a call. (The face distinctly recalls the dandiacal Sir Max Beerbohm in his last years.) This elegant survivor tiptoes on pointed feet across the flowers. Whether this suggests satyriasis, trepidation, or merely, like Charles Dickens's Mr. Turveydrop, "deportment" is not precisely clear. The object of his approach is a large pedestal surmounted by an urn with swags joined by a bow on which the formula is written in plain capitals. The urn and pedestal are clearly a tomb surrounded by a yew tree. Another variant could be, that, rather as though held in Henri Bergson's interior time, Arcadia endures alive in the memory.

The theme has certainly proved fruitful to the imagination of artists. Sir Joshua Reynolds gives us a portrait of two specially beautiful ladies set against a tomb with the familiar resonant epigraph. Later the rococo painter Fragonard depicts two Cupids embracing in a sarcophagus. According to Reade, Nicholas Poussin's famous "Les Bergers d'Arcadie" (The Arcadian shepherds) in the Louvre and Smithers's shop, which by the end of 1896 has been moved to Royal Arcade, London, are alluded to.[12] But Watteau's *fêtes champetres* seem more relevant. It has already been suggested that Beardsley was attracted in this phase of his art to Watteau's landscapes; here the attraction is to his themes. The *fêtes galantes* may be allegories of transience, but, as Erwin Panofsky puts it in his classic examination of *Et Ego in Arcadia* in Renaissance and later art,

the [*fêtes galantes*] neither visualize the annihilation of the past, nor the persistence of ideal forms outlasting the destruction of matter. They depict the fading of reality as such; existence itself seems to be subject to transience; past, present and future fuse into a phantasmagoric realm in which the borderline between illusion and reality, dream and wakefulness, nature and art, mirth and melancholy, love and loneliness, life and the continuous process of dying, are thoroughly obliterated.

[Watteau] is perhaps the only artist who conceives transience as the abolition of the boundaries, normally sensed to be insurmountable between the various spheres of thought and feeling. To him the universe means nothing but a fluctuating, permanent though not eternal, defying limitation though not infinite, and which therefore makes us divine an identity between existence and nonexistence. Thus the conceptions of Watteau, serenely gay and playful though they seem to be, reveal a profoundly tragic attitude. . . . Watteau [was] . . . doomed to die in the prime of life, so that [his] whole existence was somehow detached from ordinary life, and overshadowed by the gloom of death [but] he avoided the traditional formulas of serious and tragic expression.[13]

And Panofsky proceeds by reminding us of Watteau's debt to Claude Gillot who had used the world of masquerade and the theater to escape sham seriousness. Watteau, however, turned this fictive world to deeper uses: he transfigures the picturesque elusiveness of the world of masquerade and theater, fusing them into a sweet and serene visionary whole, death and life, so that the boundaries between art and nature, between Cupidons and real children, and between both and garden statuary dissolve. Above all, Watteau presents the excluded figures, as

in his "most monumental" painting *Gilles*—the precursor of Pierrot, a figure deeply touched by awareness of the fluctuations of common life, melancholy, aloof, facing "the only non-transient reality he can accept, the void."

Like Watteau also, Beardsley's sense of transience does not lead him to burnish his formal landscapes falling to seed with the ruins, that so readily evoke nostalgia; but at the same time the garden accessories he scatters through his drawings are omen enough, either menaced by the slow surge of vegetation or somehow incongruous in their setting.

Beardsley's relation to the "Et Ego" tradition is that of iconographical caricaturist, but not in any superficial sense. It remains to ask what the elderly figure in his drawings represents, aside from the patent incongruity or unease of the self-sufficient dandy in any Arcadia and the contraposto of age and the *momento mori*? The dandy's void is within; he is all carapace. It is of course also possible that the implied theme is similar to that of Wilde's *The Picture of Dorian Gray* or more precisely that of John Gray's "The Person in Question," a short story in which the unreconstructed "decadent" young man meets his older self, or rather the older self which the logic of his present existence posits. Such a possible older self is for Beardsley of course an impossibility, and once more caricature is used to stem self-pity.

Drawings of the Period not Reproduced in the *Savoy*

We may conclude with other drawings of the period that, in spite of Beardsley's intensifying illness, reveal no failure in power. The two drawings of Ali Baba were intended as part of a set of illustrations to tell the tale of Ali Baba and the Forty Thieves, suggested to Beardsley by Leonard Smithers in July 1896. The famous projected cover design shows the hero large and complacent in the days of prosperity that followed his robbing the robbers of their treasure. Reade[14] observes that the black and white of the *Yellow Book* phase is combined with the "tense detail" of the intricate jewelry of the *Rape of the Lock*. Opposing styles unite in this arresting image. It is in brisk antithesis to the artist's own emaciated and far from prosperous state, represented more accurately by an earlier drawing that shows Ali Baba emerging from his hiding place after he has watched the robbers hide their treasure in the magic cave. Again Beardsley combines two styles: the heavy vegetation of the *Savoy* drawings "symbolized" by white dots of varying sizes on a black background. The same effect is less dramatically

achieved in "Et Ego in Arcadia." Ali Baba's fear is brilliantly presented
by his wide curving fingers, while the Turkish slippers, though curved
formally, also suggest a corresponding rigor of the toes.

"Atalanta"

The second "Atalanta" is a reprise of the subject of an 1895 drawing
belonging to the *Yellow Book* period. In that earlier design, the image
is disbalanced by the virgin huntress's elongated body and her right
leg half truncated by the left frame. Beardsley is illustrating Algernon
Charles Swinburne's *Atalanta in Calydon* and, as Wilson suggests, the
first two stanzas of the opening chorus in particular, though the later
drawing actually includes a hound:

> When the hounds of spring are on winter's traces,
> The mother of months in meadow or plain
> Fills the shadows and windy places
> With lisp of leaves and ripple of rain. . . .
> Come with bows bent and with emptying of quivers,
> Maiden most lovely, lady of light . . .
> Bind on thy sandals, O thou most fleet,
> Over the splendor and speed of thy feet.[15]

Atalanta's boyish waist and muscular legs along with her diffused an-
drogyny—she is one of Swinburne's many sadomasochistic muses—is
captured by the drawing. The reprise dating probably from early in
1897 is also disbalanced, though not emphatically. Atalanta now
emerges from the right frame with her right leg and half her right arm
truncated; she wears a large plumed hat in eighteenth-century mode,
with hunting boots below massive legs and thighs, and the breasts are
barely suggested in the line of her decolletage to show how suppressed
they are by her Amazonianism. An eager prize whippet or greyhound
covered in a patterned coat with a crown emblem bounds forward
across the lower drawing space.

The image justifies a phallic interpretation. The hound in his stiff,
aggressive, angled leap forward serves as Atalanta's surrogate phallus.
This effect is encouraged by the arrangement of limbs lower right that
are difficult to decipher. At first glance, the dog appears to be spring-
ing out from between Atalanta's legs, though on a closer examination
this proves not to be the case. The peculiar stalking posture of Atalanta

should be compared to the cognate Messalina images. Here the femme fatale overpowers in aggressive sexuality, whereas the earlier Atalanta is all gawky adolescent tomboy. The lace on Atalanta's hat, her hair (in uniquely graded dots as Reade observes)[16], and the fringes of her dress, are spotted in the style of the *Savoy* period drawings, but there is neither foreground, middle ground, nor offscape. Atalanta moves through the white void of the *Salome* illustrations. The oddities of this striking piece may result from Beardsley's admission that he was burlesquing Swinburne's huntress. The title is also given as "Diane," and the opening chorus, to be sure, is addressed to that goddess, though Atalanta acts as Diana's surrogate in the play.

An unfinished ink drawing also illustrates a classical topic: the pursuit of Daphne by Apollo and her metamorphosis into a tree. The god strides through a vacuum, but there is no dotting or other rococo feature, though the unfinished stage of the drawing constrains comment. Apollo's robe attached to his waist by a thin cord swirls about him in baroque fashion. His figure has a youthful plumpness, is almost androgynous: the small high juicy buttocks, faintly rondured belly, firm, full slanting thighs, and mutedly protuberant breast suggest a sculptural analogue and an affinity with "Ave Atque Vale," though without the monumental gravity. A backward flowing aerial curl echoes the vortex of the robe. Apollo's right hand almost touches the right frame with an invisible thumb grazing a morsel of Daphne's breast just beneath the nipple, while behind the hand six or seven curt vertical lines represent economically the vegetation into which the river nymph is being metamorphosed. Despite the agitation of robe and hair, this drawing has a gravity and dignity that hints at the seventeenth-century neoclassic rather than the baroque, and its alignment is with both the "Ave Atque Vale" and the "Et Ego in Arcadia." These images can be seen as a preparation for a phase of Beardsley's art that death was to interrupt.

Chapter Eight
Illustration, Poster, and Book Design

Beardsley is known primarily as illustrator. He is also a decorator of books, particularly in the designs he accomplished for the John Lane Keynotes series and in his occasional commissions for book covers.

The story of book illustration begins with Pre-Raphaelitism. Other energies in the field deserve comment, but the revival of book illustration of the 1860s in such periodicals as *Good Words* and the distinguished book covers and typography of the 1890s derive for the most part directly from the circle of Rossetti and Morris. We generally associate this end of century decade with Kelmscott and the private press, but an important feature of book production at this time lies in the influence that designers exerted on commercial publishers in the direction of improvements in design.

The history of book production, mainly in the private press, parallels the aims and to some degree the history of "advanced" literature and art at the end of the century: the movement toward total art in which all the elements present, involving paper, type, cover design, frontispiece, title and contents pages, end papers, initials, and borders, are synthesized to form what Yeats was to call "the Sacred Book." Yeats's model, of course, was William Blake, mediated through the Pre-Raphaelites, particularly in those illuminated books where image, color, and text unify the page. Commercial publishers like John Lane, Elkin Mathews, and Leonard Smithers were naturally less ambitious. However, their use of distinguished artists to decorate their books and the issue of limited editions in anything from two hundred to five hundred copies and of large paper editions of ten to fifty copies, indicate that there was a public sufficiently attuned both to "advanced" books and to their book decoration.

Rossetti's brilliant, assymetrical, and ahistorical cover designs for his own *Early Italian Poets* (1861), for Christina's *Goblin Market,* and for Algernon Charles Swinburne's *Atalanta in Calydon* had no real succes-

126

sors until the work of Charles Ricketts in the 1890s. Ricketts, like Morris, moved from commercial to private press work; Beardsley, however, moved more or less in the commercial world throughout his career, for even Smithers's limited and underground volumes may be termed commercial publications.

From the 1830s on paper boards began to cede to cloth, and in that same decade we encounter modest gold blocking, a carryover from the gold tooling on the leather that had been in general use before. In the 1850s ornately ornamented bindings, often connected with the religious movements of that time, Evangelical and Tractarian, and reflecting the Victorian taste for what was hopefully considered to be Gothic, make their appearance, and in the same decade and its successor, polychromous bindings and gold blocking laid on pasted paper. Gold block on color also appears in the 1860s, but we have to wait until the 1890s for diffused binding in several colors and without gold (though individual bindings of this order can be occasionally found earlier in the century). Here, the influence of the poster is marked.

The girl and the bookshop of Beardsley's cover for John Oliver Hobbes's *The Dream and the Business* (1906) is bodily transposed from poster advertising T. Fisher Unwin's the Pseudonym and Autonym Library of 1894, but the colors are bolder than the muted shades of the poster. The original drawing reflects that disbalance Beardsley had learned from the study of Japanese prints; the result, as Reade suggests, is to dramatize the figure and suggest motion toward the empty space, as in the somewhat earlier frontispiece to *The Wonderful History of Vergilius the Sorcerer*. The bookshop toward which the woman is edging is placed immediately beneath the top right-hand margin of the rectangular panel that takes up two thirds of the design. Two trees and the two black horizontal lines of the outer margin accent the verticals, but the pavement outside the bookshop delicately curves, echoing the curves of the woman's long dress. The image of a woman gingerly moving toward a bookshop is a variant on the "forbidden knowledge" theme of such drawings as "The Mysterious Rose Garden" or, treated more satirically, "L'Education Sentimentale." In the first two images, there may, of course, be no knowledge to communicate.

What may be noted in general is the persistence of traditional motifs on bindings. Often this takes the form of assuming into pure decoration what had before been partly utilitarian, such as chords, and occasionally the detail in Beardsley's bindings seems to reflect that mode. In the 1880s we encounter also modulation into witty rearrangements:

endpapers become covers; title pages disappear, and there are conscious attempts to confuse the eye into reading as abstraction what is actually discursive and relates to the world of objects.

Early Title Pages and Bindings

Walter Crane (1845–1915), a total artist, had some influence on Beardsley both in his emaciated Pre-Raphaelite figures and through the stylized flower forms and vegetation on borders. However, Crane's unification of letterpress and drawing through the organic quality of line has only an early and marginal influence on Beardsley in such works as "Dante in Exile" and "Withered Spring."

More important an influence is art nouveau, evidenced first in the title page of Arthur Heygate Mackmurdo's *Wren's City Churches* of 1883, with its whiplash style, contrasting with geometrically drawn sans serif letter forms, pillars, and phoenices surging from the flames of the Great Fire of 1666, which gave Sir Christopher Wren his opportunity for rebuilding London's churches. The pillars indeed form the only concession to the book's topic: Renaissance architecture. They prefigure the more traditional rectangular structures of the cover designs and title pages of the artists of the Century Guild founded in the same year as the book appeared. On the title page of the Guild's house journal the *Century Guild Hobby Horse* of 1884, we encounter Morris medievalism, an art and craft *horror vacui,* the title in scroll and Burne-Jonesian tangled and curving vegetation. Beardsley drew extraordinary eclectic variations of the pillared rectangle frequent as a mnemonic on Renaissance title pages, but influences other than the Century Guild, whose lines are severe, supervene: Burne-Jonesian brambles, Botticellian lilies, and, to the right of the design, thick stylized wavering lines in a Japanese vein represent the ground in the projected cover design for the *Morte Darthur.* The *Studio* poster and wrapper of broadly the same date in 1893 have the scroll, a similar imagery, and a similar *horror vacui,* but the list of contents in both italic and roman capitals and the calligraphy in general are not distinguished.

Mature Bindings

The front cover design on the bound volumes of *Morte Darthur* is a fully mature work, representing as much of a leap in Beardsley's art as

the "Siegfried, Act II." The drawing for the ordinary edition in two volumes and the handmade paper edition in three volumes has slanting scythelike leaves moving across the spine in menacing formation with small-tongued appendages beneath and two blossoms of different species and sizes at the top and bottom. The bottom blossom, according to Reade, is a Beardsley hybrid, part Passion flower, part Clematis, and possibly part Tulip.[2] These hybrids and slanting leaves with curvilinear art nouveau stems are repeated on the front cover. The designs are stamped in gold on a pale sand-colored vellum. The cover is not discursive. We could hardly gather what kind of text lies within; the connection is entirely in terms of imagery, though that imagery amounts to Beardsley's comment on the text. Similar erect blooms and tortured lines inhabit the borders of the cardinal images in the *Morte Darthur,* particularly those connected with Tristram and Isoud.

The Front Covers of *Salome*

There are two designs for the front cover of *Salome*. The first offers a thick screen of peacock feathers with serpentine stems with scythelike leaves at the top left and right borders. Below is a Japonesque ground, so that the space becomes a spicilegium of aesthetic movement and fin de siècle decadent imagery. Beardsley's three candlestick images at the bottom and the lettering of title and author's name provide a small horizontal counterbalance. Peacock moons are strewn at the lower sides of the border in this dramatic, if not altogether satisfactory design which, as with the *Morte Darthur,* reflects the artist's own images within the cover.

The second cover design is far simpler in its gold stamping on green silk for the limited edition. The imagery is centered, compact, and transposed into the subtly assymetrical by the disposition of roses on the outside and the two-tongued exterior leaves, one again assymetrically placed, three free floating and one attached blossom rose, dots and stems composing a single form with dangling roots that suggest the unnaturally organic, so that the hermaphrodite on the title page, had it survived in its original and threatening enigmatic form, would have perfectly complemented the outer imagery. The leaves can be read as vulval and so connect with the play's themes, and the whole device becomes a seal or cipher guarding a book of forbidden knowledge that solicits but also repels decrypting.

Keynotes

Beardsley furnished, on commission from John Lane, twenty-five cover designs and title pages for this series. The title took its name from the initial volume by one of the new women, "George Egerton," otherwise (though not for very long) Mrs. Chevalita Dunne Bright. The first three front covers and title pages had panels placed to the left. For the rest, the horizontal panels of ornament were placed below the titles. This series of designs runs from 1893 to 1896 and has generally, not altogether justly, been dismissed as unimportant. Beardsley was essentially a short-winded designer; his threshold of boredom was low though the *Bon-Mots* are an exception. He was free there to follow his own impulses. A certain repetitiveness was inevitable as the Keynotes accumulated. The earlier efforts are not without distinction, and the color tones are often attractive.

In place of a cipher, on a number of the designs we have the image of a key, each involving the initials of the author. These are all ingeniously differentiated. Each design has double borders. The left placed panel of the first volume is *L*-shaped with a fat base, and the imagery suggests that Beardsley was using a drawing more or less from stock. A Beardsley woman with parasol and voluminous hat with back bows and streamers floats above a Pierrot. It is carnival time, and he appears to be supporting the lady with a gondolier's pole while a dwarf with deadpan Pierrot face strums a mandolin on which hang two hairy masks doubling as kites. The panel containing the title forms a third border line connecting to the right with the double flame by a thick black line.

The witty cover design of *The Dancing Faun* by the actress and "free woman" Florence Farr, intimate friend of Bernard Shaw and W. B. Yeats, has a panel divided into four parts. A faun sits at attentive ease on a Regency style sofa clasping one doubled hairy leg while the other dangles languidly. It has acquired the face and monocle of Whistler, but the half-hidden contour of its right breast is feminine, the body is slender and hairless, while its extended leg is pared almost into nullity and ends in a dainty shoe with a black bow. Behind this androgynous figure a standard lamp is established by wafer-thin lines.

Imaginative rather than witty is the cover design of George Moore's translation of Fyodor Dostoevski's *Poor Folk* with its heavily massed blacks on a yellow ground. A young girl looks over the parapet of a roof garden. Below her a drainpipe is displayed, described by Wilson

as "the most elegant piece of plumbing in the history of art."[3]

The unfinished and unusual design for Arthur Machen's satanic science fiction novelletes *The Great God Pan* and *The Imost Light* is far more forcible than the actual published cover design and title page where a dainty satyr has strayed from the initials or borders of the *Morte Darthur*. In the unfinished design a horned Pan is attended by two putti wreathed, or perhaps even bound in tendrils. Beardsley clearly responded with enthusiasm to the religious pornography of Machen's story. Pan, at this time, presented two faces: the demonic, and the whimsical Home Counties piper of Kenneth Grahame's *Wind in the Willows*. The head of Pan grew too large for the panel; it has little suggestion of the benevolent world-soul, let alone Grahame's piper at the gates of dawn, but clear overtones rather of the post-Christian image of the diabolic goat of the Sabbat.

In the bottom panel of H. D. Traill's *The Barbarous Britishers* (1896), last of the series, itself a parody of an earlier novel *The British Barbarians* by Grant Allen, the artist parodies his own earlier design. As if illustrating a fairy tale, recalling perhaps the walking trees of George Macdonald's *Phantastes,* the trunk of an old tree in a suburban garden has acquired a face and winks at the spectator. The trim maid on the cover and title page of Grant Allen's novel bringing out a tray for an al fresco tea is now supplanted by a sour skivvy bearing boot brushes or perhaps the materials for cleansing the bowl of a water closet. Grant Allen was a prolific libertarian sensation novelist, author of *The Woman Who Did,* while Traill was a highly conservative critic and parodist: Beardsley amuses himself at the expense of both.

Plays by John Davidson

This remarkable frontispiece is a gallery of caricatures in black and white, the black masses predominating. It was, it seems, intended to illustrate the best of Davidson's early closet dramas *Scaramouch in Naxos,* though apart from the black carnival figure of the minor poet and belletrist Richard Le Gallienne it appears to evade contact with the text. A nude Mabel Beardsley is partially hidden by an Oscar Wilde "with vine leaves in his hair," the phrase used by the great aesthete and his circle for being tipsy. A faun, commonly identified as Harland but perhaps as Reade suggests[4] a self-portrait, hangs a corona of hair that masks the nude's private parts. Sir Augustus Harris, a well-known impresario, is centered. His face is a masklike lunar disc, while to the

lower right a ballet dancer, Adeline Geneé, poses a butterfly on her lifted right hand. Wilde's legs, like those of the artist himself in his self-portrait of the *Savoy* period, "A Footnote," are roped together in allusion possibly to his insensibility to Mabel's charms. What gives this design force is the context: two attenuated white trunked trees and a large irregular spiral of spilt white at top right against the massive black ground establish an impressively abstract background. Two splashes of light behind the dancer suggesting spotlights and the artist's emblem also in white provides minor counterpoint. The manner in which Harris's morning dress emerges from the black—small white dots for trousers and part of the frock coat—is masterful also, though the design as a whole is hardly unified.

Sappho

A quiet and effective cover design for the third edition of Henry Thornton Wharton's translations of the fragments of Sappho, the sixth century B.C. poetess from Lesbos, is mutedly assymetrical with its double border, the middle more than twice the size of the other two. A faintly elongated lyre centered somewhat high is flanked by two versions of the Greek letter *psi* within a dotted and inverted pear shape, twice repeated on the spine. At the four corners in the outer panels the psi is replicated. Some suggestion of Rossetti's early designs is pervasive but without the marked assymetricality of those. Here Sappho "smites 'er bloomin' lyre": delicately discursive, the design achieves, as Reade[5] admirably puts it, a "meagre or minimal excellence," a further expression of the aesthetic ideal of such fin de siècle poets as Lionel Johnson and Ernest Dowson and, in the graphic arts, of Charles Ricketts.

The Mirror of Love

This design was intended as the frontispiece to *The Thread and The Path,* a volume of poems by Raffalovich published by David Nutt in 1895. The publisher, however, rejected Beardsley's drawing, for in his view, despite Beardsley's demurrer, the human figure represented was a hermaphrodite. The idiom of the drawing relates to the crowded efforts of the *Savoy* phase with its rococo elaborations, though the massy base of the complex of candelabra is founded, so Reade[6] informed us, on a sixteenth-century German lamp. The base ends in a censer-

shaped object with an approximation to a curling flame, and the ex-voto suggestion is rendered more plausible by a thin grid with small spikes supporting a row of ecclesiastical tapers. The base sprouts in two eared leaves on either side, and behind those a metal stem curves up to sustain two five-branched candlesticks with further votive candles while two heavy poles to right and left support two shallow shell forms. Roses and coiling stems hang from inverted shells above. The two ends of a pin piercing these poles issue in winged phallic decoration that recalls the Roman winged phalloi at Nîmes that the artist might have encountered in plates for Thomas Wright's *The Worship of the Generative Powers During the Middle Ages of West Europe* (1866). What the pin supports is a heart-shaped mirror enclosing a nude figure with a penis so dormant as to be virtually capable of being read along with its small scrotal sac as a slat. The lower belly is quite devoid of pubic hair, like a Victorian ideal nude in an academic painting. The figure has male breasts, slender body, effeminate features, and long hair. It is androgyne rather than hermaphroditic, appealing rather than threatening. A large pair of wings pursues the line of the heart-shaped mirror, composed of the familiar tongued leaves: vulval counterpoint to the phalloi. A miniscule pair of differing sized wings fledge the ankles. Vulval and more prominently phallic imagery accrete rather densely.

What this image attempts to express is the theme of Raffalovich's poem: the quest through the labyrinth of the world and the flesh for the Uranian ideal that involves and transcends both sexes. When discovered it will be found to be the quester's double. The intended frontispiece could be read as the positive version of what is satirically expressed in "The Platonic Lament" from the *Salome* sequence. Unfortunately, "The Mirror of Love" has a convoluted fussiness that makes it manifestly inferior to the earlier image.

The Rape of the Lock

The four different covers for the four editions of *The Rape of the Lock* are the most impressive aspects of the volume. According to Reade,[7] the strength and beauty of the indian ink drawing were modified on the gold on blue cloth of the ordinary, and more distinctly so on the vellum of the large de luxe edition. The contrasts of vertical straight wavering lines and elaborate candleholders and the scissors of the oval marry exuberance with severity. The two bijou editions issued the following year (1897) are equally attractive: the gold on vellum of the

large paper and the gold on red cloth of the ordinary edition. Vellum tends not to wear well and blurs complex imagery. By 1896 and early 1897 Beardsley had become the equal of the finest cover designers of his time, and, at a point in the chronology of his art that produced a number of less satisfactory drawings, the *Savoy* period, he was able to use the rococo idiom for his book covers in a manner that overcame some of the limitations that his ancien régime models had imposed.

Verses by Ernest Dowson

Type poet of the 1890s, Dowson was master of the small lyric sigh, the delicately personal music. He has survived in a scatter of anthology pieces, one of which has the refrain that has served as epitaph on the poet's life and art—"I have been faithful to thee, Cynara! in my fashion"—and that same poem contains a line that has become proverbial enough to have been heard in Hollywood: "I have forgot much, Cynara, gone with the wind." And Dowson is as typical in his life, which was as untidy as his art is daintily costive. He was a devotee also of all things French and spent most of his last desolate years in Paris and Brittany. Beardsley was somewhat equivocal about Dowson as both artist and man. When a well man, Beardsley enjoyed his company and no doubt appreciated his attempts to chasten late romantic sensibility with classical rigor, but Dowson's grubby Bohemianism was distasteful, and as Beardsley's illness intensified, he may well have extended his dubieties to an art that, however chiseled, seemed, by the side of a Racine or a Pope, jejune and void. Such equivocation is possibly present in the cover design, gold on vellum, of the *Verses* of 1896.

This can rightly be termed the purest "design" that Beardsley ever did. There are three curving lines that look as though they should, but do not, tie together the corners of the frame that Beardsley has set them in, which in turn almost but not quite coincide with the cover. Yet as we look closely at those curving lines (he had used them in 1893 for "Les Revenants de Musique"), we may see that we are being referred not simply to the abstraction "design" as related to "book cover," but to the relationship between lines and the notion of art nouveau plant forms, from which they are derived. And we move still further from abstraction when we realize that the lines form a *Y* whose message has become the medium: "why was this book ever written?"

The Houses of Sin and *A Book of Bargains*

Vincent O'Sullivan, an expatriate American of the same generation as other gifted expatriate writers such as Stephen Crane and Harold Frederic, spent much time in England from early on; he was an undergraduate at Oxford; later he was to live in France. He was talented poet, critic, and essayist and published novels and short stories. Beardsley admired the poems in *The Houses of Sin* and produced a design that is both sumptuous and a guide to the content of the volume. The design is repeated on both front and back covers. The panel to the right is in form of a squat unfluted column rioting with rococo decoration and what appears to be a capital with possibly an Ionic volute. This echoes in reverse the *L* panel of *Keynotes*. A winged head, a woman's blending into a sow's, emphatic lashes, pendant ear ring, nuzzles. The title poem has these lines that sufficiently relate to Beardsley's design:

> Then, as a perfumed wind came glancing by
> And kissed me with a melancholy sigh,
> And wooed me to its lair
> Of flower haunted rooms. . . .

The sow-woman, with her head truncated below the chin and her wings, operates as iconographical parody, as a baroque cherub or emblem of the wind. Reade[8] suggests a possible source in Félicien Rops's "La Femme au Cochon" from *Pornokrates,* and there are fluttering cherubs also in Watteau's *The Embarcation for Cythera* preceding the woman in that painting. This is one of the most incisive and experimental of the cover designs.

The book's format is narrow and horizontal, though not so manneredly as the Persian Saddle Book shape of Ricketts's design for John Gray's *Silverpoints* of 1893. Beardsley had originally intended that the design should be printed in gold upon black smooth cloth, though purple also suggested itself to him. Wilson[9] opines that though these alternatives were interesting, they could barely have been more effective than the final choice of gold stamped on vellum. Both the Dowson *Verses* and *The Houses of Sin* were, after all, not precisely *livres d'occasion* or part of the room furnishings; they were intended to be looked at on occasion for mood music or phrase.

Beardsley also designed a frontispiece for *A Book of Bargains* (1897),

macabre short stories. The figure of a woman is established below the hair, face, and shoulders by dotted lines that contrast with the solidity of the only furnishing, a desk, and represents an apparition from the first story of the book. The facial type resembles that of the faces in the Mademoiselle de Maupin illustrations, the image of the Roman dancer "Arbuscula" and the bookplate of the same date for the poet Olive Custance, after Lady Alfred Douglas.

A Book of Fifty Drawings

The front cover of *A Book of Fifty Drawings* dates from about September 1896 and consists in gold stamped on green vellum, a material by now customarily used for large paper limited editions. Of two horizontal panels, the detail of the larger is condensed on the right side: a woman with body slanted toward a bird that connects the empty left side of the panel with the curtain, the woman, and a landscape background of women and trees. The facial type again somewhat resembles the other women of the last phase. Critics have lavishly praised this design, and its composition is indeed witty and capricious in Beardsley's best manner, an elegant shorthand. But the gold of the wide cushion, the bird, woman's hair, ground, and tree predominate over the green, and of the detail only the barely arresting tree shapes are at all sharply silhouetted. This is one of the last designs either signed or initialed by the artist.

The Pierrot of the Minute

That same distinction between trade edition bound in green cloth and edition de luxe in vellum is observed in the design for what Beardsley termed a "foolish playlet." Dowson's one-act piece is light both on length and substance, though it contains a few lines of evocative verse. Despite his contempt, Beardsley produced some delightful images.

Dowson's version of Pierrot capitulates to the sentimental, disappointed, and immature idealist of the middle of century rather than the more acrid figure of the fin de siècle. Pierrot's whiteness is connected with his devotion to the moon, or the surrogate moon-maiden, an Endymion myth, and on the front cover the moon-maiden is shown in what appears to be a full wig holding an hour glass with a minute amount of sand in allusion to the brevity of Pierrot's encounter with her. The image is enclosed within a triple border with a slightly larger space between and beneath the monumental Roman lettering. The

frontispiece shows Pierrot in a garden scene with trees, trellises, and an Eros on pedestal. This is no nearer to the actual gardens of Versailles where the action is presumed to occur than Dowson's "green alleys" that "most obscurely wind" (line 4)—more Keats than Le Nôtre. Beardsley's resigned or dazed Pierrot and the whole garden context clearly derives from Watteau's Gilles and his pastoral scenes. In the headpiece Pierrot has acquired the features of Ali Baba in prosperity, though with less calory power. In his left hand he holds an hour glass. The background with fountain and term is a purified version of the backgrounds of the *Savoy* cover designs. The initial letter *P* embodies images of beetles, perhaps a satiric comment on the real context of the lunar epiphany and Gilles recurs in the *cul de lampe*. Pierrot with a sour expression is detained within an oval and placed to the right with his face turned leftward. A sharp line on the scalp marks off head from hat so that he appears either as bald or uncanonically with full mask. Reade[10] comments on the "shells, stylized roses, garlands, and ribbons surrounding the vignettes in dots," a style inspired by other sources that became popular with book designers after the decline of the art nouveau idiom in the 1900s.

Volpone

The cover design was stamped in gold on turquoise blue cloth for the ordinary edition and in gold on vellum for the limited. Dating from November 1897, this was the artist's last essay in book design. A single border encloses a swirl of fronds, blossoms, and vaguely vegetal shapes with a small space slightly above center for the title. The design is not unattractive but hardly represents the radical development that many critics insist took place with the accomplishment of the *Volpone* drawings. Indeed, the imagery disconcertingly recalls Walter Crane's punning flower illustration to Shakespeare subjected now to some violent weather; or more relevantly perhaps Crane's interesting endpapers where we are never sure whether we are looking at pure pattern or what is actually discursive. No such tension exists here. Beardsley's design has no relation to the volume it covers.

Other Illustrations

What kind of judgments we can make on illustrations that do not in some broad sense cover the whole text has been much debated. It is argued, for example, that only when the whole text has been considered

and the climactic moments have been chosen for illustration can we judge the tact of inclusion and omission and possess sufficient evidence to decide the effectiveness with which the illustrator has mediated between word and audience. These criteria, however, are irrelevant to Beardsley, for he prefers to disconcert the reader, and his choice of the moment to illustrate will often therefore seem arbitrary. Two examples of brief or incomplete illustration may be mentioned. Four drawings only were commissioned by the Chicago publisher Herbert S. Stone for *The Works of Edgar Allan Poe*. In each case the subject is taken from a short story, and Beardsley focuses on a climactic moment.

The Works of Edgar Allan Poe

Drawn in the later part of 1894, these images relate to the black and white of the *Yellow Book* phase. Each, however, is attacked through a different technique. "The Murders of the Rue Morgue" on a white ground shows us the great ape carrying his victim dressed in her underclothes across an interior. Like the monkey bearers in the frontispiece to the Juvenal, the ape has human feet with long prehensile toes, nails manicured to a point, and a large earring. In profile, the beast's face mingles dinosaur with fetus. The woman's hair, her one draggling slipper, the knobs attaching the tassels of the curtain, and the candlestick emblems are the only black areas. The ape is clearly a degenerate aesthete.

"The Black Cat" illustrates the moment when the police break down the cellar wall in which the alcoholic narrator has secreted the wife he has murdered. When alerted by a "long, loud and continuous scream," the police act and the corpse is at once revealed: "Upon its head, with red extended mouth and solitary eye of fire, sat the hideous beast whose craft had seduced me into murder and whose informing voice had consigned me to the hangman. I had walled the monster up within the tomb." Wilson remarks: "the real compositional masterstroke lies in the stark opposition of the densely black cat and background and the pure white of the woman's face, a contrast compounded by a brilliant reversal of technique between the two from white in black to black on white. The dead whiteness of the woman's face has an absolutely literal expressive function since she is in fact dead."[11]

"The Fall of the House of Usher," an image of extreme simplicity, shows the last scion of the house brooding in a chair in a room bare of all but a curtain and the unseen chair in which he sits. He is muffled

in a large white cloak like a cerecloth. Reade[12] relates this drawing to one of Frederic (*sic*) Chopin in Beardsley's Japonesque phase of 1892.

The drawing for "The Mask of the Red Death" shows the moment when the revellers, enclosed in their palace of pleasure and as they think immune from the plague raging without, encounter in the midst of their frenzied carnival the image of the plague itself. In Poe's tale, Plague is masked as a skeleton but here emerges unmasked with pinched face dressed in white with a night cap—graveclothes are again suggested—at the right border with only part of his head, the pinched face, and the lower part of his voluminous robes visible. Four of Beardsley's icons face the white shadow: among them a Pierrot of dubious gender related to a similar figure in "The Scarlet Pastorale" with receding chin and bare scalp raised by a growth or a bruise, and a horned woman with bare breasts, loose ruffled and billowing sleeves, full pantaloons, and leaning on a stick. At her waist like trophies flutter three Burne-Jones cherub heads. Background is established by two curving vertical lines and a hanging tassel.

The True History

Of the five drawings for a translation of the second-century Greek satiric writer Lucian's *True History,* an early example of fantasy literature, two only were published when the volume appeared in 1894. Two of the five were entitled "A Snare of Vintage." Both relate to the episode in which the narrator and his companions come "among a world of vines whose tops were women, from the hips of them upward having all their proportion perfect and complete. . . . Some of them desired to have carnal mixture with us and two of our company were so bold as to entertain their offer, and could never afterward be loosed from them."[13] The first version of the episode showing the "carnal mixture" taking place was not used. The male victims of these cannibal dryads have mouths open in a blend of orgasm, astonishment, and horror as the symbiosis proceeds. Drama, however, is reduced by the distracting lushness and detail of leaves and vines, though this, to be sure, enacts the fertilizing effect of the victim's blood and juices. The second version is larger in size but compresses the action so that we see only the heads and upper torsos of the participants. The background is a white expanse on black which banally establishes itself as a cliff line abutting on the sea. It may be compared to its disfavour with the background in the frontispiece to Davidson's *Plays.*

"Dreams," which was published in the book, is an essay in the hair-line style with clear affinities to "Siegfried, Act II" and the nightmare vignettes of the *Bon-Mots*. The by now familiar icons include a fetus, a dragon with a hairy horn, two Medusa-like figures with hair resembling barbed wire, while a conventional female angel with pudgy legs bestrides the dragon and a corps of insects, butterflies, and hybridized grotesques appear in attendance. "Birth from the Calf of the Leg" and "Lucian's Strange Creatures" are exercises in the heavy black and white mode. In the first image, the fetus, part of the calf, and the midwife are mysteriously spotted. A pair of partly opened scissors points toward the idle genital parts of the mother, who is shown only below the waist. The strange creatures also reveal several lingering reminiscences of the *Bon-Mots*: A fetus, a symbiosis of cockatoo, angel, and man; a bald nude woman sumptuously curved, clearly a clothing store's undraped mannequin; and a winged insect whose upper shape is entirely defined by the fiery white dots of its eyes. The woman who holds the fetus is a Beardsley beauty of the *Yellow Book* phase and so too is the bald masked Pierrot whose main interest is the nude bald female. A few moons from *Salome* lie scattered about. From the lower right frame a genial cobra has emerged, while above it a monocled face bears the Semitic cast of the ladies in "The Wagnerites" and a horned woman with mooned hair, slabs of lips, wide nose, and exposed breasts. These are pungent images, but in spite of the black and white technique they leave an effect of negligent *horror vacui* and in general look backward rather than forward.

Posters and Oils

These must be summarily treated, though little that Beardsley touched is without his peculiar adornment. Poster design is a prominent feature of the 1890s, more particularly in France with the work of Cheret, Grasset, Lautrec, and Mucha, though Americans such as Will H. Bradley, Louis Rhead, and J. J. Gould, and German and Austrian artists all began to establish reputations in this field in the second half of the decade. The assault on the public eye by the bold colors of the poster parallels the typographical sensationalism of the "new journalism" and the popular press in general. As his essay on the poster makes clear, Beardsley was fully aware of the possibilities of the form, though he tended to use it to project his images in their autonomy rather than submit to the requirements of the client.

The Comedy of Sighs

This is the first of his posters and dates from early in 1894. Lithography was popular throughout the nineteenth century and developed in such a way as to allow artists to draw on the stone, and subtle tintings were now possible. The lithographic process was available for a work of art specially designed to exploit the medium. The subtlety of Beardsley's first poster, though, lies in its simplicity. A delicate color harmony involves blue, green, white, and a pale sand tint. The lower right-hand panel successfully overcomes the mid-Victorian incoherence of a message delivered in a promiscuous melange of types by some inventive calligraphy in green. It was the left-hand panel that struck viewers and critics. Here in color, at varying heights in public places, the Beardsley woman in her power and aggressive sexuality confronts the eye from behind a half-drawn lace curtain decorated with small green rondels and dottings that can hardly mute her helmet of hair defined by a white line in reserve; the broad sloping shoulders, the powerful forearm, and arrogantly relaxed arm; the slant calculating gaze and the broad nose closely set above the large wide bow of a mouth. In no way does she resemble the elegantly beautiful Florence Farr, with her sensitive mouth and crescent eyebrows, who was managing the Avenue Theatre production. The press reaction was exacerbated. The *Globe,* for example, found the mysterious female who "vaguely loomed" unnecessarily repulsive in facial type, and Owen Seaman of *Punch* in his 'Ars Postera" addressed the artist with a parody of Alfred Tennyson's Lady Clara Vere de Vere, ice to the mysterious female's sullen fire:

> Mr. Aubrey Beer de Beers,
> You're getting quite a high renown;
> Your Comedy of Leers, you know
> Is posted all about the town;
> This sort of stuff I cannot puff
> As Boston says, it makes me "tired";
> Your Japanee-Rossetti girl
> Is not a thing to be desired.[14]

Children's Books

In another splendid poster ostensibly advertising Children's Books such as *Topsys and Turvys, The Brownies at Home,* and *The Pope's Mule,*

Beardsley makes no concessions. Another sensual female sitting in a winged chair has a profile that suggests a younger version of the audience in "The Wagnerites." A huge (ostrich?) feather grows out of her hair, and her arms are enveloped in leg-of-mutton sleeves, conscious discords in clothing. She holds an open book that hardly strikes one as likely to be *The Brownies at Home,* though *The Pope's Mule* is perhaps a title of more promise. The subtle simplicity here is even more pronounced than in "The Comedy of Sighs," and the tones of flesh and the black and heavy pink are masterful. Beardsley's later posters are of good standard, though none equals these two. An exception is "The Spinster's Script" of 1895, which was probably never translated into poster form. Here the artist uses the inverted 'L' shape of some of the Keynotes series to divide the two panels. A woman in sphinx posture leans forward over the inverted base of the main panel and stares at a boldly silhouetted woman holding a dog leash and wearing a large hat. Clark notes the drastic stylization of contemporary costume. The title presumably is ironized, though whether we are looking at two lesbians or at two heterosexual ladies who are only spinsters in a legal sense remains puzzling.

Oils

Two paintings in oil are extant on different sides of the same canvas. "A Caprice" has a Venetian context and shows a woman in black holding a muff in one hand and staring in profile at a dwarf Negro in red turban and carnival outfit. In "A Masked Woman" the subject stares ahead while along the table to the front of her runs a mouse, a Freudian topos it seems.

Both paintings are roughly sketched though the artist may have deliberately evaded fashionable "finish." The colors are not specially striking, much less striking than the tones and tints of his poster work, and both pictures remain experimental.

Chapter Nine
Prose and Verse
Early Works

From early on Beardsley had cherished literary ambitions; indeed, he termed himself on one occasion "man of letters." As a boy, writing was one of several competing gifts. His musical talents were to fulfill themselves in connoisseurly enthusiasm rather than in composition, and his theatrical interests were to be subsumed in his art; his talent as a writer, though, was to be pursued virtually to the end of his brief life. Much of his work is illustration, his inspiration is often literary and he lived at a time when word and image were closely connected.

The most significant of his early pieces is undoubtedly "The Art of the Hoarding," contributed to the *New Review* of July 1894, in which Beardsley makes it clear that he is well aware of the need for self-advertisement in the era of "new journalism" when personalities rather than issues were promoted, and principles were invariably trivialized and controversies were deliberately engineered for purposes of circulation. Like Whistler and Wilde before him, Beardsley took the view that no publicity was worse than bad publicity and practiced the art of writing provocative letters to the press, arresting attention at all costs and baiting the bourgeois public. The prestige of oil painting, anecdotal painting, the Royal Academy, all familiar targets, are here mocked in elegantly offhand tone. "The popular idea of a picture is something told in oil or writ in water, to be hung on a room's wall or in a picture gallery to perplex an art less public. No one expects it to serve a useful purpose or to take a part in everyday existence. Our modern painter has merely to give a painting a good name and hang it."[1] The argument of the piece, then, is that the poster is a new form of art and the lay public finds difficulty in realising how closely it relates to our daily lives. Its bright colors enliven the drabness of the modern townscape. "As to the technicalities of the art," Beardsley shruggingly remarks, he has "nothing to say," showing the same distrust of generalizations about art that Yeats ascribes to the contempo-

rary poets of the Rhymers' Club. And he closely echoes Whistler's *Gentle Art of Making Enemies* in his contempt for the middleman between artist and public: " 'twere futile to lay down any rules for the making of posters. One's ears are weary of the voice of the art teacher who sits like the parrot on its perch learning the jargon of the studios, making but poor reply and calling it criticism." Beardsley seems to have acquired the art of "period" prose as rapidly as he acquired mastery of his art.

Of Beardsley's prose and verse, only those texts that he himself illustrated require comment. Chief of these is his incomplete novel involving the medieval *Minnensinger* or warrior-bard Tannhäuser's visit to the Venusberg.

Venus and Tannhäuser: Sources

His text is founded on the knight's legend or afterlife. Beardsley follows the version that had crystallized by the close of the sixteenth century: Tannhäuser has become a Christian knight who is seduced by the Goddess Venus, sorceress and succubus, so representing the medieval view of the pagan gods as fallen angels. Tannhäuser enters Venus's palace, the Venusberg or Horsel, situated under a hill, through a dark cave. The cave entrance and the delights that lie beyond it relate to the tradition of the secular Love Garden emblematized as a woman's body, the earthly paradise. Tannhäuser serves Venus, literally and figuratively, for a number of years and then, stung by repentance, leaves the Venusberg and journeys to Rome to beg absolution from the pope. On hearing his history, the pope announces that Tannhäuser's sin is so extreme that he is beyond hope of redemption. Only an unconvenanted mercy, an act of extraordinary grace, can now absolve him, and in illustration the pope points to the wood of his staff, saying that Tannhäuser must remain unshriven till the dry wood bursts into blossom. Tannhäuser dejectedly leaves, but soon after he has gone the staff does indeed blossom, but by then it is too late: Tannhäuser has unwillingly returned to the pleasure and damnation of the unholy hill. The motif of the blossoming staff is connected typologically with the Old Testament Book of Numbers, 17:8, *virga Aaron florida,* where Aaron's rod buds, brings forth blossom and yields almonds. As priest, Aaron is a type of Christ, and the Old Testament episode is fulfilled by Christ's assuming the role of priest after the order of Melchesidec with the powers of propitiation and sacrifice for sin that priesthood carries with

it. But the blossoming rod is also a type of the Virgin Mary and of forgiveness through her intercession; in her case roses rather than almonds are yielded. The conflict for Tannhäuser's soul becomes a conflict between Mary and Venus, reflecting the absolutes of medieval morality, salvation, and damnation. As the legend develops, Venus loses her demonic attributes, though her paradise of all the senses strongly resembles the witch gardens of the Renaissance romance epics: those of Alcina, Armida, Acrasia. Milton's Satan bringing Sin into Eden has Satan speak of Adam and Eve as "imparadised in one another's arms": reaffirming woman's body as earthly paradise, a fallen lover's geography (*Paradise Lost,* 4.506).

In the nineteenth century the legend was touched by, among others, Ludwig Tieck, Charles Baudelaire, Algernon Swinburne, Walter Pater, William Morris, and Richard Wagner. With all of these versions, excepting probably the Tieck, Beardsley would have been familiar, but his own treatment differs radically from all of his sources.

Venus and Tannhäuser: Texts

Beardsley's text is found in two printed versions and a manuscript, which need not concern us here. The first printed version, which appeared in two issues of the *Savoy* in 1896 and represents the author's own censored version of *Venus and Tannhäuser,* was entitled "Under the Hill." Arthur Symons, the literary editor of the *Savoy,* may also have played some part in the expurgatory process; his attitude to Beardsley's literary works was not notably sympathetic. The *Savoy* publication has six illustrations that relate to "Under the Hill." In this chapter we shall not consider *Venus and Tannhäuser* which, even though it subverts its own eroticism, belongs to the "hidden" world of pornography and the limited, or clandestine, edition typical of Smither's activities as a publisher. However, "Under the Hill" subverts or perhaps even "desecrates" the religious, and the Wagnerian, and Venus herself under the name of Helen is transformed into a Lolita-like figure, an image connecting with the child cult of the 1890s. In the *Savoy* version we may also note that Tannehäuser appears as the Abbe Fanfreluche (bauble or penis) indicating the limits—the indecent obscurity of a foreign tongue—placed on expression.

After alighting from his horse, Fanfreluche "stood doubtfully for a moment beneath the ombre gateway of the mysterious hill," the *mons veneris,* entrance to the Earthly Paradise or profane love-garden of Ve-

nus, representing as in Renaissance literary tradition a parody of the
Garden of Eden, a garden of false art: art that is in conflict with nature,
rivaling it, distorting it. Venus's realm is envisaged as a giant female
body: a clear analogue (in *Paradise Lost,* 4.135–38) to Satan's discovery
that the obvious entrance to Eden is

> a steep wilderness, whose hairy sides
> With thicket overgrown, grottesque and wild,
> Access denied; and overhead upgrew
> Insuperable highth of loftiest shade. . . .

significantly impassable. Yet now this venereal portal is entered with
ease. But what is subverted also is the mediaeval love-garden as Beards-
ley's epigraph to the manuscript reminds us with its quotation from
the *Roman de la Rose*: "Le chaleur du Brandon Venus [*sic*]" (the heat of
Venus's torch) makes plain, as interpreted in the Morris–Burne–Jones
cult of medieval love. Fanfreluche is immediately described in terms
of painting—"his hand, slim and gracious as La Marquise du Deffand
in the drawing by Carmontelle"—suggesting also the effeminacy of the
hero.

The hour of Fanfreluche's entry is described in terms of a *dix-huitième*
fairy tale, spiced with "camp" vocabulary: "it was taper-time: when the
tired earth puts on its cloak of mists and shadows, when the enchanted
woods are stirred with light footfalls and slender voices of the fairies,
when all the air is full of delicate influences, and even the beaux, sit-
ting at their dressing tables, dream a little."[2] We may suspect that the
chevalier striking a few intense notes on his little lute in response to
distant music is also committing a muted double-entendre: in *Venus
and Tannhäuser,* he will commit some fine tuning of Venus herself.

The second chapter introduces us to the public toilette of Helen (in
the *Savoy* version Venus's surrogate), a theme that always fascinated
Beardsley. We meet Venus's attendants and particularly her maternal
lady of honor, here called Mrs. Marsuple, a version of Oscar Wilde
with an appearance of androgyny and a voice "full of salacious unc-
tion."[3] The toilette scene ends with Helen's refusal to wear a frock; her
petticoat is sufficiently delicious, though, a note of ravishing discord,
she does wear gloves. The first meeting with Fanfreluche is omitted as
part of the technique of making each chapter center on one elaborate
scene of rich but static detail, along with descriptions of the person-
ages, scattered like stage directions.

Chapter 3 brings another set description: the supper on the terrace. The effect is of a tableau spiced with an amazing menu whose items allude to many acts of love, one of the lists that litter the story emphasizing Beardsley's evasion of any analysis of character through interaction or dynamism of plot. The characters are richly suffocated by context: first, an *ekphrasis,* or description of a work of art, a fantastic fountain. All is excess and stylish incongruity: Fanfreluche in slippers with "a wonderful dressing gown" counterpointed with Farcy, Helen's principal comedian, who wears full evening dress. Art draws attention to its violation of nature in the account of enterprising masks of many materials, representing animals, birds, reptiles and sea creatures, men, women, "little embryons," and those "like the faces of the gods." Nature is subjugated and inverted: "big living moths stuck in mounts of silver sticks" do duty for fans; wigs are built up of living hair, vegetation, apocryphal animal skins, silver threads, and metals. Nothing remains stable. Women transform themselves by red spots near the mouth or by wearing great white beards after the manner, we are told, of Saint Wilgeforte, a fabulous female saint who, according to legend, was the Christian daughter of a pagan king of Portugal. To preserve her vow of chastity when commanded by her father to marry a pagan prince, she prayed God to disfigure her body. God caused a beard to grow on her chin, and her father, distinctly piqued, had her crucified. The description of the feast is dense with Beardsley's icons, as though designed for illustration: masks, embryons, comic hermaphrodites, grotesques, satyrs, dwarfs, "about the wrist a wreath of pale, unconscious babes." Even the banally natural "upon an elbow, a bouquet of spring flowers" becomes grotesque.

Chapter 4 begins with Fanfreluche's awakening under the coyly undescribed "curious patterned canopy" and looking out over a pastoral vista arranged like the landscape of a Claude or a Corot. The gracefully cultured Fanfreluche begins daydreaming. After a while the Abbé's reverie shifts to Saint Rose, the well-known Peruvian virgin:

how she vowed herself to perpetual virginity when she was four years old; how she was beloved by Mary, who from the pale fresco in the Church of Saint Dominic, would stretch out her arms to embrace her; how she built a little oratory at the end of the garden and prayed and sang hymns in it till all the beetles, spiders, snails and creeping things came round to listen; how she promised to marry Ferdinand de Flores, and on the bridal morning perfumed herself and painted her lips, and put on her wedding frock, and decked her

hair with roses, and went up to a little hill not far without the walls of Lima; how she knelt there some moments calling tenderly upon Our Lady's name, and how Saint Mary descended and kissed Saint Rose upon the forehead and carried her up swiftly into heaven.[4]

A later hagiography does not admit this assumption, but Beardsley was presumably relying for this and the St. Francis-like audience of her orisons on the seventeenth-century accounts of her acts and miracles. His illustration of the saint's assumption will be considered later; it literalizes the chic vocabulary of fin de siècle devotion with which Beardsley was becoming familiar, probably through his acquaintance with Raffalovich. A footnote advises that "all who would respire the perfumes of Saint Rose's sanctity, and enjoy the story of the adorable intimacy that subsisted between her and Our Lady should read Mother Ursula's 'Ineffable and Miraculous Life of the Flower of Lima'" of 1671, recently reprinted in a cheap edition.[5] The nature of her intimacy with the Virgin is dealt with in more detail by Beardsley in his illustration of the ascent.

This catalog is not connected by any peculiar logic and, as in much of *Under the Hill* (and in some of Beardsley's drawings), the author seems merely to aspire to conquer the blank depths of the page. As Linda Dowling observes,[6] the narrator's delight in assembling heterogeneous materials as in the description of the supper—shells, lustres, petals, eyebrows, or in the random tabulation of pleasures—parallels the lingering, inconclusive pornographic pattern of the narrator: digression, chatter, frank exposition of the amorous routines in Venus's paradise. Food, pageants, paintings, dresses are accented as much as sexuality: all are endlessly available and all as carelessly expended. But the narrative voice postpones, and so enacts and subverts the pornographic, since consummation is endlessly postponed and so can hardly be renewed.

Fanfreluche's thoughts next stray to *Das Rheingold,* particularly to the first and third scenes of Wagner's opera, which are described by Beardsley as tableaux. In the first, the Rhine maidens tease and mockingly stimulate the gnome Alberic until he furiously renounces love and so is able to possess the Rhine gold. In the third scene (or tableau), Loki (or Loge) tricks Alberic into transforming himself into a toad. Alberic is then ignominiously captured and forced to yield up all of his treasures.

If Beardsley is a camp writer—one who treats in a trivial manner

the matters most important to him—then one can decrypt much of interest from this Wagnerian episode. Thus Fanfreluche affects to find Alberich's rejection by the Rhine maidens "beautiful and witty." Surely there is a poignant correspondence between Alberich's situation and Beardsley's—the grotesque, the unloved alien, the fetus, the man whose incapacity for normal human love gives him extraordinary powers. However, as if exorcising a hateful spirit, the Abbé's next favorite tableau in the opera is Loge's defeat of Alberich: "like some flamboyant primeval Scapin," the reference to the *commedia dell'arte* and to Molière's play is telling.

Illustrations

In Beardsley's other illustrations to the *Rheingold* (illustrations that were to feature in a text by Beardsley himself, so the letters tell us, before they were rifled for the *Savoy* and "Under the Hill") Beardsley presents Alberich tied up and defeated. In his illustration to the fourth tableau Loge jeers at the Rhine maidens, whose loss of the gold is the punishment for their coquettishness. Loge is thus an appropriate image for Beardsley to assume, and it is certainly the most favorable of those he chooses for himself. Loge is a strange, independent god, sexless and unimplicated in the sexual conflicts of the work (like all of Beardsley's personae); he remains as ungraspable as a will o' the wisp, disappearing totally after *Die Walkurie* in the Wagnerian oeuvre, "the flicker of a dying fire." He is the life-essence, the divine spark, at the opposite extreme from Erda, who in Beardsley's illustration of her is a somewhat phallic variation on his theme of the mountainously breasted virago.

Beardsley's description of the third tableau reveals much about his character and his tastes in art: "Alberic's savage activity and metamorphoses, and Loge's rapid, flaming tongue-like movements, make the tableau the least reposeful, the most troubled and confusing thing in the whole range of opera. How the Abbé rejoiced in the extravagant monstrous poetry, the heated melodrama, and splendid agitation of it all."[7] Beardsley is, of course, writing about the effect of the music, as much as about the story; perhaps he saw a correspondence between the enigmatic, essentially light, yet powerful leitmotiv used to describe Loge and his own style of drawing and personality.

The grotesque Loge of Beardsley's drawings—a double-chinned, puny, middle-aged man burgeoning with some of Beardsley's most stylized art-nouveau lines in his stylized flames—is like Pierrot co-

vertly in command of the situation although ostensibly Wotan's ser-
vant; he is equally at ease in celestially light Valhalla and in the darkly
infernal Nibelheim (the black and white of Beardsley's own art?), for
he is his own element. It is not difficult to grasp how the indepen-
dence, integrity, ambivalence, and humor of Loge so much appealed
to the artist.

Beardsley once expressed a wish to write a novel entirely in pictures.
"Under the Hill" seems to be composed with its author's illustrations
in mind. He had intended twenty-four of those, but eight only were
completed. The drawing that Beardsley contributed to the third vol-
ume of the *Yellow Book* (October 1894), achieved at about the time
when the notion of his story was maturing, could be used for the be-
ginning of chapter 7 of *Venus and Tannhäuser*. It shows us a head (not
resembling Beardsley's own) in a mob cap peeping out of the sheets
with eyes half closed by the flakes of sleep under an elaborate and
enveloping bed, its curtains gently apart and with two long florid tas-
sels looped around them. The tester is partly beyond the drawing. One
of the bedposts is visible: its middle portion is in the form of a satyress
with a half-moon headdress (Artemis of the woods). Beardsley had
drawn satyresses among the borders of the first page of book 2, chapter
1, of the *Morte Darthur,* but this creature is without the simian rest-
lessness of the earlier images. The eyes of the satyress are veiled by its
blond locks or its wig and reflect the half-waking figure on the bed.

The pen, ink, and wash drawing of "The Return of Tannhäuser to
the Venusberg," dated 1896, reworks the 1891 india ink and wash
version of the same theme. That earlier, Pre-Raphaelite drawing, as
criticism has remarked, may be "amateur" but reveals Beardsley's
awareness of sin, repentance, and return; its final note being an ado-
lescent intensity. This intensity does not evaporate in the later draw-
ing. A panel at the top of the 1891 version furnishes a frame with
sunflower petals in the mode of Rossetti's watercolors of the 1850s,
which evades the problem of perspective and more positively leaves a
sense of diffuse claustrophobia. The panel is replaced in the later draw-
ing by a wooded mountainy landscape and by the more strained face
and cadaverous outline of the central figure. The brambles through
which the pilgrim struggles are now more elaborate and menacing
(they recall among other images Selwyn Image's cover design for the
magazine the *Century Guild Hobby Horse* of the 1884 and later issues),
and the large blossom immediately behind the figure of Tannhäuser in
the 1891 version has now disappeared. His eyes and arms yearn upward

to the dark mammary contours of the Venusberg at the top right of the drawing. Half horizontals, Tannhäuser's groping arms, are comically contrasted with the acute verticality of the row of trees in the background.

The opening of "Under the Hill" is illustrated with some literalness by the pen-and-ink drawing entitled "The Abbé." At the top of the picture hangs a small zone of partially clouded sky. Space is stifled by the vegetation—tree, shrubs, and the huge, gloomy, and uncataloged flora of the text—that has almost enveloped the twin salamonic pillars (one with a naked female torso in low relief), while the ornate and bulbous-eyed moths hover. The dandy hero has spavined legs, while the folds in his trousers about the crotch suggest the feminine genitals. He is almost lost in his immense cloak. His cravat is tied in a knot that suggests butterfly or moth wings and flows downward like a ball dress. Thumb and index finger of one hand just protrude from his muff lightly holding a cane as slim as a wand while the wrinkles in his cloak to the left prolong themselves into antennae suggesting once more some assimilation into this prolific theater of insects and flowers: the motif in turn prolonged by the intricate piping and tasseling of his dress that hang like the seeds of trees. His large slanted sash seems also faintly animated. Behind his richly coiffured hair we may distinguish the giant ostrich plumes of his hat. The total effect is a paradox of natural images assumed into the antinatural dandyism of the dress. At the bottom right of the picture are hanging fetal shapes.

"The Fruit Bearers" illustrates the banquet scene from chapter 3. A man with cloven feet and a youth, with a parasol dangling at his right thigh like a sword, carry dishes along a balcony beyond which a dark water may be distinguished with the Doric portico of a garden temple on its farther side. The motif of the drawing is a rose blossom decorating the costumes and on a pergola high above the balcony. Brigid Brophy remarks of the leading fruit bearer that his feet are almost "the goat feet of rococo and Regency furniture. The creature is a walking, a stalking console table."[8]

"The Toilet of Helen" shows us an ingenue Helen in a corrupt context and indicates Beardsley's typical joke of revealing what current bourgeois taste might have hidden and conversely hiding what bourgeois taste or morality would have permitted to be revealed: the heavy eyes of reverence or satiation of the attendant girls; the full but sleeping breasts of Helen, exposed between the waves of lace and, contrasting with the ritual formality of the toilette, the rowdy dwarfs. The trivial,

the minutiae of that toilette becomes pornographic: evil lies in frustration, not in expression.

There are two attempts at a frontispiece. The first, made in 1895, shows Venus standing with arms behind her back in a fluent robe that masks her figure, whose upper decoration has a phallic suggestiveness. A rose is pinned to her dress above the cleavage and the lower decoration repeats the roseal theme. The goddess fronts us between two terms with pipes that relate to the trellis behind. A basket filled with fruit on both heads transforms the terms into atlantes, while the suggestion of horns suggests a cornucopia and organically connects with the riot of coiling branches and the galaxy of roses. A crown hovers over Venus's head, supported by branches. The imagery conspires to suggest the pastoral, fertile features of the Venusberg. The background, Reade suggests,[9] harks back to *Morte Darthur*.

The second drawing is rectangular, resembling a Renaissance title page. The goddess stands behind an aperture closed by coupled columns and behind her windows open on a formal garden, an allée with fountain bisected by the central pilasters of the window spaces over which the artist's initials and the date "1895" are inscribed in formalized lettering within a roundel. The severity of this design secretes a number of sexual allusions: the breasts and genitalia of the swags around the coupled columns, a motif repeated on the composite capitals; the breasts that compose the major design of the large goblet standing along with the attenuated ecclesiastical candlestick; and a jeweled cabinet on which two doves are symmetrically perched on a ledge before the goddess so that she appears to be conducting a rite at a venereal altar and her right hand is extended in benediction. Her left hand, however, appears to be miming genitalia.

There is also an unusual design for a title page, the facial type of Venus resembling that of the second frontispiece and with a dress and headdress of the sixteenth century.

Poems

Beardsley also wrote and illustrated several poems. "The Three Musicians," a graceful ballad, was published in the *Savoy* for January 1896. The meter, something perhaps of a deliberate modal discord, resembles that of Swinburne's grave philosophic poem "Hertha." The three musicians—a lightly frocked soprano, a Polish genius, and a

"slim and gracious boy"—wander in some woods and while the Polish genius amuses himself by conducting an imaginary band, the soprano and the boy escape into some woods; and the boy throws himself at the cantratrice's feet:

> And weighs his courage with his chance;
> His fears soon melt in noonday heat.
> The tourist gives a furious glance,
> Read as his guide-book grows, moves on, and offers up a
> prayer for France. [10]

The tourist, undeniably British, and probably tweeded or blazered with straw hat, feels shame and imputes guilt in this golden world of pastoral France, the nearest thing on earth to the Venusberg, where art and nature are at one. Does not the Polish genius onanistically conduct with aphrodisiac poppies in hand, and is not love free and innocent? In his first drawing Beardsley shows the youth not at the lady's feet but with his hand on her knee, and this was deemed too inflammatory for publication. Beardsley then made another, more accomplished, version in which the pair saunter toward the shade against a background of picturesque woods with a chateau in the distance. The lady is tall, slim but maternal, and dwarfs her ardent admirer. Similar double-entendres can be identified in the allusions to "hair" and the "little death" of organism. The boy (slang for the male member) is dressed, in the costume of 1830, a date suggested perhaps by Franz Himmel's latest roundelay that the three have been practicing, though there may be some confusion here between Himmel (floruit 1800) and Hummel who is more appropriate to 1830.

"The Coiffing" illustrates "The Ballad of a Barber" that appeared in the *Savoy* for July 1896, and involves similar slang terms such as bees (male genitalia) and Meridian Street (the genitalia of both sexes):

> The king, the Queen, and all the Court,
> To no one else would trust their hair,
> And reigning belles of every sort
> Owed their successes to his care.
>
> With carriage and with cabriolet
> Daily Meridian Street was blocked,

> Like bees about a bright bouquet
> The beaux about his doorway flocked.

At the climax of the action:

> The Princess gave a little scream,
> Carrousel's cut was sharp and deep;
> He left her softly as a dream
> That leaves a sleeper to his sleep.
>
> He left the room on pointed feet;
> Smiling that things had gone so well.
> They hanged him in Meridian Street.
> You pray in vain for Carrousel.[11]

In his fine abrupt way, Lord Clark calls the poem "ridiculous," though earlier in his little book he does concede that it is "fully equal to the work of the minor poets who surrounded Beardsley."[12] Who these are, we are not informed; presumably other contributors to the *Savoy* such as W. B. Yeats, Arthur Symons, etc. The theme is the worship of girlish innocence often found in the poems and short stories of Dowson, for example, and parodied by Max Beerbohm's cult of the young star of the music hall, Cissie Loftus. The barber is a species of poet who kills "the thing he loves" in order to preserve it forever at a perfect moment, a beauty untroubled by sexuality or self-consciousness; it is hardly the murder itself that is a work of art. His coiffeuring cannot make her more perfect. Linda Zatlin, [13] though, suggests that the Princess's scream marks the loss of her virginity; her sleep indicates exhaustion after her initiation, and Carrousel's "pointed feet" are satyrine.

The drawing has been much praised. The action occurs in a late Victorian interior, not in a palace, with art-nouveau knickknacks, a vase on a table with a fragile curved leg, so that the act seems not heroic or revolutionary, but simply something we might read about in the newspapers. Carrousel, befitting one who has never shown "a preference for either sex," "has a female form" and "wears a symbolic apron tied with a sash at the back." His wig, not altogether hiding the hair, is most elaborately and irregularly curled. The barber's expression and the domestic setting limit the finely gratuitous act of murder (or

seduction) and, as Brian Reade[14] suggests, marvellous as the drawing is, it rather betrays than illustrates the poem; so resembling some of the *Venus and Tannhäuser* drawings. The Princess herself represents the tendency at this time of Beardsley's heroines to become less and less of mature femmes fatales figures and more the ingenue. Coy and banal beauties coupled with a curious childish innocence more pertinently occur here in the sanctity of those middle-class homes it was Beardsley's intention to rock. More and more the ingenues are surrounded with voluminous clothes so as to suggest inaccessibility and provoking the violence of the barber's cut. But this points also to the concealment in the object of desire, part of what may be seen as an essentially immature approach to the erotic. The banality of the girl is Beardsley's comment on the early Wordsworthian lines: "She was as joyous and as wild / As spring flowers when the sun is out."

Lord Clark directs attention to the figurine on the sideboard in the background, a Virgin and Child, suggesting the Latin Catholicism that through the influence of Andre Raffalovich had already taken possession of the artist's mind.[15] The Madonna is "jewelled and lacy in the Spanish taste," and the image reminds the viewer that Beardsley, like the Holy Child, was to predecease his mother. The statuette of a mother protecting a child clearly contrasts with the role of the barber in relation to the princess: the Godhead entrusted to a woman; the adolescent princess to the barber. The severe semicircle of birds in flight outside the window contrasts with the insecurity of the table with its rickety curved leg and the station of the vase of flowers, for Beardsley has omitted the line that should prevent it from sliding.[16] Carrousel will leave the room on "pointed" feet, a vivid epithet, like a dancer or a satyr; quietly so as not to break the princess's sleep; to accent a rite accomplished. In the second drawing, as a colophon to the poem, the old pun that connects both figuratively and literally love and death is realized in the figure of an amorino bearing in place of quivers and arrows the noose and the gallows that await Carrousel, amusingly described by Brophy as "a sonsy, callipygian, wing-flirting amoretto . . . flouncing along in profile silhouette, like a boy tart on the beat. This beat, however, is also a march to the scaffold and a road to Calvary."[17]

The drawing illustrating the assumption of Saint Rose of Lima counterpoints that for "The Coiffing." Brophy suggests that the Spanish tone of the madonna and child figurine now takes on a Peruvian tinge, as seen in the design of the wedding gown that the young saint wears

as she is carried heavenward by the crowned virgin. The facial types and the image itself consciously echo debased versions of that popular subject of much baroque, Counter-Reformation art: the assumption of the virgin. The smile of Saint Rose's face is certainly that of an earthly as much as a heavenly love, while the two roses that have fallen from Rose's hair spell a lesbian consummation. The second rose may play the peacock eye, as Brophy suggests, on the tail of the madonna's robe, but it also turns the tail of the robe into a monster that threatens male sexuality with open mouth. The joke is a camp one on baroque art and on vulgar Catholic piety. As against Freudian criticism, one might suggest that the playful attitude to a subject who so deliciously avoids sexual maturity indicates that Beardsley's attitude toward his own deprivation was not by any means always one of exorcism or regret; it is not infrequently one of amused resignation, or, as suggested elsewhere, counting one's blessing.

Beardsley's translation of Catullus's poem addressed to the ashes and the shade of his brother is his best and indeed one of the better lyrics of the English fin de siècle. Catullus was a culture hero for the young poets of that time: as a confessional poet and as a writer of intense erotic lyrics. Of more relevance, perhaps, to Beardsley's interest was the study of Catullus's *Attis,* produced by that restless dilettante Grant Allen in 1892, and which was to be translated later with other Catullan works by Arthur Symons. The theme of castration in the *Attis,* even if his attitude toward that is as much of resignation as of fear, is clearly of prime importance to Beardsley. However, it was probably the mode of *vituperatio* that Catullus so brilliantly practiced that Beardsley most admired, for he was generally attracted to the acerb and satirical elements in ancient literature. Like Beardsley, Catullus died young of tuberculosis, and the poem would have had its appeal to one suffering his barely indefinite reprieve from death.

> By ways remote and distant water sped,
> Brother, to thy sad grave-side am I come,
> That I may give the last gifts to the dead,
> And vainly parley with thine ashes dumb:
> Since she who now bestows and now denies
> Hath ta'en thee, hapless brother, from mine eyes.
>
> But lo! these gifts, the heirlooms of past years,
> Are made sad things to grace thy coffin shell,

Take them, all drenched with a brother's tears,
And brother, for all time, hail and farewell![18]

Beardsley, on the slender evidence of his few poems and fragments, had little metrical gift, but here the slow formality, the delicate caesuras, are altogether appropriate. And entirely appropriate to the translation is the beautiful drawing "Ave Atque Vale" that accompanies it. By contrast with Beardsley's recent work, this reverts to the black and white of an earlier phrase. Yet, as Reade[19] stresses, the figure of the mourner leaves an impression of solidity and modeling, defined by the vivid economy of the navel and the nipple (placed deliberately too far to the right to enhance the effect). The figure also achieves sculptural balance through the high ritual gesture of the raised right hand posed against the trees in the upper right background.

Beardsley's illustrations to his own writings are mostly distinguished. Two of those intended for *Venus and Tannhäuser* exhibit the *horror vacui* of "The Cafe of Spleen," ("The Abbé" and "The Fruit Bearers") while "The Abbé" and the two versions of the "Three Musicians" have the elaborate floriation and background of the *Savoy* phase. "The Ascension of Saint Rose of Lima" exhibits rococo features in the design of the Saint's robe, and the dotted landscape is again in the manner of the *Savoy* period drawing. "The Fourth Tableau of Das Rheingold" and "Ave Atque Vale" are both splendid essays in black and white. However, the background of trees in both cases, though diminished, is once more reminiscent of the *Savoy* style. Interpreting his own works may have given Beardsley a certain additional vivacity, but the drawings themselves accord with the general evolution of his style.

Early in 1898, Beardsley was engaged on his last and more serious effort in prose, the prospectus to the *Volpone* of Ben Jonson, which Smithers had asked him to illustrate. This is an index of his later, severe taste and contains some trenchant criticism. For the play, he expresses the highest admiration. "The finest comedy in the English language outside the works of Shakespeare," it is "daring and forcible in conception, brilliant . . . in execution." Even Juvenal falls short of the ardent and "saturnine genius" so perfectly revealed in *Volpone*: "Volpone is a splendid sinner and compels our admiration by the very excess of his wickedness. We are less shocked at his lust than moved by the magnificent vehemence of his passion. We are moved and aghast rather than disgusted at his cunning audacity."[20] The "passionate virulence" displayed in the play ensures that "like many other classic comedies,

like the *Misanthrope, L'Avare,* and *Festin de Prince,*" *Volpone* "may more fittingly be styled as tragedy."[21] The mockery of the Fox at the end seems too condign a punishment. The strict construction, moral rigor, and pitiless satire of the play are aligned in Beardsley's mind with Juvenal and Swift and, in spite of the acknowledgement of Shakespeare's primacy, we may be sure that Jonson's comedy appealed to him more deeply.

Chapter Ten
The Last Illustrations
The Rape of the Lock

At the suggestion of Edmund Gosse, by the 1890s highly influential in literary circles, Beardsley undertook to illustrate Alexander Pope's glittering mock-heroic poem for Leonard Smithers. The designs "embroidering" the text appeared first in an ordinary edition in May 1896, with gold on blue covers, and in a deluxe edition on vellum. The following year a bijou edition appeared in red cloth stamped with gold. We can follow the progress of the drawings from Beardsley's letters between February and March of 1896 (*L*, 115–118).

About the choice of text, quite aside from Gosse's advocacy, there was nothing remarkable. The Evangelical and early Victorian reaction against a frivolous and skeptical eighteenth century had long been waning. Thackeray's enthusiasm for the Georgian era had led him in 1852 to build himself a house in what he optimistically conceived to be the Georgian style. John Shaw in that same decade was already designing his excellent Wren and *dix-septième* style Wellington School, while over the next twenty years the prevalent neo-Gothic idiom was successfully challenged by such architects as William Nesfield and Norman Shaw working in a loose version of the "Queen Anne" style favored by the aesthetes of the 1870s.

The principal poet of the eighteenth century, Alexander Pope, had never lost his popularity. In the provinces, where Byron was a dangerous name and the romantic poets too difficult, the moral song of Pope was especially valued, and throughout the century there were a number of editions of *The Essay on Man*. Matthew Arnold's description of Dryden and Pope as "classics of our prose," burnished by carefully chosen quotations, was not a majority view, though it was shared by Beardsley's contemporary, Oscar Wilde. Other contemporaries, though—Lionel Johnson, for example—greatly admired Pope. But if Pope the moralist was acceptable, the morality of *The Rape of the Lock* was perhaps too subtle for many mid-Victorian readers.

In the 1860s and 1870s a school of formalizing poets, "The Ron-
doliers," whose members included, besides Gosse himself, Austin
Dobson, Andrew Lang, and the young William Ernest Henley, became
active. In a minor way, these poets were followers of Théophile Gautier
and his cult of form, and they were responsible for the use in English
of many old and middle French forms of some complexity: ballade,
double ballade, pantoum, kyrielle, villanelle, etc. Dobson, like Gosse,
was an admirer of the eighteenth century and particularly of the ancien
régime, though his own work tended to the sentimental and moralis-
tic. His eyes were open to the elegance, but not to the elegant vice of
that period.

From early on, Beardsley, too, had been attracted to the French and
English versions of the eighteenth century, but it was typically the
harsher and more satirical aspects of the period that attracted him. At
school he had read Swift and had embellished his copy with illustra-
tions; he had also illustrated Congreve's *The Double Dealer.* Gosse's ap-
peal was to the converted. The drawings were furnished in a few
months and the first issue of the *Savoy* in January 1896 contained a
prospectus for *The Rape of the Lock,* together with an order form. From
the prospectus, we gather that the edition deluxe was limited and
priced at ten shillings six pence, with twenty-five copies printed on
Japanese vellum and costing two guineas. The binding has been well
described by Robert Halsband:

Its symmetrical design, stamped in gold on turquoise blue cloth, is a sump-
tuous and provocative introduction to the poem within. (The binding of the
de luxe edition, gold on off white, is bland and indistinct.) On a profane altar
(or simply the lower border of a rectangular frame) stand a pair of elaborate
candelabra, whose many candles are unlighted. Their stems and bases are
ornamented with sinuous swirls of vegetable forms, though if examined more
closely these take on a resemblance to shapes of animals or humans or foetuses.
The candelabra support between them an oval frame for a pair of scissors above
which floats the lock of hair, its curved form like a flame or a spermatazoon
or a tiny animal (perhaps a sea horse). The outermost border of the design is
lined with a continuous succession of curves and bulges that could be lips or
breasts or buttocks, or all of them. The binding, with its symbolism and
ambiguities, thus serves the same function as the frontispiece in [the] 1714
illustrations—by synoptically preparing the way for the drama within.[1]

Brophy[2] draws attention to the oval as suggesting a miniature paint-
ing on a wall, so alluding to Pope's miniaturized and domesticated

epic; to the distant intimation of hair severed in classical sacrifice, and suggests that the disposition of the hair and scissors recalls the skull masks of classical altars and mortuary sculpture. Unfortunately, her characteristically pungent and sensitive analysis leads up to the usual focus on Beardsley's art as magical evasion of his castration fears.

The title page is *dix-huitième,* while the eclectic frontispiece, "The Dream"—the titles were all supplied by Beardsley—shows a courtier in a rose-trimmed dress, according to Reade, worn by ballet dancers in the opera at the time of Louis XIV and Louis XV,[3] carrying a long cane or baton tipped with a star, looking through the drawn bed curtains, a representation presumably of the disguised Ariel. Halsband relates this to one of the trenchant illustrations to Juvenal's sixth satire, dating from late 1896 or early 1897, "The Impatient Adulterer." The iconography is certainly similar, except that the adulterer is dressed in the extreme of dishabille, rather than the full formal wear of the courtier, and as Beardsley himself put it, is "fiddling with his foreskin in impatient expectation" (*L,* 155) but with his left hand rather than the right hand, in which the courtier carries his cane. The expression on the courtier's face is one of impassive, almost bored benediction, while the adulterer looks tensed and angry at the postponement of his pleasure. Halsband comments on "how graphically this reveals the erotic foundation of the over-dressed eighteenth century figures that Beardsley designed for the *Rape of the Lock.*"[4] However, "The Impatient Adulterer" does not belong to the *Rape* series, and the effect of "The Dream" is fussy rather than incisive, while the bodies under the clothes in these illustrations seem to be invariably nonexcited. Beardsley moves away from the tradition of costuming the characters in appropriate Annian style. His own idiom is essentially eclectic and had a strong influence on styles of ornament up to 1914. Motifs for the furnishings are taken from the roccoco of Louis XVI and the Aesthetic periods: the male clothes appear to be early, the women's clothes late, in the *dix huitième.*

The second drawing, "The Billet Doux," Belinda sitting up in bed and reading her letter—" 'Twas then *Belinda*! if Report say true / Thy eyes first open'd on a *Billet-doux*" (l. 117–18)—reverts to Beardsley's coy and banal child image, a development of Kate Greenaway's repertoire, though this child has one fairly budded breast exposed. Halsband notes the appropriate fan form of the headboard and the butterfly suggestion of pillow and headdress. The effect of the drawing is of a giggling naughtiness. As in "The Dream," dots counterpoint lace and embroidered patterning.

"Belinda's Toilet" illustrates the brilliantly poised lines that describe how "Awful beauty puts on all its Arms." This image is probably the least interesting drawing that Beardsley ever made on a topic that never ceased to attract him because of its theatrical overtones, its sensual mystery. Pope's own ironies about beauty and artifice say all there is to say: that irony is double as in much of *The Rape of the Lock*: Belinda both "awakens" all her grace and "calls forth" her face's wonders, but she is also engaged in deception: "repairing" her smiles and purifying her cheeks: "a purer blush." But the illustrator denies himself some gross fardeuse or one of his own really grotesque totems. The word "embroiders" is now seen to apply not merely to the almost anxious suppression of blank paper in these drawings, but a subservience to the text that runs counter to Beardsley's dialectical genius. Not that Beardsley is unaware of the dangers of "embroidery," an exquisite but minor form: he selects from the "Unnumber'd Treasures" on the dresser the proleptic scissors and, proleptically once more, draws what appears to be a bottle but is actually a shrunken version of that dwarf page boy who is to carry the weight of Beardsley's critical distance from the text, an intermediary between text and audience, like the angel in the frontispiece to *Salome*.

Indeed, Beardsley seems so dazzled and respectful to the surface of Pope's poem that he shields himself from its accomplished cold glare by pursuing a fertile linear invention, unfettered by any functional demand. The clothes have no relation to the bodies beneath them, which are conceptually divorced from their environment. Yet this, of course, is unfair; it is to understate Beardsley's intelligence and his acute response to literary texts. He is fully aware of Belinda's role in the ritualization of nature, or rather her ideal role, and so much is indicated in the trompe d'oeil decorated screen that appears to be a garden visible through a window. The garden itself with its cupola-topped pavilion is a reminiscence of the French gardens that Beardsley looked at with a predatory eye on his visit to Paris in 1893. What we witness is the formalization of an already formalized nature. The problem is that Beardsley's image has a "frozen" quality that seems to suggest that his view of Pope's art is strictly limited. The frozen quality is not unrelated to the off-centered central figure with counterbalancing detail.

Plate 7, "The Baron's Prayer," offers us another worshipper at another altar, a theme to be repeated, with its iconography reversed, in one of Beardsley's last images, Volpone adoring his wealth. The effem-

inate baron, in dressing gown and nightcap, kneels on one knee before the altar he has raised to love, an altar consisting of twelve French romances gilt by the now distinctly familiar rococo decorations, topped by the relics of the impotent baron's voracious fetishism—ribbons, garters, coquettish lingerie—whether soiled or clean, neither poem nor illustration clarifies, though the crumpled forms in Beardsley's image might suggest the former, and the fetishism itself might recall the logic of the need in *Venus and Tannhäuser,* for the object that functions as a synedoche of the beloved (as property) and which must have some continuing direct physical connection with her. Small ribboned flames of sacrifice rising from this miscellany of *frou-frou* issues in stylishly coiling smoke. One burning candle in an ecclesiastical candleholder stands at the side of the pyramid; candlestick and altar melt into a vast priapus. A tapestry on the wall stipples into a country landscape with part of a chateau visible between the trees. A table with legs sufficiently bent to resemble the rear legs of a horse stands half out of the scene on the right.

Plate 8, "In the Barge," alludes to the voyage that Belinda, the rival of the sun, "Launch'd on the Bosom of the Silver Thames" makes to Hampton Court. Belinda, surrounded by admirers on the floridly decorated steep-canopied poop, as Halsband suggests[5] glistens in a setting that suggests a theater box or Drake's *Golden Hind,*[6] with the river visible beyond and the black indeterminate mass of trees providing a backdrop: nature once more as artifact. The dwarf Negro page boy makes another appearance; dressed in turban and with flounced sleeves, he appears to be in a doze. The composition is divided horizontally, at a slight angle, though unified by the stippled baskets, tassels, and rosebud designs, and Halsband suggests that the lower portion represents Belinda's libido: phallic and testicular forms hang from the three sun-images, "connected to each other by festoons of rosebuds which themselves are genitalian. The lightly stippled forms are sexual: breast-nipples, apertures vaginal or anal, and phalluses, particularly the fragment of the ship's oar (in the lower left), which projects like a distorted penis. . . . Presiding over this riotous display of sexuality sits the heroine, prim and demurely remote."[7] To much of this analysis, we may assent, though the oar is very distorted and any oar might suggest (like the courtier's cane) the male member; but it seems as likely that the libidinal forms are generalized; they are what Belinda's role as coquette, prude, and goddess is designed to stem but not to destroy.

The ninth plate, "The Rape of the Lock," describes the crisis of the

poem but places the actual rape at the left of the image; Belinda sits on a chair, her face hidden and with her back to the baron, dressed in a black gown relieved only by random feather-swirls. Carrying the scissors from the dressing table, the baron advances, but the focus of the picture is on the dwarf page boy, just right of center, who has helped himself to a drink—coffee, chocolate, or tea—and who is the only one of the personages who looks directly at the viewer. His look is a wink or a leer, and this contrasts with the faces of the other characters, which are without expression. We may be invited either to assent, to participate in the action, or to judge it, or do both. But we may not be altogether convinced that the page, like the angel on the title page and list of contents in the *Salome,* is altogether in control, and he tends to become, paradoxically because of his historically acceptable role in the drama (black pages were not infrequent), merely a decorative irrelevance.

Halsband comments on the fact that Belinda, the baron and Sir Plume change costumes for each scene,[8] as in a divertingly produced play, while the shape of Belinda's gown as it rests on the floor resembles "a gigantic derrière." A natural scene is visible through an actual window, but it remains a formalized nature with an allée of trees and one urn that recalls the garden of Hampton Court Palace, just outside London, to which Beardsley was attached, and which is, of course, the scene of the rape and the battle of the beaux and belles. This is a distinguished image, the figures frozen into a moment of balanced tension.

"The Cave of Spleen" (plate 10) might at last appear to have provided Beardsley with the opportunity for his mordant fantasy and wit; but Pope has already anticipated much of what Beardsley could do— is too much a kindred spirit to kindle the equivocal attitude toward the text that Beardsley's genius mostly demands for its full expression. Certainly he labors hard and with enjoyment, but can only follow where Pope has led. Belinda, having lost her lock, retires to her bed with a "Megrim." The cave is lined with hair, and hair—appropriately indeed as plumes and peacock feathers—constitutes the pervasive textures of the drawing (Spleen's gown and the backdrop); the cave is in Halsband's vivid phrase "a grotto of hair," and a small male bust just above the drawing's center represents the poet himself and pays witty and oblique tribute to Pope in a grotto of his own devising, analogous to the grotto he had constructed at Twickenham to connect two disparate parts of his own property.[9] Each of the inhabitants of the cave

is meticulously recorded: the man-jar on the left, for example, with his couvade and the eyeglass of the imperialist politician Joseph Chamberlain, who was much in the news at this time with the abortive Jameson raid into Boer South Africa in January 1896. Next to the man-jar stand Pope's two "living teapots," one with a fetus in his thigh, recalling one of Beardsley's illustrations of *Lucian's True History,* an image of birth from the calf of the leg. A silhouette in a cage like a gazebo may be—as Halsband opines—one of the "Angels in Machines."[10] There is nothing in the text to suggest the Sphinx, with peacock wings and without a lion body, but with legs resembling those of sirens, a gesture toward Moreau and the chimerical fauna of the symbolist painters. The mischievous Umbriel is shown full length carrying his branch of spleenwort, a parody of Gabriel with his lily or the Celestial Messenger of epic. Umbriel's elaborate turban is topped with a forest of plumes; he has feminine hips, plump thighs, and, like the Abbé in the first issue of the *Savoy,* spavined legs. Beardsley has added a stunted female figure with almost mature breasts, and a veil covering an oversized child's head. Halsband suggests that Beardsley is here interpreting Pope's allusion to Affectation who "Shows in her Cheek the Roses of Eighteen / Practis'd to Lisp and hang the Head, aside" (4:32–33). The page makes a miniaturized appearance staring at a maid corked in a bottle, a development of Pope's line, at the lower right. "The Cave of Spleen" is the most inventive of the drawings; yet, despite witty transformations and one or two inspired additions, the profusion of images finally strikes the viewer as overindulgent.

In the "Battle of the Beaux and the Belles" Halsband draws attention to the chair on its side, an indication of the violence of the battle, and drawn from memories of the same scene in the 1714 illustration.[11] Belinda has a fan as weapon of offense, replacing the bare bodkin of the text; the baron kneels, begging her forgiveness, while the page boy stands almost between them with slanted head and a muted version of his standard leer. The curtains of the window in the background are of hair, echoing the leitmotiv of the "Cave of Spleen." And yet, in spite of the fallen chair, the effect of the image is a freezing of the action: the baron poses operatically with right hand plaintively held to his heart; the fan in Belinda's hand remains furled (though sharper), and the only figure who shows the faintest emotion is one of the beaux.

"The New Star," drawn for the *cul de lampe,* presents a figure in Louis XIV costume rather gingerly nipping between thumb and index finger the bottom ray of the star that emblematizes the apotheosis of the

beautiful but transitory lock. The cover of the bijou edition repeats the stipple and rose motif of the drawings. Like the plates of the 1896, those for the bijou edition were much reduced in scale (the *cul de lampe* of 1896 by half).

The *Rape of the Lock* illustrations were in the nature of an experiment with stippling and counterbalancing after what Beardsley must have felt was the temporary exhaustion of the black-and-white idiom. With the exception of a few patches of white, the whole surface is intricately patterned, anxiously segmental. The result is finally tedious as drawing and not particularly illuminating as illustration to Pope's text or subtext. Beardsley's rococo idiom is at fault: itself a corrupt classicism, to work properly its angular assymetry and curvilinear smoothness must contrast with and be seen to break away from the severity of rectilinear Classical motifs, rather as the clouds on the illusionist ceiling of a southern German rococo church hover near and partially obscure the Corinthian or composite pillars or pilasters. Beardsley's "The Coiffing" furnishes a far more effective rococo because of its restraint: that absurd little puffed forelock set in the center of a room of uncharacteristic Victorian constraint contains more humor and suggestive artificiality than, for instance, the frozen tumult of the "Battle of the Beaux and the Belles." In the *Rape* drawings, everything seen, even backgrounds, is ornate and flaccid. The eye soon rebels and turns away, dissatisfied that so much manifest labor has produced such moderate effect. This is the opposite of the reaction to Beardsley's sparer, tenser styles where we marvel that such apparently slight labor can be so resonant with significance.

Neither are the ambiguities of Pope's poem stressed in the Beardsley illustrations. The tension between heroic and mock-heroic and Belinda's roles as coquette, virago, goddess, and belle are barely captured. It would be asking much for any illustrator to have succeeded in undertaking a poem that so illustrates itself; Pope's art, as the poet himself recognized, is analogous to painting. The poet is too much for the artist. Unable to assume the mask of mocking interpreter, standing between audience and text, he capitulates to the brilliant surface of Pope's couplets.

Lysistrata

The case is far different with the drawings that Beardsley produced in that same year for another Smithers publication: Samuel Smith's

translation of Aristophanes' *Lysistrata*. A return to black and white, these drawings, too, are an experiment, but one that triumphantly succeeds. Beardsley admired the *Lysistrata*, but was not inhibited by admiration, though he remains faithful to the spirit of the text and focuses on the incidents that most readily lend themselves to illustration.

Written during the closing phases of the Peloponnesian War, the play centers on the efforts of women, inspired and led by "a new woman," Lysistrata, to bring peace by denying men their marital rights. The women of Athens capture the citadel and are joined by the women of the other warring city-states. The comedy is made more keen by the frustration of the women no less than the men. The women finally bring peace.

"'The Lysistrata' and all obscene drawings": Beardsley's obsession with the risen phallus was in part mischievous; the pudenda could be imported all too facilely into his drawings: the phallus posed a more radical challenge to the publisher and, if it passed uncensored, to the middle-class public. Beardsley's publisher in the present instance was Leonard Smithers, who was selling the book on the underground market, or at all events safely limiting its circulation by price. To Smithers, Beardsley observed: "if there are no cunts in the picture, Aristophanes is to blame and not your humble servant (*L*, 139).

The immediate source material was Beardsley's visits to the British Museum with its statuary and Japanese *shunga* with its sexually explicit imagery. The drawings focus first on the women in the citadel with their often ambiguous gestures: pudeur, solace, or simply scratching; mostly naked except for elaborate stockings and sometimes—furnishings derived from Rowlandson and from the pornographic tradition generally—large and equally elaborate hats. We may repeat the comment that Beardsley's images demand to be "read" but often baffle us by subverting the normal iconographical poses that invite and accede to "reading." In one image, for example, an older man may or may not be touching a younger man's erect penis, but there can be little doubt as to what one small angel is up to in "The Toilet of Lampito" as he powders her derrière while her right arm is pointed directly between her thighs. Yet it is also typical of Beardsley that one of his "Ladies in Distress" who is about to assist a friend with a sapphic gesture has her feet planted in a position that makes the act of charity virtually impossible. All of Beardsley's penises are circumcised, though the translation by Samuel Smith, a schoolmaster and a friend of Ernest

Dowson, speaks of ladies finding a bed rather cavernous without the company of "a friendly foreskin." We do not, however, know if Beardsley read Smith's translation. It is in prose and, like so many translations of the comic poets, jagged in tone, veering from jaunty but dated colloquialisms such as "it's all fudge" to "I ween" and spiced also with a fair amount of Kelly's cribbage. And then there are the familiar, frantic, and feeble attempts at rendering the Aristophanic pun. Sam Smith is clearly no menace to Dudley Fitts.

It remains difficult, nonetheless, to assess Beardsley's distance from the text except by applying some general sense of what the play, quite aside from its immediate political thrust, is imaginatively about: the war between the sexes, but in what terms and with what resolution? The characters' comically inflated vascular laments sanction Beardsley's unremitting and, indeed like the committee man's on the Spartan herald's, myopic focus on the penis. But what does the committee man's expression indicate: envy? scientific curiosity? the herald's own non-committal face? diplomatic calm presumably in the face of an international male crisis? Beardsley certainly illustrated the obvious moments, with one exception: he has no image of the chorus, which, unusually, in the *Lysistrata,* is divded between old men and old women. This omission reflects the same rage to simplify that led him strangely to omit the sylphs from the *Rape of the Lock* drawings. Even when the heat of physical attraction dies down, men and women, the play seems to tell us, are drawn to one another, if not by hatred or desire, by some other necessity, as when one of the old women of the chorus gets an obstinate fly out of an old man's eye. And the aged conduct a shadowy sex war and are reconciled like the others at the close. There would have been models for an illustration of the chorus, though such would not have suited the prevalent style of those drawings, which confined the number of figures.

Seven of the eight original drawings survive. The first shows us "Lysistrata Shielding her Coynte" with the usual gesture of pudeur, but, as D. J. Gordon notes, not with the palm of her hand but with two fingers extended while the little and the index fingers rest lightly on her robe.[12] Lysistrata, whose state, perhaps appropriate to a "new woman" (married, unmarried, widowed, is not clear from the text), is represented as buxom, not so young. On the left of the drawing a term wreathed in flowers culminates in an ithyphallic garden god without a left arm (as in the title page of the *Salome*). The penis emits a gloria, like those on the heads of saints. On the right of the drawing is a

monumental erect penis, rendered as sculpture, the pubic hair appearing as formalized plant growth from which the sculptured hair form rises. Lysistrata's left hand rests on this amazing object as if it were a garden ornament, holding delicately between her fingers a spray of olive, an image that clearly encapsulates the action of the play. The enormity of the penises illustrates frustration, as do the attempts of the women to leave the citadel and copulate with their husbands and the erotic or autoerotic suggestions of the women's hands. In the opening image, Lysistrata is not only indicating the end of the play, she is also illustrating its course: her gesture is that of pudeur in relation to men, but she is also actually initiating the gesture of masturbation: the point is very obvious.

Reade suggests[13] that the elaborate patterned stocking in "The Toilet of Lampito" and "Lysistrata Defending the Acropolis" reflect the influence of Félicien Rops, Belgian artist of the late nineteenth century, whose prints were distinctly pornographic. This may well be so, but while Rops's attitude toward women was Manichean—woman as the "instrument of Evil"—it is safe to assume that Beardsley's attitude toward Lysistrata and her colleagues is, like that of Aristophanes, broadly sympathetic. Three of the drawings are frankly comic, all involving the loss of male dignity. Lysistrata and her colleagues "defend the Acropolis" by the time-honored means of the chamber pot, the contempt of the derrière, and the "posterior trumpet." The women are all presented as robustly feminine, rounded haunches, ripe flesh, emblems of vitality, while the solitary man, who flinches under the salvo, is wizened and old. In the two other comic drawings the frustrated phallus assumes a portentious questing weight of its own, which clearly no amount of autoeroticism will divert. In the punning "The Examination of the Herald," words are unnecessary. An old man in a black cloak over a pair of rucked pantaloons exposes a long, narrow, sagging penis and touches the bottom of the Spartan Herald's glans. The herald himself has a feminine face and daintily rococo pubic hair that contrasts with the penis that has launched itself level with his shoulders; but his face shows no expression, a sculptural detachment.

"The Lacedaemonian Ambassadors" is more of a grotesque. All three ambassadors are naked, with tumescent organs. That of the tallest and youngest is long and slender with rococo pubic hair; no hair on the chest, while the hair on the head is piled high like a helmet. He wears pointed shoes in eighteenth-century mode, patterned stockings, and lace ruffles up to the shins. His face, like that of the herald, is some-

what effeminized. Beardsley is deliberately applying the techniques of pornographic drawing to his male figures. This image recalls Henry Fuseli's harlots with their elaborate fetishistic hairdoes; the androgyne designed for the cover of Raffalovich's "Mirror of Love" and the young nudes of the *Morte Darthur*. As to the immense organs, the media are clearly the message; but the women are not impressed; it is more than possible that Beardsley is subverting traditional pornographic images. An older man, with a broken nose and a squat, vigorous penis, has the usual formalized plant growth of pubic hair and florid medieval-style boots. If this figure makes the pornographic tradition suspect, the third figure, one of Beardsley's dwarfs, confirms the mockery. He has a turban and a positive pillar or tree of hair and a phallus of awesome size against which he is pressing his nose and grasping the stem with both hands. Reade darkly suggests[14] that the "comic cartoon rays" may indicate an inflamed ulcer on the dwarf: "the inference being that this undersized person reaches oversize in one respect, not to be outdone, by manipulations in the manner of accomplished Japanese courtesans." But with a scholar's caution Reade faces the dull judgment that the detail may be intended for a hairy mole.

"Cinesias Entreating Myrrhina to Coition" freely illustrates the episode in the play where a wife, having teased her husband to extremes, evades his clutch at the cost of her robe, which falls away from her naked body. Cinesias's headdress is a plume, formalized in tree form, and it now begins to appear as if a distinct imagery relates the circumcised phallus to formalized natural shapes. But Myrrhina's stockinged leg and more naturalistic pubic hair gesture toward eighteenth-century pornography.

"Two Athenian Women in Distress" shows one woman with a finger positioned for the solitary act, but with her right leg buoyed up by a bird; another on image right slides down a rope, while a disembodied arm reaches down from the top of the drawing. This wittily illustrates the passage where Lysistrata complains about her difficulty in keeping the women away from their husbands. "I found . . . another one slipping down the pulley . . . and another one I dragged off a sparrow by the hair yesterday just as she was ready to fly down to the house of Arsilochus" (a well known pandar, so Samuel Smith informs us). The woman climbing down the rope is very fat, and the varying thickness of Beardsley's line indicates a quivering mass of flesh, besides being something of an innovation in Beardsley's repertoire of shapes, though,

as has been observed before, it grows out of Beardsley's fascination with fat women.

"He is haunted," Robert Melville observes, "by the male genitals, and in some of his drawings for the *Lysistrata* and for Juvenal, he exaggerates their proportions in a way normally associated with the vulgarest pornography; but they must be among the most refined, meticulous, decorative and reverential drawings of the male genitals ever devised."[15] The first three epithets can be accepted, but—"reverential"? To recur to the point, the difficulty with Beardsley's images is that they demand to be read, and yet defy reading. Let us look again at the old man in "The Examination of the Herald." We asked if he were impotent, or anxious to assure himself that he is not by fingering the herald's triumphant organ? Curious, envious, admiring, or utilitarian merely? Or is it reverence? If such were Beardsley's intention, then it would be conveyed by some quality in the actual drawing of the phallus, for, unlike the public hair, this is in all cases drawn objectively as a natural object, as it really is as a shape; and if there is reverence it is the reverence involved in attempting to see and render the object as in itself it really is: to disinfect the object of the privacy of shame. Or is it reverence for the phallus as an object of power, of distinct powers: what makes a man a man, the seed producers (Aristotle's version of generation) as well as the organ of pleasure. But the phalluses are not isolated in the drawings. How are we to interpret the expressions on the faces of the old man and the herald? The young man is standing with arms akimbo displaying the organ. He is paying no attention at all to the old man, and nothing can be read from his face. But if one says "displaying," then that implies an interpretation of what he is doing, derived from his stance, which may after all be perfectly unjustified. Yet we can hardly look at this image as an arrangement in black and white. Some drama is going on. There he is, the old man, his age, his expression, his gesture, the state of his genitals. But where does the young man come in? And what is his relationship to his own gigantic phallus?

Our judgment as to whether these drawings are pornographic must itself be a historical judgment, for to use the word "pornography" at all is to import a historic element: what is admitted, and what is not, in a specific group, a community, at a specific time and place. All that can perhaps be said at the present about our judgment of what is pornography (whether "hard" or "soft" may be left aside) is that what we

are concerned with is the relationship of writing or visual image to deed. Everything depends on the viewer, and Beardsley sometimes gives the impression of being his own. It is clear that Beardsley's forbidden erotic writing, *Venus and Tannhäuser,* is fantasy, directed to induce fantasy and both to provoke and to check the solitary deed. About the *Lysistrata* we can be less sure, and it seems certain that "The Impatient Adulterer" from the Juvenal series barely shows us "Sin transfigured by beauty,"[16] Arthur Symons's definition of Beardsley's central quality. Beardsley was something of a moralist, after all, closer to Watts than to Whistler, exposing the superficiality of current morality. And of Beardsley's *Lysistrata* images we can say that they reveal his familiar opposition between the object of desire and the environment that renders satisfaction conceivable.

To these drawings, Beardsley brings a grotesquerie and a humor more or less in keeping with Aristophanes' text. Seldom has "obscenity" been less self-conscious and embarrassing. The traditional vice of pornography lies in the very nature of its subject matter. It tends to offend our sensibilities by its reduction of women to the status of characterless utensils. This is deftly avoided by Beardsley in the *Lysistrata* drawings, as it is avoided by Aristophanes, for the women have both character and humor. Perhaps this is not surprising, for Beardsley's oeuvre reveals no interest at all in masculinity or in the traditional male world. As with Aristophanes, and in other plays besides the *Lysistrata,* men in Beardsley's images are absurd. There is hardly reverence so much as an element of joke or caricature in his treatment of the erect phallus, with its comically luxuriant pubic hair that nonetheless suggests fruitfulness, distorted by a misplaced virility. In spite of Beardsley's typical "decadent" attitude to Nature, the context of a "macho" imperialism makes this reading at least possible. It remains ironic that though these pictures have the notoriety of opening the depths of a wayward and sinister genius, they are perhaps the most uncomplicated and good-humored works that Beardsley ever penned. Aristophanes proved a source considerably more fertile than Pope.

Juvenal's Sixth Satire

The drawings illustrating Juvenal's epillyon-length satire on women constitute another equally successful experimental series. Beardsley's interest in this splendid demonstration of misogyny can be gathered from the first version of "Messalina," which dates from 1895, while

"The Impatient Adulterer" was drawn either in late 1896 or early 1897.

The frontispiece had been published in the January 1895 issue of the *Yellow Book* as a double-paged supplement. A woman, face just visible between the curtains of a sedan chair, is being carried by two turbaned and braided monkeys with the large bare feet of *homo sapiens*. The emblem barely seems ambiguous: dark and animal sexuality guides the reason. Heavy, sullen, predatory, the profile of the woman in the chair points equally unambiguously to Messalina, the whore-empress of Rome and the model in Juvenal's view for the capital's ma-trons and young girls. Victorian rather than baroque or rococo, the sedan chair has two thick, heavy posts topped with crowns and plumes, and it suggests the object of furniture over which Messalina indisput-ably reigns. A continuum of seventeenth- and eighteenth-century fa-cades extends from frame to frame and closes the horizon. The Whitehall Banqueting Hall is clearly recognizable, and the scene sug-gests a London and a Brighton that Beardsley knew well, rather than a Rome that he had never visited.

The other four drawings relate stylistically to the *Lysistrata* with similar strong outlines, without massed blacks and generally void of background. "Juvenal Scourging Women" reverses the role pursued in the frontispiece to John Davidson's *Earl Lavender*: a mature, heavily built woman in a stippled, transpicuous garment that covers breast and pudenda, is impaled on a columm that acts as a gigantic dildo. A belaureled Juvenal, with robe rucked up, revealing a heavy, not alto-gether dormant, uncircumcised penis, and a pair of frilled stockings, with his right hand lays on a three-tentacled whip. This is the famous whiplash of art nouveau whose origins lie in illustrations of cephalo-pods and stingrays, and which has elements of cruelty and perversity. The poet's body is half swiveled toward the viewer, though his head is turned toward his victim. His mouth is open and grimacing, contrast-ing with the woman's impassive face, and his smile has a possible sexual significance. On the left of the drawing is half of a triumphal arch with coupled Corinthian columns and a heavy swag across the architrave.

Beardsley's copy of Dryden's 1697 version of Juvenal is at Princeton, and there are references to Gifford's translation of the satires in the letters (*L*, 409, 413), but it is likely that he also worked with the Latin. Dryden omits the line that gives the topic of the second draw-ing, "Bathyllus in the Swan Dance," while Gifford renders "chirono-

mon Ledam molli saltanto Bathyllo"—literally, "the soft Bathyllus dances the part of the gesticulating Leda,"—as "Lo! while Bathyllo, with his flexile limbs, / Acts Leda and through every posture swims."[17] Chironomon is the name of the dance, which would be accompanied by a commentary from the chorus, while Bathyllus is a generic name for the principal dancer in the pantomime, deriving from a famous executant in the time of Augustus.

The effeminate young man with plump bottom and thighs is naked excepting a veil that partly hides his left thigh, while his hair runs to knee length along his back. Bathyllus's head is coyly turned over his right shoulder, though slantingly from the viewer, while his hands gently repel a swan of reduced size in midair to the right with beak in a direct line with Bathyllus's hidden genitals. The curve of the swan's wing forms a semicircle (an iconographical device deriving from sculpture and present in a number of versions of the Leda and Swan history—Leonardo's, for example), and a line drawn around from webs to neck completes the circle. The history was popular among the late nineteenth-century painters after Moreau's symbolic machines had presented Leda's rape as an apotheosis, and there are a number of poems in English on the topic: by Beardsley's friend, John Gray; Charles Dalmon; "Michael Field"; and the well-known sonnet by W. B. Yeats. The circle in Beardsley's image may allude to Moreau's haloed swan or possibly to the egg of Leda in Pausanias,[18] or to one of the eggs that resulted from the union. Unlike Moreau and the poems on the theme in English, Beardsley's tone is far from serious. "Bathyllus Posturing" shows a similar figure now entirely naked with an ample bottom presented slantingly to the viewer, his left hip thrust out while the fingers of his right hand touch his rectum, possibly an indication of the mounting bird. Brophy[19] reads this as an explicit invitation to buggery, taken with the lewdly inviting left hand, and observes that "the over-muscled heroic Greek body" has been "bloated out into Roman blowsiness." Over his right shoulder Bathyllus flings "something remarkably like a Wagnerian maiden's plait," which is also a displaced horse's tail. This is possibly an allusion to the horse position in coition. Both of these images of Bathyllus are without background.

Beardsley drew two versions of the famous passage describing Messalina's nocturnal visits to the stews to stem her nymphomania, an enterprise invariably unsuccessful. The story is recounted also in Tacitus and Suetonius: "et lassata viris necdum satiata recessit," or, as Dryden puts it with his usual paraphrastic swagger: "All filth without and

all a fire within / Tired with the toil, unsated with the sin."[20] Both of Beardsley's images radiate a sense of evil and of gross power. The first is startling, almost melodramatic, and shows Messalina returning to the Imperial Palace with her maid. Where Juvenal merely tells us that "assuming a night cowl, and attended by a single maid, she issued forth" (l. 119), Dryden, as usual, enlarges:

> but one poor wench allow'd.
> One whom in Secret Service she could trust;
> The Rival and Companion to her Lust.[21]

Gifford follows the original more closely. Though Messalina's inflexible, coarse face represents a partial return to caricature, and the heavy lips are compressed with anger and frustration, the young maid, completely muffled in cloak and hood, has the slack mouth and feral eyes of one who still finds the expedition rewarding. The melodrama is made more acute by the contrast of a running black ground lit by the large plumes that trail over Messalina's immense black hood like smoke with a single tongue of blackness snaking toward the bottom left of the drawing, in visual allusion perhaps to the smoking lamps that in Juvenal light up the brothel where Messalina, impersonating "the wolf girl," has been outdoing the professionals. It may possibly refer to the smoldering itch that returns with her. The black ground is also lit by the wide and heavy white of Messalina's skirt, the exposed shoulder, and bulbous, still-pointed breasts (bereft, no doubt of their gold leaf patina), and by the maid's dainty pointed foot. These may be Beardsley's allusions to his written text. A delicate Renaissance fountain sleeps in the background. Beardsley's imagination has clearly seized on the phrase "black hood"; Messalina and the maid echo one another in clothing, but the empress's naked front expresses her greater shamelessness. Brilliant though this design is, the detail somewhat blunts the effect and the wash that the artist applied later to Messalina's skirt, and the exposed portions of skin is not altogether fortunate.

Such a judgment could only be justified in context of the later drawing, "Messalina Returning from the Bath." Like the *Lysistrata* drawings, this image has no background, and the only massed black is confined to the steps up which the empress is climbing and presumably throwing her shadow. Even her black hair is relieved by white lights. On the other hand, as Reade observes, the lines, particularly those that define Messalina's body, are "stouter and heavier."[22] The absence of

maid and background, the heavy forward thrust of the body, isolates
the savage nature of Messalina's fiery pursuit of sexual pleasure. She is
perhaps the most accomplished example of Beardsley's version of the
nineteenth-century femme fatale, with her malignant breasts, suggest-
ing opposition to the fructifying powers of woman, viewed now as
emblems of decay, again a fine response to the Latin text: "ostenditque
tuum, generose Brittanice, ventrem" (exposed to view the womb that
bore thee, O nobly born Brittanicus). Yet we cannot subvert her power
by laughing at her. In this and in the following image, Beardsley rises
to his full power, no longer an accomplished caricaturist, but a satirist,
one who at once fears and is attracted to what he excoriates. Here, and
in "The Impatient Adulterer," one can readily gather what Yeats ac-
cented in his account of Beardsley and the "Tragic Generation," the
"vision of Evil," an evil that is far from the self-induced luxurious
shudder normally attributed to the artists and poets of the fin de siècle.
In these two drawings, the artist joins the tortured elect, those who
fully enter into and by entering exorcise spiritual as well as physical
corruption.

The last of the series, "The Impatient Adulterer," illustrates the
episode where the wife's lover has been smuggled into the home by the
mother-in-law. The daughter pretends to be sick as an excuse to take
to her bed, and she and her lover have to endure the visit of the doctor:
"et secretus adulter / impatiensque morae silet et praeputia ducit,"
which, apart from the splendid initial phrase, Dryden renders rather
tamely as "The Panting Stallion at the Closet Door, / Hears the consult
and wishes it were O'er."[23] Gifford for once is superior—

> While the rank letcher at the closet door,
> Lurking in silence, maddens with delay,
> And in his own impatience melts away . . .[24]

suggesting premature ejaculation and not so far from Beardsley's touch,
showing the adulterer "fiddling" at the foreskin of a large and half-
erect phallus. But in a copy of the folio of 1693 now at Yale, a presen-
tation copy to Thomas Monson, there are some manuscript additions,
not in Dryden's hand, that may well represent Dryden's unrevised
draft. The coincidence with Beardsley's image is startling, though the
artist took his image direct from the Latin: "et praeputia ducit": "The
Panting Stallion in ye closet stands; / And thinks on love and helps it
with his hands." Dressed in wig and filmy blouse, the adulterer peers

through a bed curtain, and his leering face resembles in the closeness of long and thick-lipped mouth to the nose the new facial type of woman in the ensuing illustrations to *Mademoiselle de Maupin*; but the curve of the sharply receding forehead and the straight line of forehead and nose also have a disconcerting resemblance to the pig on the brilliant cover design of Vincent O'Sullivan's *Houses of Sin* (1897). The shift here from caricature to satire was perhaps accentuated by Beardsley's reading at this time in Jansenist works of piety, preparatory to his reception into the Latin Catholic church, but whatever the origins of this sharp sense of evil, such an exposure not only of the current bourgeois notions of immorality, but of the amorality of his contemporaries and fellows, retains a disturbing power.

Mademoiselle de Maupin

Equally successful are some of the illustrations to *Mademoiselle de Maupin*. The hero of Gautier's charming novel (1835), D'Albert, is dandy and poet. In search of an ideal woman, or rather a creature of the third sex who combines the virtues of both the genders, he enters on a liaison with a carefully chosen and compliant lady, Rosette. A flashback tells how Rosette, then a chaste young widow, fell in love with a young man, Theodore, a new acquaintance of Rosette's brother. Although exquisitely versed in the male accomplishments of fencing and horsemanship, he possesses a face and skin as delicate, and as graceful a figure, as that of a young woman. Theodore's position as guest in Rosette's house provides many opportunities for consummating the affair, which the young man unaccountably evades. Theodore leaves, after Rosette has in desperation come to his room at night to force the issue and has been discovered by her brother, who provokes Theodore to a duel, in which the brother is wounded. Theodore, believing that he may well have killed the brother, rushes from the house. To efface Theodore's image, Rosette has a series of affairs, and her latest lover is D'Albert, to whom she is still devoted, though he has reached the stage of affectionate boredom in his attitude toward her. Theodore returns unexpectedly to Rosette's house, rousing D'Albert's jealousy, but also, to his chagrin, attracting his desires. It emerges that Theodore is indeed a woman, a virgin who by disguising herself and by rigorous practice of riding and swordplay has been able to pass herself off as a man and acquaint herself at firsthand with their real, as opposed to their social, selves. She grants her favors first to D'Albert, then to

Rosette, and disappears without a trace, leaving the two lovers bound by a shared possession of their ideal. It is unfortunate that Gautier actually gives us Theodore's story in her own words, as this blurs the logic of the tale: that Theodore has no independent existence, but is an androgynous ideal common to both D'Albert and Rosette.

Beardsley was still changing his style every year. This emerges in the addition of watercolor and wash to ink and in a new facial type of woman. In the first of the illustrations, however, "Mademoiselle de Maupin," pen, ink, and green and pink watercolor are vapid and blurred. The *Mademoiselle de Maupin* illustrations that work well succeed despite, rather than because, of Beardsley's highly imperfect pen and wash technique, which mists and reduces the effect of his splendid outlines. In the title drawing, we are distracted from the delightful originality of the costume by the scratchy pen work. However, "D'Albert" and "D'Albert in Search of His Ideals" do succeed. D'Albert's face is feminine but strong, with nose and mouth close set and large elongated eyes set under a mysterious cone-shaped hat that may be of Beardsley's own devising, or a memory perhaps of eighteenth-century chinoiserie. The slanted face and gaze are haunting. In "D'Albert in Search of His Ideals" the hero acquires once more the new, feminized face with fulsome lips and hooked nose. D'Albert's figure is also effeminate: the thighs are plump, the hips are rounded below a waspish waist (a dandiacal feature); the eyes are long and narrow and leave the impression of looking past an impasto of cosmetic. In the background are a young woman of similar facial type, the ingenue no longer, and an elderly buck carrying a large hatbox. Reade distinguishes[25] a return to caricature in this image with its exaggerations. The remaining illustrations are masterful. "The Lady at the Dressing Table" adds a new touch of grotesquerie, of the surreal almost, to the familiar toilette scene by setting it in the open air of a city on some species of verandah, with a church designed in the style of Nicolas Hawksmoor in the left background and to the right a parrot on a tall perch. The fardeuse has an older, distinctly ugly version of the "new" face, nor is her mistress young, while the altar of the toilette is altogether severe. "The Lady with the Rose" has similar, though younger features, which Reade[26] defines as "uterine," suggesting that they define a direct sensuality that is not in any sense malignant. Certainly the fardeuse in "The Lady at the Dressing Table" if ugly, leaves no impression of evil. The hermaphroditic dwarf amoretto at the lady's side echoes the facial type. In "The Lady with the Monkey" the heroine's pet splendidly mimes the man-

nered ennui of D'Albert, who, like nearly all of Beardsley's male figures, is devoid of real interest and dissolves beneath his costume. The atmosphere of the *Mademoiselle de Maupin* drawings is a more urbanized version of that of "Under the Hill" (though the action of Gautier's novel takes place mainly in the country). It is a grotesque little courtly society that surrounds and enhances the beautiful and the erotic: an ugly fardeuse, a parrot, a monkey, a monstrous amoretto. As in "Under the Hill," all that really exists is the atmosphere; plot and character, as so often in Beardsley's work, remain of minor interest to the artist. With these drawings, we may group the bookplate for Olive Custance, the poet, and "Arbuscula," a modern version of a famous dancer of later Roman times.

Two late designs are connected with the Pierrot imagery, discussed earlier: the Pierrot Library plates and the illustrations for Ernest Dowson's *Pierrot of the Minute.* The first of these are both slight and uninteresting commissions from persons who had quite misconstrued the keenly individual Pierrots that had earlier on inspired some of Beardsley's finest lines. Earlier Beardsley might well have borrowed the makeup and costume of Callot's grotesques and the characters of Watteau's *commedia dell'arte* characters, but had had no use for their reflective melancholy. In the Pierrot Library illustrations, Pierrot has returned to his rustic origins but has something of the smooth, melancholy features of Watteau's Gilles. The illustrations for Dowson's lachrymose *pierrotade* are distinctly more successful; the artist had little sympathy either with the poet or his work, so was able to apply his critical gifts to the text he was illustrating.

Volpone

Beardsley's last works, the incomplete series of illustrations for *Volpone,* have always been highly praised, though lately distinguished dissenting voices—Reade and Gordon, for example—have been heard. The experiment with the pencil alone, the *sfumato* effects, was a false step, though the elephant of the initial *V* and the reduced *sfumato* of the *S* so assisted by the shape of the eagle, are both successful. In the image of Volpone adoring his treasure, we have a sense of *déja vu.* The toilette scene of *Mademoiselle de Maupin* repeats a familiar theme, but does so in a manner that significantly adds to the repertoire, adds new subtleties. But in the *Volpone* image, we have nothing of Beardsley's characteristic subtlety and elegance; neither wit nor understatement;

no grotesquerie of atmosphere: simply a greedy man, somewhat melo-dramatically posed; an attempt at realism all too evident in the palisade of breasts in the initial *M* and more successfully in the trees reminiscent of the later eighteenth century. The combination of thick lines and slavish hatching robs the picture of depth and invests all with a card-board flatness.

As an artist Beardsley tends to stand or fall by line, and to add modeling (and sometimes heavy-handed modeling) is to borrow from a quite different idiom. The effects achieved in "Ave Atque Vale" are more reticent. If Beardsley was seeking to imitate a baroque effect, then his drawings should have been engraved; only then might they have acquired that species of monumentality that we may assume he was striving toward. But such would have been a step backward in a highly innovatory career. The whole *Volpone* project suggests a young man's anxiety to achieve respectability by the canons of traditional art—a loss of faith in his earlier work, both in its technique and subject matter. One might draw the parallel with the tubercular Keats's at-tempt at the Miltonic verse of *Hyperion* or the further restless experi-ments indeed of the last year or two of his creative life. *Volpone* would probably have shown us a Beardsley subjecting himself to Jonson's moral art with results more disappointing than in *The Rape of the Lock* "embroideries." But Beardsley's energies were very likely being di-rected elsewhere. *Volpone* was a deliberate distraction. Jonson's notion of a man whom everyone thinks is about to die, but who is in fact a healthy, "libidinous" creature, must have been entirely congenial.

Chapter Eleven
Summary and Afterlife

What was Beardsley's contribution to the English tradition and why is it that his images are cogent for us today? The English up to the early part of this century were considered in general terms to be supreme in the art of poetry and to be distinguished also in architecture. In painting and music, though not devoid of major figures, their tradition was considered to be less impressive.

As to English art, abroad its great period was presumed to be the eighteenth century of William Hogarth, Thomas Gainsborough, Sir Joshua Reynolds, John Constable, William Blake, and Joseph William Mallard Turner. Of these, Blake and Turner remained somewhat equivocal figures, eccentric, isolated, and somehow without the breadth and generative power associated with great art. The recent exhibition of Turner's painting in Paris is said to have struck French art critics forcibly. The French tend to be somewhat inhospitable to art that has the misfortune not to be French or at second best is without the fortune of being strongly influenced by the Parisian schools, the condition to which all art naturally aspires. The modes at which the English excelled were crafts and watercolors from the eighteenth century down to the mystical and chivalric images of Rossetti. Constable had great influence in France; so too to a less degree had the Pre-Raphaelites, particularly Burne-Jones, but Beardsley was more immediately famous, and his influence extended throughout Europe and to the United States.

The position of drawing in Britain through much of the nineteenth century was minor. The Royal Academy founded in 1768 maintained a strict control over the ethos and patronage of art. For years it had a virtual monopoly of the schools of art. The way to success as a painter lay through the annual exhibition at the Academy and the Academicians sat in judgment, determining whether painting should be hung, "skied" out of the normal eye range, or favorably sited, or more likely simply rejected. The work of the Fellows themselves, however dry or incompetent, was always hung and always favorably sited. Robert Ross

quotes Beardsley's ironical defense of the Academy. It ran to the effect
that he would rather be an Academician than an artist: "it takes only
one man to make an artist, but forty to make an Academician." Forty
being the number to which the Fellows were limited.[1]

One of the consequences of this control of ethos and patronage, of
this continuous predominance, had been the survival of the eighteenth-
century attitudes inherited from neoclassicism which tended to hier-
archise the various branches of an art. Oil painting and heroic sculpture
were placed analogously to epic and tragedy as the highest types of art
that every artist should attempt if he were anxious for reward in his
own life and fame after his death. Watercolor was viewed as a distinctly
limited activity, corresponding perhaps to the lyric among the "kinds,"
and though Reynolds in his Academy lectures admitted drawing to be
the foundation of fine art, it was considered to be a raw, private, and
even incomplete act. As Robert Ross succinctly puts it: "The most
finished drawings of the old masters were done with a view to serve as
studies of designs to be transferred to canvas, metal, or wood, not for
frames at an expensive dealers"[2] From Ross's remark we may gather
that by the first decade of this century taste had sharply veered. Con-
stable's "sketches," his cartoons roughly and spontaneously painted, are
now if anything valued more highly than the oils he found it necessary
to submit for the Academy with their high "finish"—that crucial
word—and the mellow glazing designed to give them a patina of in-
stant age. Present-day taste prefers the raw, the unfinished, the sug-
gestive, a field, a space, a text, in which the viewer or the reader is
expected to collaborate with the artist or even abolish him. When
Beardsley showed Burne-Jones his drawings, the Pre-Raphaelite master
assumed that these were sketches for paintings in oil, and it was the
same Burne-Jones, though no particular friend to the Academy, who
had deplored the want of "finish" in Whistler's Nocturnes. Beardsley,
who by no means despised fame, made one or two experiments in oil
and wash, but these were not his natural direction. His achievement
as a draughtsman did much to raise the prestige of that branch of the
art as an autonomous activity.

Other draughtsmen, to be sure, had been popular in nineteenth-
century Britain, and their work had been widely diffused; but it was
often secondary and discursive, limited to political and social carica-
ture, satire and book illustration. Beardsley extended the range of pure
drawing by making it more expressive and by his acquisition of a mas-
tery of sinuous line and subtle massing. He was "modern" in technique

and often in topic but was also in his later phase more purely classic. His eclecticism was not a mere Alexandrian synthesis. He was anti-romantic in his romanticism and his classicism like some of the twentieth-century masters. He evaded the tired quality of much nineteenth-century art and literature by overstatement and reduction, by parodying and reestablishing iconographical traditions. He was unremittingly devoid of sentimentality. His art was also intellectual, critical, interpretative; he brought to light not only what the threatened patriarchal culture of his time knew and feared, but what it did not know and feared to recognize when it was enforced on its attention. He had no stringent art education to react against; his eye saw without being tutored by conventions of seeing, and like artists of greater stature he imposed his own perhaps narrow and probably feverish version of reality on what was commonly agreed to be the "real." He decomposed the materials of the objective world and recomposed them into an ideal geography of his own devisal. And all this was accomplished with an icy fire of consciousness, a cold intensity that appears at first antithetical to the sensational, even melodramatic, features of much of his art, and to the frenetic quest for all that can be clutched and held and possessed by one who was continuously in a state of physical dissolution.

The Afterlife

His enemies, when he died, were delighted to assert he was already forgotten; that he had never been able to draw; that he was the cause and the symptom of a brief phase of culture known as the "decadence" which by 1898 was already past, displaced by the bracing onset of a noble imperialism. But like all major talents he survived because his work was constantly to give up secrets to each generation that succeeded; a creator of sharp images, he was himself eminently subject to image-making; a culture-counter who could be deployed in various and often contradictory roles: possessed by devils, simple saint, moralist with "a vision of evil" (Yeats), the "Fra Angelico of Satanism" (Roger Fry), "Master of the Line Block" (Pennell), dirty-minded scribbling precocious schoolboy (Wilde), "seer of the invisible dance" (also and more typically Wilde). It is fitting at this point to engage with some of the versions of Beardsley that have enabled his art to survive.

At his death in 1898, his friend Max Beerbohm and his collaborator Arthur Symons both contributed an éloge to the public prints. Beards-

ley had been out of public view for more than a year: no new, scandalous images had discomposed the bourgeois eye, and it was widely presumed that the artist had himself mysteriously evaporated with the end of "the Beardsley boom" at the close of 1896.

No man is on oath in an obituary notice, but, though obviously written by a man both intelligent and kind, Max's elegy is designed to reduce the impact of Beardsley's disturbing impact on his time. The artist is described as a devoted brother and son, morbid only in his earlier drawings; the asperities of both his work and his character are subdued, though his greatness is unequivocally asserted. Beerbohm suggests that he was a tragic figure, essentially lonely like all high talents, enjoying life but never wholly involved in it. *Salome* and Wilde (who had been out of prison for a year) go unmentioned. The "Ave Atque Vale" and "The Coiffing," both works of the *Savoy* period, are isolated as his finest work. The conclusion is that "no man ever saw more than Beardsley. All the greatest fantastic art postulates the power to see things, unerringly, as they are."[3] Morally speaking, this perhaps may be so; but visually Beardsley's power resided precisely in seeing things unerringly as they were not.

Conceding that Beardsley was sincere in his conversion and that he died resignedly, Beerbohm makes no connection between Beardsley's art and his beliefs. This connection is made in Arthur Symons's first piece on the artist which was published in the *Fortnightly Review,* enlarged for publication as a slender book later in that same year and again in 1905. Where Beardsley in Beerbohm's version of him remains a relatively one-dimensional figure, Symons's is more complex. He stresses the contradictory elements in the artist's genius, and the fact that he was writing immediately after Beardsley's death does not inhibit criticism. Symons too stresses the fact that "with all his interests in life, with all his sociability, he was . . . essentially lonely." His contempt for the public led him, we are told, "to that lower kind of beauty which is the mere beauty of technique. . . . he allowed himself to be content with what he knew would startle.[4] Symons has no embarrassment in praising the *Salome* drawings: in the best of these and occasionally after, "he attains pure beauty. From the first it is a diabolic beauty, but it is not yet divided against itself. The consciousness of sin is always there, but it is sin first transfigured by beauty; sin, conscious of itself, of its inability to escape itself, and showing in its ugliness the law it has broken."[5] The Beardsley of Symons's essay is a Paterian symbolist with touches of Baudelairean Satanism:

His world is a world of phantoms. . . . It is the soul in them that sins, sorrowfully, without reluctance, inevitably. Their bodies are faint and eager with wantonness; they desire more pleasure than there is in the world, fiercer and more exquisite pains, a more intolerable suspense. They have put off the common burdens of humanity, and put on that loneliness which is the rest of saints and the unrest of those who have sinned with the intellect. Here, then, we have a sort of abstract spiritual corruption, revealed in beautiful form; sin transfigured by beauty. . . .[6]

Symons's insistence on the phrase mirrors his own obsessions. However, as the essay proceeds we become aware of external influences on the essayist's version of the artist. The one thing, he tell us, which is without hope in the moral world is mediocrity: "Better be vividly awake to evil than in mere somnolence, close the very issues and approaches of good and evil. For evil itself, carried to the point of a perverse ecstasy, becomes a kind of good, by means of that energy which, otherwise directed, is a virtue. The devil is nearer to God . . . than the average man who has not recognized his own need to rejoice or repent."[7] At this point in his career Symons was in close touch with Yeats and was preparing his *Symbolist Movement in Literature*; the essay has to be read in that context. Beardsley is of the lineage of Baudelaire; one certain of Hell, dubious of Heaven. Satanism becomes the homage the tortured artist pays to God; the mode of easing the tensions imposed by a religious temperament, though Symons had earlier described the artist as *anima naturaliter pagana* (a soul paganized by nature), pagan signifying not amoral or irreligious but a non-Christian sense of the divine mysteries. Yet, according to Symons, Beardsley had once told him of a singular "vision" (the word is Yeatsian) he had experienced as a child: a dream of waking in which he saw a giant crucifix with a bleeding Christ falling off the wall, and by a leap of the imagination Symons could connect this with the artist who had died in the peace of the last sacrament, holding the rosary between his failing hands. The bleeding Christ tale appears also in that eloquent rag bag of anecdote and myth, Yeat's *Autobiographies*. It was in 1898 also that Symons wrote a poor poem in Beardsley's memory and many years later a more substantial suite of poems on the *Salome* drawings.

The unfortunate issue of Symons's stress on Satanism, Sin, and Beauty (the capitals underline the point) was that the artist readily became imprisoned in the fin de siècle. This superficial view became the hinge of Roger Fry's damaging and influential *Athenaeum* article of

1904. At the same time as Symons was busy with his obituary, a con-
versation about Beardsley was taking place in that Grange End House
which the young artist and his sister had visited seven years before. Sir
Edward Burne-Jones was within months of his own death, having out-
lived his dear friend William Morris by two years. Beardsley's impa-
tience with the *Morte Darthur*; and his considered attempts to shock
the public, his parodies, and his "naughty" pictures had been duly
marked by the older artist, and Burne-Jones's view of one whom he
had earlier encouraged had turned acrid. Above all he shuddered from
the presence of what he termed "lust" in Beardsley's art: Lust was al-
most a metaphysical force he seemed to suggest, and he feared its pres-
ence in himself. This is acute and defines precisely why Burne-Jones
as illustrator was a minor Beardsley. These views were recorded by his
assistant T. M. Rooke, who defended Beardsley's talent and insisted on
his mastery of line. Burne-Jones replied that this could be said of many
artists and that Beardsley would soon be forgotten. His attitude was a
somewhat more sophisticated distillation of the opinions of the press
and the mood of the middle classes.[8]

Some Influences

Beardsley's posters in particular influenced the distinguished Amer-
ican designer and typographer Will H. Bradley. In his periodical *Brad-
ley's Own* (1896) and some drawings for the *Chapbook* (1894–98), the
Beardsley woman makes her familiar formidable appearance. The im-
ages of *Salome* and art-nouveau candlesticks, assymetry and columns,
roses masquerading as nipples, can be detected on the border and il-
lustrations of Stephen Crane's *War is Kind* (1899). Bradley designed
the text and binding of this volume in gray ingres paper. A less for-
tunate influence was exercised by *The Rape of the Lock* illustrations on
turn-of-the-century work in this field. The impresario Serge Diaghalev
who had met Beardsley at Dieppe in 1897 commissioned from the
Scots critic D. S. Maccoll an acute if not altogether sympathetic article
on the artist for his symbolist magazine *Mir Isskustva* (The Art World)
in which there also appeared a design by Leon Bakst considerably in-
fluenced by the English artist who also remains a presence in Bakst's
work for the Russian Ballet. Beardsley's influence can be sensed in
literature, particularly in D. H. Lawrence's *The White Peacock* of 1911.
Exhibitions were held in the decade succeeding Beardsley's death: Rob-
ert Ross's Carfax Gallery in 1904, the Galeries Shirleys in Paris in

1907, the Baillie Gallery in London in 1909, and the Berlin Photographic Company in New York four years later. In the 1890s and later, Beardsley's influence can be detected in the black and white fantasias of Sidney H. Sime, while in the immediate postwar years, artists such as Austin Osman Spare, Frederick Carter, and "Alastair," C. Hans Manning Voigt, assimilated Beardsley's images. The vogue for their work did not survive the 1920s though they have recently been revived.

Connoisseurs and Forgers

The populace, the press, and the art critics might have buried Beardsley but the collectors of drawings had not. Leonard Smithers had experienced hard times and in 1899 had been declared bankrupt. He survived perilously for another eight years publishing pornography and selling Beardsley relics to support himself, and when the supply of drawings failed, he turned to forgery. An unpublished typescript by the journalist Dan Ryder contains some information that identifies the factory that Smithers established at this time.

John Black, nicknamed by Smithers "John Peter," was an Irish barrister with rooms in the Temple, a limited legal practice, and a fertile drawing pen. Black modeled his style on the 1897 collection edition of Beardsley drawings. His first job was to copy Beardsley's more erotic pieces, particularly the *Lysistrata* illustrations, working with a magnifying glass to ensure accuracy.

To copy a Beardsley drawing such as these completely and accurately (even down to the counting and placing of the number of dots decorating a skirt) in such a manner as to deceive even Smithers himself would occupy Black a week or sometimes longer. . . . The original *Lysistrata* drawings had been shown to one or two wealthy amateurs by Smithers, notably Pickford Waller and Harry Pollitt, shortly after Beardsley's death and a large sum (£300) was asked for them. There was also a rich collector in Vienna, a great patron of Beardsley's work, who had made inquiries about these. Waller and Pollitt were known to each other and Smithers could play one off against the other. . . . The unfortunate Viennese collector neither knew them nor was known to them. Pollitt eventually became the owner of the drawings but only when the "copies" were finished and could be sent off to the Austrian. Only one drawing was sent at first . . . as a sample, and he eagerly grasped at the opportunity of securing the complete set of his "idol's" most remarkable achievement.[9]

The role that Smithers' mysterious partner, H. S. Nichols, played in these early transactions is not altogether clear. In his monograph on Beardsley, published in 1909, Robert Ross a little optimistically declared: "There are at present in the market many coloured forgeries of his work: these have been contrived by tracing or copying the reproductions; the colour is often used to conceal the poverty of the drawings and the hesitancy of line; they are nearly always versions of well-known designs, and profess to be replicas."[10] Even so, as late as 1950 R. A. Walker (the pseudonym of Georges Derry) found it necessary to issue a pamphlet on how to recognize forgeries of the drawings. Provenance in all cases, as Ross stressed, was of the first importance. But what if the provenance were that of Smithers and his associates?

The Nichols Exhibition

The boldest attempt at circulating suppositious items was at the H. S. Nichols exhibition in New York of 1920. The catalog was described as running to 500 copies on "specially manufactured paper," but it was not the paper only that was manufactured, for all the drawings were forgeries. They were, however, in black and white unlike the versions alluded to by Ross, and were not replicas, though they are anthologies of parts of geniune drawings, obtained doubtless by copying or tracing.

Roger Fry

Reviewing an exhibition of Beardsley's work at Ross's Carfax Gallery, the Bloomsbury critic Roger Fry seized on Symons's article. Far from denying the morbid and hieroglyphic elements in Beardsley's art, though, Fry accepted them as useful for the limiting judgment his own version of art history constrained him to pass. "The Fra Angelico of Satanism," Fry's brilliant phrase comes as the climax of a concise, cleverly reductive account of the artist. Fry's method is praise followed by instant radical qualification. He admits Beardsley's genius, but it was "precocious and eccentric." He has an entirely personal style, though a confirmed eclectic. "It mattered nothing what he fed on; the strange and perverse economy of his nature converted the food into a poison."[11] Despite the judicial tone, the epithets are colored and prejudiced: "eccentric," "strange," "preverse." Beardsley may have had "an amazing gift of hand" and this endeared him to these low fellows, publishers,

and process block makers (so much for his fame) but his line was fre-
quently mechanical. Whistler had rightly termed him the last of the
writing masters: his "meandering flourishes ending in sharp spikes and
dots," however firm and precise the lines often are. This fertility of
invention is admirable and so too his masses of black and white (a point
developed sixty years later by Lord Clark,[12] that late fine flowering on
the Bloomsbury thorn). Also successful was Beardsley's planning of
three tones: black, white, and gray, so that "it is not a mere false
analogy to talk of the colour effects of designs in black and white, for
he so disposes the three tones, getting the grey by an evenly distributed
network of fine black lines, that each tone produces the sensation of
something as distinct from the others as do flat washes of different
tints."[13] The frontispiece of *Salome* is given as an excellent example.
Beardsley has, in Fry's view, the decorative impulse, but, and here the
concessions are seen to be fatal to the artist, the impulse is not con-
trolled by "a larger more genial sentiment for architectural mass" and
so is not "ennobled."[14] Elegance rather than beauty is Beardsley's ideal;
a dandyism that becomes a mode of cherishing a diabolism that was
"sincere enough." For Fry, a descendant of Quakers, Beardsley is never
funny or witty: "his attempts in this direction are contemptible." (Vi-
sual puns are clearly not for this critic.) There is a touch of the austere
in his style, proper to the priest of a Satanic cult, all of which imprisons
Beardsley in 1890s diabolism and marks him as a solemn adolescent
attempting quite unsuccessfully to "shock" his public. Fry confuses
Beardsley's tone absolutely with that of Wilde. In his drawings, we
can detect "the stigmata of the religious artist"; predilection for flat
tones, precision of contour, and all want of the sense of mass and relief.
Unlike many other commentators, Fry will have nothing to do with
Beardsley's "classic spirit" so dear to later admirers. If we discount the
"Ave Atque Vale" or "Et Ego in Arcadia," Fry senses that the *Savoy*
period and the *Volpone* drawings represent ambition rather more than
achievement. The essay concludes in a manner that turns the key on
Beardsley as a purely fin de siècle phenomenon; it is as the Fra Angelico
of Satanism that he will be remembered, and he is dismissed with
massive patronage: "This work will always have an interest for those
who are curious about this recurrent phase of a complex civilization."
Fry's ideal was already forming itself: Cézanne and the archaic; the
primitive.

To clarify this we may turn to Fry's comments on Beardsley's in-
ability to do anything with Nature herself. "Everything that was to be

in the least expressive had to come from within, from the nightmare of his own imagination."[15] It is a good description of northern expressionist art, unknown in England at that date.

Already Fry's dogmas of plasticity and solidity are present, even though his worship of Cézanne as emergent deity lies a few years in the future. Walter Sickert compared Fry lecturing (not to say preaching) to a heron, that priestly bird, with his one repeated monotone: "Cézannah! Cézannah!" Cézanne, with his still-life triumphs and his detection of "harmonies" in natural forms, looks forward to cubism and abstraction, but he looks back also to a romanticism, a natural world that once contained an immanence of meaning. Whatever Cézanne's achievement, Fry's comments, his vocabulary, reveals him as still confined to the ratio of the five senses. Recent art in the view of Fry and his Bloomsbury associates could only be French or, if it were English, it could only be Bloomsbury. Beardsley "designifies" nature to re-create it with new meanings; escapes from the conventions of the eye in the manner recommended by Wilde in the second part of "The Critic as Artist": "By its deliberate rejection of Nature as the ideal of beauty, as well as the imitative method of the ordinary painter, decorative art not merely prepares the soul for the reception of true imaginative work, but develops in it that sense of form which is the basis of creative no less than of critical achievement. . . . To be natural is to be obvious, and to be obvious is to be inartistic."[16]

The artist's reputation in the dreary, depressed, socially conscious, and apprehensive 1930s was maintained largely by scholars such as R. A. Walker, connoisseurs, and literary figures. Even as late as 1950, judging by the prices offered for some of the drawings at the sale of part of Walker's collection, Beardsley had been deserted by the cultural establishment. It was not until the early 1960s with the revival of art nouveau that he threateningly reappeared, impinging on the young particularly through cheap, reprinted selections, coffee table books, images affixed to mirrors, or staring from the hairy length of towels.

The attack on patriarchy, on gender determination, and the drug culture all play their part. The Beardsley woman with masklike features and blank eyes was clearly "stoned." And on the sleeve of the Beatles' *Revolver* (1964), with its four heads in black and white, the revival was aptly imaged. The hair on each head ran into that of its neighbor; it looked like Beardsley, it should have been Beardsley, it was not Beardsley. And in the following year the art establishment itself stirred: two lectures on Beardsley by Kenneth, Lord Clark of

"Civilization," the gist of which was repeated in 1966 in the *Sunday Times* and in 1967 as the preface to a volume of selected images. Clark was an inheritor of Bloomsbury, and his problem was to reconcile his continued admiration of Beardsley with Fry's dismissive comments.

Like Fry, Clark too had reacted sharply against the frivolity of the 1890s. First, then, Beardsley had to be redeemed from the fin de siècle, and this is accomplished by Clark's repetition of the traditional view of the absolute irrelevance of the *Salome* drawings. Second, Beardsley must be made reputable by his legitimate progeny; not, of course, "Alastair," but Paul Klee and Wassily Kandinsky. Beardsley's art moves toward abstraction, and "The Toilet of Salome" offers the palmary example: "The same disregard for actualities which allowed him to eliminate all which he could not absorb into his system of design left him free from all anxieties about period or probability." And after these optimistic relatives, "The complete exclusion of anything . . . which does not contribute to the essence of the design is startling. No wonder the young artists of the nineties who felt the need for abstraction Kandinsky and Klee looked with astonishment at this drawing . . ."[17]—the "Demon of Progress" positivist approach to art. At all events, Beardsley is now an honorary modern. However, Clark justly warned against assumptions that in all cases the block maker succeeded in translating Beardsley's images accurately, and his close comments, unlike his generalizations, are as one might expect invariably suggestive.

But it was the exhibition of 1965 at the Victoria and Albert Museum, London, devised by Brian Reade, that confirmed the Beardsley revival. Exhibitions can echo or create a public mood. This, with its stunning range, did both. It was followed by an effervescence of scholarship and criticism: Reade's close examination of the drawings in his Studio Vista volume of the ensuing year; an edition of the collected letters; Stanley Weintraub's readable and informative biography; Brigid Brophy's useful illustrated life; and more recently the detailed biography of Miriam Benkovitz and the sensitive comment of Simon Wilson. British television has given the life and works a showing; exhibitions are frequent. Beardsley has returned, and it is not altogether likely that he will go away.

Notes and References

Preface

 1. Roger Fry, *Vision and Design* (London: Chatto & Windus, 1928), 236.

 2. Theodore Roethke, *Straws for the Fire* (Washington: University of Seattle Press, 1980), 21.

 3. Brigid Brophy, *Black and White: A Portrait of Aubrey Beardsley* (London: Jonathan Cape, 1968), 12.

 4. James Thorpe, *English Illustration: The Nineties* (London: Faber & Faber, 1975), 10–11.

 5. Brian Reade, *Aubrey Beardsley* (New York: Viking Press, 1967).

Chapter One

 1. *The Letters of Aubrey Beardsley,* ed. Henry Maas, J. L. Duncan, and W. G. Good (London: Cassell, 1970), 22–23; hereafter cited in the text as *L.*

 2. Malcolm Easton, *Aubrey and the Dying Lady: A Beardsley Riddle* (London: Secker & Warburg, 1972), 164.

 3. Brigid Brophy, *Beardsley and His World* (London: Thames and Hudson, 1976), 23.

 4. Quoted in S. Weintraub, *Beardsley: A Biography* (New York: George Brazillier, 1967), 82.

 5. Ibid., 61.

 6. Leslie Frewin, *The Cafe Royal Story* (London: 1963), 23.

 7. Weintraub, *Beardsley,* 59–60.

 8. Ibid., 58.

 9. Ibid., 105, quoting from the *Westminster Gazette.*

 10. Quoted in Weintraub, *Beardsley,* 72. Beerbohm's letter is dated 30 October 1896.

 11. W. B. Yeats, *Autobiographies of W. B. Yeats* (London: Macmillan, 1955), 329–330.

 12. Brophy, *Beardsley and His World,* 34.

Chapter Two

 1. Reade, *Beardsley,* 13.

 2. Mikhail Bahktin, *Rabelais and His World* (Cambridge, Mass.: Harvard University Press, 1968), 320, 318.

Chapter Three

 1. *Sunday Times,* 12 April 1966, Supplement, 11.
 2. Reade, *Beardsley,* 313.
 3. Simon Wilson, *Beardsley* (1976; rev. ed., Oxford: Phaidon, 1983), 2, plate 1.
 4. Reade, *Beardsley,* 333.
 5. Wilson, *Beardsley,* 14.
 6. Reade, *Beardsley,* 313.
 7. Ibid., 315.
 8. Wilson, *Beardsley,* 4.

Chapter Four

 1. The source lies in P. Bourget's *Essaie de psychologie contemporaine,* (Paris: Lemerre, 1881) but I use Havelock Ellis's translation of the passage in *Views and Reviews* (London: Desmond Harmsworth, 1932), 51–52. Ellis had discussed Bourget's views on the topic in *The Pioneer* (1889).
 2. Wilson, *Beardsley,* 19.
 3. Ibid., 4
 4. Ibid.
 5. Reade, *Beardsley,* 319–20.
 6. Wilson, *Beardsley,* 5.
 7. Reade, *Beardsley,* 316.
 8. Ibid., 324.
 9. Kenneth Clark, *The Best of Aubrey Beardsley* (London: John Murray, 1979), 17.
 10. Reade, *Beardsley,* 328.

Chapter Five

 1. Haldane MacFall, *Aubrey Beardsley, The Man and His Work* (London: John Lane, 1928), 50.
 2. Clark, *Best,* 22.
 3. Sir William Rothenstein, *Men and Memories,* (London: Faber & Faber, 1931), 1:184.
 4. Clark, *Best,* 20.
 5. *Saturday Review,* 8 April 1894.
 6. Arthur Symons, *Aubrey Beardsley* (London: Unicorn Press, 1898), 30–31.
 7. Holbrook Jackson, *The Eighteen Nineties* (New York: Capricorn Books, 1966), 103.
 8. R. A. Walker. *The Best of Beardsley* (London: Spring Books, 1948), 4.
 9. Brophy, *Black and White,* 12.

10. Easton, *Aubrey*, 68.

11. James G. Nelson, *The Early Nineties: A View from the Bodley Head* (Cambridge, Mass.: Harvard University Press, 1971), 242.

12. Reade, *Beardsley*, 336.

13. Elliot L. Gilbert, "Tumult of Images: Wilde, Beardsley and Salome," *Victorian Studies* 28, no. 1 (Winter 1983).

14. Ibid., 138.

15. *Pall Mall Gazette*, 27 February 1893.

16. Rothenstein, *Men and Memories*, 1:183–84.

17. Gilbert, "Tumult," 153.

18. Douglas, *Autobiography* (London: Secker, 1931), 72.

19. Oscar Wilde, *Intentions* (London: Osgood & McIlvaine, 1891); quoted by Gilbert, "Tumult," 144.

20. Walter Pater, *Studies in the History of the Renaissance*, ed. Donald L. Hill (Berkeley: University of California Press, 1980), 187–88.

21. Gilbert, "Tumult," 145.

22. Ibid., 146.

23. Reade, *Beardsley*, 13.

24. Gilbert, "Tumult," 147.

25. Graham Robertson, *Time Was* (London: Hamish Hamilton, 1942), 126.

26. Gilbert, "Tumult," 149–50.

27. Ibid., 152.

28. Ibid.

29. Ibid., 154.

30. Ibid., 156.

31. Ibid., 157.

32. Ibid., 152.

33. Ibid., 157–58.

34. Ibid.

35. In a private communication.

36. Clark, *Best*, 19.

37. Easton, *Aubrey*, 54.

38. *Salome: La Sainte Courtisane, A Florentine Tragedy* (London: Methuen, 1918), 22; hereafter cited in the text as *S.*

39. Weintraub, *Beardsley*, 64.

40. Walker, *Best*, 4.

41. Brophy, *Black and White*, 16.

42. Reade, *Beardsley*, 338.

43. Ibid., 336.

44. Ibid., 337.

45. Wilson, *Beardsley*, 12.

46. Pater, *Studies*, 93.

47. Walker, *Best*, 5.

48. Gustave Flaubert, *Oeuvres Completes* (Paris: Club de Honnete Homme, 1972), 4:275.

49. Wilson, *Beardsley,* 15.

50. Ibid.

51. In a fragmentary passage of 1798, Novalis writes: "Is the embrace not similar to the holy communion"; and in later passage: "Communal eating is a symbolic act of union. . . . All pleasure, appropriation, adaptation, and assimilation is eating, or rather eating is nothing but appropriation. All spiritual pleasure may therefore be represented by eating . . . it is a genuine trope to substitute the body for the soul, to enjoy at a memorial banquet of a friend with supernatural imagination his flesh in every bite and his blood in every drink." See Ernst Heilborn, *Schriften, Kritische, Neuausgabe auf Grund des handschriftlichen Nachlasses* (Berlin: Verlag, 1901), 2:239ff.) The following passage is also of interest: "About sexual desire, the longing for carnal contact, the pleasure in naked human bodies. Can it be a concealed appetite for human flesh?" (ibid., 2:261).

52. G. Moreau, *Catalogue Sommaire* (Paris: Musée Gustave Moreau, n. d.), 46.

53. Walker, *Best,* 7.

Chapter Six

1. Reade, *Beardsley,* 344.

2. Max Beerbohm, *Letters to Reggie Turner,* ed. Rupert Hart-Davis (London: Hart-Davis, 1964), 92.

3. *Yellow Book* 1 (April 1894):129.

4. Reade, *Beardsley,* 346.

5. Ibid., 347.

6. Wilson, *Beardsley,* 21.

Chapter Seven

1. Reade, *Beardsley,* 355.

2. "Dieppe: 1895", *Savoy* 1 (January 1896):86.

3. Reade, *Beardsley,* 355.

4. Ibid.

5. Ibid., 357.

6. W. B. Yeats, *The Poems,* ed. R. J. Finneran (New York: Macmillan, 1983), 344.

7. Reade, *Beardsley,* 357.

8. "Under the Hill," *Savoy* 2 (April 1896):192.

9. *Savoy* 6 (October 1896):52.

10. Reade, *Beardsley,* 359.

11. Ibid., 358.

12. Ibid., 349.

13. E. Panofsky, "Et Ego in Arcadia and the Elegaic Tradition," in *Philosophy and History* ed. Raymond Klibansky and H. J. Paton (Oxford: Oxford University Press, 1936), 223–54.

14. Reade, *Beardsley,* 360.

15. A. C. Swinburne, *Atlanta in Calydon and Erechtheus,* in *Collected Works,* vol. 4 (London: Chatto & Windus, 1920), 249; Wilson, *Beardsley,* 47.

16. Reade, *Beardsley,* 362.

Chapter Eight

1. Reade, *Beardsley,* 343.
2. Ibid., 334.
3. Wilson, *Beardsley,* 43.
4. Reade, *Beardsley,* 340.
5. Ibid., 350.
6. Ibid.
7. Ibid., 352.
8. Ibid., 363.
9. Wilson, *Beardsley,* 45.
10. Reade, *Beardsley,* 362.
11. Wilson, *Beardsley,* 26.
12. Reade, *Beardsley,* 347.
13. *Lucian's True History,* trans. Francis Hickes; illus. William Strang, J. B. Clark, and Aubrey Beardsley; intro. Charles Whibley (London: Lawrence & Bullen, 1902), 12–13.
14. "Ars Postera": Owen Seaman, *The Battle of the Bays* (London: John Lane, 1896), 58.

Chapter Nine

1. *New Review,* July 1894, 59.
2. *Savoy* 1 (January 1896):156.
3. Ibid., 160.
4. *Savoy* 2 (April 1896):187–88.
5. Ibid., 188.
6. Linda C. Dowling, "*Venus and Tannhauser*: Beardsley's Satire of Decadence," *Journal of Narrative Technique* 8 (1978):3.
7. *Savoy* 2 (April 1896):195.
8. Brophy, *Black and White,* 46.
9. Reade, *Beardsley,* 350.
10. *Savoy* 1 (January 1896):66.
11. *Savoy* 3 (July 1896): 91–93.
12. Clark, *Best,* 39.
13. In her as yet unpublished study of Beardsley and feminism, "Drawing the Lines."

14. Reade, *Beardsley,* 356.
15. Clark, *Best,* 39.
16. Ibid.
17. Brophy, *Black and White,* 11.
18. *Savoy* 7 (November 1896):52.
19. Reade, *Beardsley,* 357.
20. MS at Princeton.
21. Ibid.

Chapter Ten

1. Robert Halsband, *The Rape of the Lock and Its Illustrators 1714–1896* (Oxford: Oxford University Press, 1980), 91.
2. Brophy, *Black and White,* 18.
3. Reade, *Beardsley,* 332.
4. Halsband, *Rape,* 92.
5. Ibid., 100.
6. Ibid.
7. Ibid., 101.
8. Ibid., 103.
9. Ibid., 106.
10. Ibid.
11. Ibid.
12. D. J. Gordon, "Aubrey Beardsley at the V & A," *Encounter* 27 (4 October 1966):14.
13. Reade, *Beardsley,* 360–61.
14. Ibid., 360.
15. Robert Melville, "Aubrey Beardsley," *New Statesman,* 71:786–87.
16. Arthur Symons, *Aubrey Beardsley* (London: Unicorn Press, 1948), 22.
17. William Gifford, *The Satires of Decimus Junius Brutus Juvenalis* (London: G. W. Nichol, 1802), 4:168, lines 94–95.
18. Pausanias, *Description of Greece,* trans. W. S. S. Jones and H. A. Ormerod (Cambridge, Mass.: Harvard University Press, 1958), 700.
19. Brophy, *Black and White,* 14.
20. *The Poems of John Dryden,* ed. J. Kinsley (Oxford: Oxford University Press, 1958), 2:700, lines 184–85.
21. Ibid.
22. Reade, *Beardsley,* 363.
23. *The Poems of John Dryden,* 700, lines 335–36.
24. Gifford, *Satires,* 176, lines 335–36.
25. Reade, *Beardsley,* 363.
26. Ibid., 364.

Chapter Eleven

1. Robert Ross, *Aubrey Beardsley* (London: John Lane, 1909), 17.
2. Ibid., 33.
3. Max Beerbohm, *Idler* 13 (4 May 1898):544.
4. Symons, *Aubrey Beardsley*, 22.
5. Ibid.
6. Ibid., 22–23.
7. Ibid., 23
8. *Burne-Jones Talking: His Conversations 1895–1898 Preserved By His Studio Assistant, Thomas Rooke*, ed. Mary Lago (London: John Murray, 1982), 174–75, 187–88.
9. Dan Ryder, "Adventures with Frank Harris," chap. 5, pp 6–8, typescript in Reading University Library: MS. 2012.
10. Ross, *Aubrey*, 37.
11. Fry, *Vision and Design*, 232.
12. Clark, *Best*, 44.
13. Fry, *Vision and Design*, 233–34.
14. Ibid., 232.
15. Ibid.
16. O. Wilde, "The Critic as Artist," in *Intentions* (London: McIlvaine & Osgood, 1891), 87.
17. Clark, *Best*, 24–25.

Selected Bibliography

PRIMARY SOURCES

1. Manuscripts
A fragment of *Venus and Tannhäuser* and fragments of verse and prose are located at Princeton University; the manuscript of *Venus and Tannhäuser* is at the Rosenbach Foundation, Philadelphia.

2. Drawings
The principal collections of original drawings are to be found at the Fogg Museum, Harvard University; Princeton University; the Victoria and Albert Museum, London; Tate Gallery, London. A number are in private hands.

3. Collections of Drawings and Illustrated Books (in chronological order)
Studio 1, no. 1 (April 1893):14–19.
Bon-Mots of Charles Lamb and Douglas Jerrold. Edited by Walter Jerrold; grotesques by Aubrey Beardsley. London: J. M. Dent, 1893.
Bon-Mots of Sydney Smith and Brinsley Sheridan. Edited by Walter Jerrold; grotesques by Aubrey Beardsley. London: J. M. Dent, 1893.
Bon-Mots of Samuel Foote and Theodore Hook. Edited by Walter Jerrold; grotesques by Aubrey Beardsley. London: J. M. Dent, 1894.
The Birth Life and Acts of King Arthur of his Nobel Knights of the Round Table their marvellous enquest and adventures the achieving of the San Graal and in the end Le Morte Darthur. . . . The text as written by Sir Thomas Malory . . . with many original designs by Aubrey Beardsley. London: J. M. Dent, 1893–94.
Keynotes. By George Egerton. London: Elkin Mathews & John Lane; Boston: Roberts Bros., 1893. The title of this work gave its name to a series of novels published over the next three years, most of the cover designs being the work of Beardsley.
Lucian's True History. Translated by Francis Hickes; illustrated by William Strang, J. B. Clark, and Aubrey Beardsley. London: Lawrence & Bullen, 1894.
Salome: A Tragedy of One Act. Translated from the French of Oscar Wilde; illustrated by Aubrey Beardsley. London: Elkin Mathews & John Lane; Boston: Copeland & Day, 1894. The John Lane edition of 1907 adds two more illustrations.

The Works of Edgar Allan Poe. Chicago: Herbert S. Stone & Co. 1894–95. Beardsley's illustrations appeared only in the Japanese paper issue of ten copies. They were republished in the edition of 1901.

Pierrot's Library. London: John Lane; Philadelphia: Henry Altemus; Chicago: Rand-McNally & Co. 1896.

Savoy 1–8 (January–December 1896).

The Rape of the Lock. By Alexander Pope. Illustrated by Aubrey Beardsley. London: Leonard Smithers, 1896. Reissued in 1897 with smaller plates.

The Lysistrata of Aristophanes. Illustrated by Aubrey Beardsley. London: Leonard Smithers, 1896. Published for private distribution.

The Pierrot of the Minute. By Ernest Dowson. London: Leonard Smithers, 1897.

A Book of Fifty Drawings by Aubrey Beardsley. Iconography by Aymer Vallance. London: Leonard Smithers, 1897.

Six Drawings Illustrating Theophile Gautier's Romance Mademoiselle de Maupin by Aubrey Beardsley. London: Leonard Smithers, 1898.

Ben Johnson his Volpone: or the Foxe. Critical essay on the author by Vincent O'Sullivan; eulogy of the artist by Robert Ross. London: Leonard Smithers & Co., 1898.

A Second Book of Fifty Drawings by Aubrey Beardsley. London: Leonard Smithers, 1899.

The Early Work of Aubrey Beardsley. London: John Lane, 1899.

Four Illustrations for the Tales of Edgar Allan Poe, drawn by Aubrey Beardsley. Chicago: H. S. Stone & Co., 1901.

The Later Work of Aubrey Beardsley. London: John Lane, 1901.

An Issue of Five Drawings Illustrative of Juvenal and Lucian. London: Leonard Smithers, 1904.

Under the Hill: The Story of Venus and Tannhäuser. Completed by John Glassco. Paris: Olympia Press, 1959; London: New English Library, 1966.

The Letters of Aubrey Beardsley. Edited by Henry Maas and W. G. Good. London: Cassell, 1967. Beardsley's letters are mostly short, but not without wit and with useful comment here and there on his art.

SECONDARY SOURCES

1. Catalogs

Catalogue of the Aubrey Beardsley Exhibition at the Victoria and Albert Museum. London: Victoria and Albert Museum, 1966. A marvellously rich and varied record of a superb exhibition. Most of the items on show were transferred to New York for an exhibition in the following year. Brian Reade was responsible for both the London and the New York events.

2. Books and Articles

Beerbohm, Max. "Aubrey Beardsley," *Idler* 13, no 4 (May 1898):532–46. Reprinted in *A Variety of Things* (London: William Heinemann, 1928). An elegant and discreet éloge.

————. *Letters to Reggie Turner.* Edited by Rupert Hart-Davis. London: Rupert Hart-Davis, 1964. Lively letters with incidental references to Beardsley.

Benkovitz, Miriam J. *Aubrey Beardsley: An Account of His Life.* New York: G. P. Putnam's Sons, 1981. A detailed if pedestrian account. Stronger on biography than criticism.

Brophy, Brigid. *Beardsley and His World.* London: Thames & Hudson, 1976. Admirably illustrated and with a detailed text.

Brophy, Brigid. *Black and White: A Portrait of Aubrey Beardsley.* London: Jonathan Cape, 1968. A discursive, but often penetrating discussion of selected images. A Freudian reading.

Clark, Kenneth. *The Best of Aubrey Beardsley.* New York: Doubleday & Co., 1978. Highly perceptive comment on individual drawings and with acute comment on the relationship of originals to reproductions. Tends to treat Beardsley as though he had little to do with the 1890s.

Easton, Malcolm. *Aubrey and the Dying Lady: A Beardsley Riddle.* London: Secker & Warburg, 1972. Or Aubrey and Mabel. Discursive and occasionally acute.

Fry, Roger. *Vision and Design.* London: Chatto & Windus, 1929. An influential essay that makes limiting judgments on Beardsley's art.

Gilbert, Elliot L. " 'Tumult of Images': Wilde, Beardsley, and *Salome*." *Victorian Studies* 28 (Winter 1983):133–60. A brilliant study; the accent rather more on Wilde than on Beardsley.

Gordon, D. J. "Aubrey Beardsley at the V & A." *Encounter* 42 (October 1966):1–16. A brilliant article setting Beardsley firmly in the 1890s with perceptive comment about the drawings.

Ironside, Robin. "Aubrey Beardsley." *Horizon* 14, no. 81 (September 1946):190–202.

King, A. W. *An Aubrey Beardsley Lecture.* Introduction and notes by R. A. Walker (Georges Derry). London: R. A. Walker, 1924. Reminiscences by a master at Beardsley's old school, Brighton College.

Lane, John. *Aubrey Beardsley and the Yellow Book.* New York: John Lane, 1903. Reminiscences.

McColl, D. S. "Aubrey Beardsley." *Mir Isknistva* 7–8 (1900):73–84. In Russian. Diaghalev's periodical. "The New English Art Club and the Meissonier Exhibition." *Spectator,* 22 April 1893. McColl wrote several articles that allude to Beardsley's "freakish talent". Though less limiting in his judgments than Fry, he is equally constrained by *parti pris*: in this case, Impressionism rather than Post Impressionism. Beardsley is placed as a

caricaturist with artists as diverse as Blake, Hokusai, Lautrec; his emotion is not born of "a strenuous marriage of eye with fact."

————. "Aubrey Beardsley." In *A Beardsley Miscellany,* edited by R. A. Walker. London: Bodley Head, 1949. Articles by a distinguished art critic that express some reserve about Beardsley's art, though the general tone is favorable.

Macfall, Haldane. *Aubrey Beardsley: The Clown, the Harlequin, the Pierrot of his Age.* New York: Simon & Schuster, 1927. Occasionally perceptive.

May, John Lewis. *John Lane and the Nineties.* London: John Lane, 1936. Reminiscences by an office boy at the Bodley Head.

Pennell, Elizabeth. *Nights.* Philadelphia: J. B. Lippincott, 1916. Wife of Joseph Pennell and like him a worshipper of Whistler; incidental allusion to Beardsley.

Pennell, Joseph. *Aubrey Beardsley and Other Men of the Nineties.* Philadelphia: Pennell Club, 1924. More about Whistler than Beardsley.

Reade, Brian. *Aubrey Beardsley.* London: Studio Vista, 1967. The definitive study.

Ross, Robert. *Aubrey Beardsley.* London: John Lane, 1909. Charmingly written and with occasional acute points.

Stanford, Derek. *Aubrey Beardsley's Erotic Universe.* Introduction by Derek Stanford. London: New English Library, 1967. The first book to focus in a neutral spirit on the erotic detail of Beardsley's drawings. Replete with suggestive critical comment.

Symons, Arthur. *Aubrey Beardsley.* Rev. and enl. ed. London: J. M. Dent & Co., 1905. Elegant criticism though tending to give too much away to the "diabolic" school of interpretation.

Vallance, Aymer. "Aubrey Beardsley." *Bookmark* 3, no. 12 (November 1927):1–4. Reminiscences by a friend of Beardsley's early years with some critical comment.

Walker, R. A. (Georges Derry). *How to Detect Beardsley Forgeries.* Bedford: R. A. Walker, 1950.

————. *La Morte Darthur with Beardsley Illustrations: A Bibliographical Essay.* Bedford: R. A. Walker, 1945. Useful, but Walker's judgments are less satisfactory than his detailed knowledge of Beardsley's oeuvre.

Weintraub, Stanley. *Beardsley: A Biography.* New York: George Braziller, 1967. The best biography. Informative and lively.

Wilson, Simon. *Beardsley.* Oxford: Phaidon, 1976. Revised and enlarged edition, 1983. Subtle criticism.

Index